MOUNT
WASHINGTON

MOUNT WASHINGTON

• • •

NARRATIVES AND PERSPECTIVES

EDITED BY

MIKE DICKERMAN

THE
History
PRESS

Published by The History Press
Charleston, SC
www.historypress.net

Front cover images courtesy of Chris Whiton.

First published 2017

Manufactured in the United States

ISBN 9781625859013

Library of Congress Control Number: 2017934940

CONTENTS

ACKNOWLEDGEMENTS

Until I began piecing together this book, I had no idea how much time and energy would be required. Like any project of this sort, I suppose, the work was both fun and frustrating. Certainly tracking down the various pieces that compose this anthology was the most time-consuming but enjoyable part of the journey. Likewise, finding photographs to match the written words was a thoroughly enjoyable challenge. At the same time, eliminating deserving articles or photographs—primarily because I'd run out of space—was a wrenching experience, especially knowing how much time and effort went into choosing these items in the first place.

That I've made it this far with the book is a true testament to the encouragement and assistance offered by numerous individuals throughout northern New Hampshire, most of whom share my interest in Mount Washington and the entire White Mountains region. Without these folks, who I'll get to in just a moment, the stories you are about to read and photographs you are about to view would never have come together.

First and foremost, I'd like to thank the staffs of the New Hampshire State Library, the Littleton Public Library, Pease Public Library of Plymouth and the Bethlehem Public Library. At each library, staff members went out of their way to help me find whatever I was searching for.

Contributing authors such as Floyd W. Ramsey and Peter Crane were equally helpful, not just for allowing me to reprint their invaluable contributions to this book but also for loaning me photographs and suggesting other worthwhile pieces.

Acknowledgements

Descendants of two of the White Mountain region's most famous twentieth-century photographers, Winston Pote and Guy L. Shorey, need to be thanked for providing or allowing me to use a number of their vintage photographs. Other vintage photographs were supplied by the ever-encouraging Dave Govatski of Jefferson; Jeff Leich and New England Ski Museum; the Mount Washington Observatory; accomplished Bethlehem, New Hampshire photographer Chris Whiton; the White Mountain National Forest; and the Littleton Area Historical Society.

Thanks must also go out to the Trustees of Dartmouth College, the Appalachian Mountain Club and dear friend Eleanor Stephenson of Bethlehem, who all graciously agreed to let me publish previously written pieces.

The Amherst College Alumni Association needs to be recognized as well for providing invaluable biographical information on several of the authors whose work appears in this book, while Art and Abby Tighe at Foto Factory of Littleton did a superb job reprinting several old photographs appearing elsewhere in this volume.

INTRODUCTION

Although I grew up in northeastern Vermont, a little more than an hour's drive from the Presidential Range, Mount Washington has always been a part of my life.

As a kid growing up, the mountain was brought into my living room every night courtesy of Channel 8 out of Poland Spring, Maine. Sometime shortly after six o'clock, there would appear on the television screen the fuzzy, black-and-white image of Marty Engstrom, who would give a live report from the top of the mountain, detailing prevailing weather conditions at the summit. Being just kids, though, with little interest in meteorology, it wasn't the weather update we were interested in; it was Marty's signature grin that would keep our eyes peeled to the screen. Just before he would sign off for the night, Marty would flash that goofy smile of his directly into the camera, and all of us, Mom and Dad included, would immediately crack up with laughter, even though we'd seen it a hundred times before.

It was hard to take Marty seriously—and still is—and that made it difficult to accord the mountain as much respect as it obviously warranted. It wasn't until 1982, when I suddenly became interested in hiking, that I really gave much thought about what it was truly like on the mountain. I had to assume there was more to it than just a television camera pointed in Marty's face, but I needed to find out for certain, so my older brother organized a fall expedition up the mountain, and I got to see in person what Mount Washington was really about.

INTRODUCTION

Ever since that crisp, clear October day on the top of New England, there has existed in me a curious fascination with this 6,288-foot mountain. The fact that it is the tallest mountain in New England (and one of the highest in the entire Appalachian Mountain chain), that it is home to some of the worst weather on earth, and that it has a history that is perhaps unrivaled among all North America peaks, makes Mount Washington one of the most visited and most written about mountains in the world. It goes without saying that I am not alone in having a fascination with this mountain.

It has been my fortune these past thirty-five years to get to know Mount Washington in a variety of ways. I have seen it from a hiker's perspective, dragging one foot after another up its steep, rocky cone, wondering if my legs or heart would give out before I reached the summit. I have seen it from a journalist's perspective, chronicling enough tragic events on the mountain over the years to fill a book of its own. And more recently, I have seen it from an aspiring historian's perspective, who has gobbled up every morsel of information he can find in hopes of learning everything about the mountain's storied past.

It is no wonder, then, that I am still drawn to its summit every year, even though I remain intimidated by this mammoth mound of rocks. Despite years of hiking and climbing in the White Mountains, I find every trip up to its heights as exhausting and exhilarating as that first one. And even when I am not on the mountain itself, but instead find myself plodding along some footpath elsewhere in these White Mountains of northern New Hampshire, Mount Washington beckons. It is always there on the horizon, standing head and shoulders above all else, its summit structures pointing skyward.

The mountain is hardly pristine, for humankind's presence is obvious most everywhere, and it is certainly not hospitable. Still, for all its faults and foibles, Mount Washington remains a lifelong acquaintance, and I am glad I have gotten to know it better over the years.

Twenty years ago, when I first began compiling the pieces that made up the first edition of this book, it was not my intention to focus solely on Mount Washington. The project started out as an anthology of White Mountain literature but soon developed into a book solely devoted to pieces related to the Rock Pile, as the mountain is commonly known.

Although this new edition is a condensed version of the original book that was first published in 1999, I still like to think of this compilation as a prewritten history of the mountain, for it tells the story of Mount Washington through the words of those who knew and wrote about the mountain long before I was born or before I'd ever seen or heard of the Presidential Range.

Most of the mountain's major events—from Darby Field's historic climb of 1642 to the tragic Cog Railway crash of September 1967—are chronicled on these pages. Sure, there are a few events I have skipped over, and certainly some readers may feel too much of the mountain's morbid past is covered. By and large, though, I think you will come away with a good sense of why this particular White Mountain peak has captured my imagination, and the imagination of many others, for so many years.

For the most part, the republished works appearing here are in their original form, with the spelling and punctuation virtually unchanged. It is my intent, in keeping things as they were, to give readers a flavor of the times in which these words were first written.

THE GLORY OF MOUNT WASHINGTON

By Julius Ward

From The White Mountains: A Guide to Their Interpretation, *1890*

The White Mountains: A Guide to Their Interpretation *was published in 1890. Its author, Reverend Julius H. Ward (1837–1897), was an editorial writer for the* Boston Sunday Herald. *Most of the passages appearing in* The White Mountains *had first appeared in the Boston newspaper. The Appalachian Mountain Club, of which Ward was a member, said of the author in its 1891 review of the book, "Mr. Ward seems to be as much at home all through the mountainous parts of New England as common folk are in their own gardens, and his love for the hills is genuine and inspiring. He has learned their secrets in lonely climbing."*

Approached from whatever point of view, Mount Washington stands alone for grandeur and isolation among its kindred peaks. Seen from North Conway, it lies in majestic repose against the northern sky—now enveloped in clouds, now brightened in the sunshine, but always in an attitude of dignity and strength, the monarch of the hills; seen from the Glen, its massive shoulders, its enormous ravines, and its length and breadth and height dwarf everything within its range; seen from Fabyan's, its magnitude is lost in comparison with the companions that lend themselves to its greatness; seen from Bethlehem or Jefferson Highlands, the distance lends enchantment to the view, and the imagination kindles with its greatness and with the grandeur of the whole Presidential range; seen in the distance from Moosilauke, it lies hard against the eastern sky, and holds the mountains in its embrace as a shepherd keeps his flock.

There is no part of northern New England where a sight of it does not thrill the soul with its serenity and power. It is so high it stands sentinel of the country round-about; if the highest mountain in New England, it is far from being the highest in North America, and in the west it would sink into insignificance; but here it represents to the distant observer that outreach of the earth to the heavens for which we have no better symbol than the mountain whose peak pierces the blue.

The danger is, that in visiting Mount Washington this fascination of distance may be lost and nothing put in its place. It is with mountains as it is with great men—at a distance and at their best they are towers of strength. Nothing of their weakness is discovered. It is a different thing to live with them, to bear with their foibles, to ignore their defects, to admit their superiority. Only the greatest and noblest of men can endure the ordeal of being known for what they truly are. It is so with the mountains. It is easy to invest them with the colors of the spirit, but the difficulty is to trace these colorings when you are climbing them or enjoying the outlook from their summits. The nearness and the reality oppress the imagination. Mount Washington is approached with the feeling that the majesty and grandeur are to be revealed without personal effort, and people carry away nothing like the impressions which they had hoped to obtain. One sees in the mountains only what he is prepared to see. A quick sensibility to the beauty and glory of the outer world is a great help to seeing them, but even this gift needs to be trained and developed before the mountains reveal their secrets and have their full effect upon our sensitive life. One must not be disappointed if Mount Washington fails at first to meet his expectations. It is so unlike any other summit, except Jefferson and Adams and Madison in its own range, that one is at a loss to compare it with anything that he has known; and if it is his first acquaintance with the White Hills, he is like a man who has suddenly inherited a fortune—he is ready to enjoy it if he only knew how.

The interpretation of Mount Washington is as much an undertaking as the following of the frescoes of Michael Angelo in the Vatican, or the entering into fellowship with the genius that created The Divine Comedy. Both are understood only as you enter into the mind of the artists or the poet and give to him the sympathy of a kindred spirit. The greatest things in literature and art are the commonest, and yet the power of mind and soul that goes into them takes them out of the common order and calls us up to their level. This represents the situation to one who visits Mount Washington. There is nothing here which is not common to our life. The rocks, the sky, the clouds, the light, the darkness—all these one is familiar

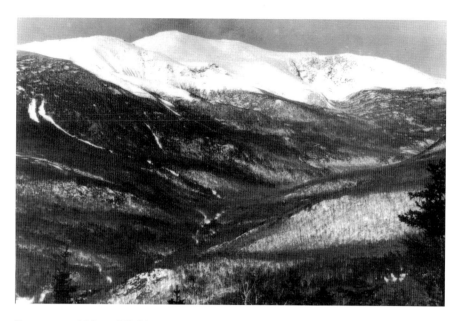

Snow-covered Mount Washington and Pinkham Notch. *Winston Pote image, author's collection.*

with; and when you begin to exchange the feelings with which you have regarded this grandest of our mountains for the hard and bleak and desolate realities of its daily existence, the imagination is set its hardest task to rise above the awful nakedness of the summit and invest it with the ideal majesty which belongs to it when seen from afar. Ruskin says that "all the power of Nature depends on subjection to the human soul." It is not difficult to comprehend the great poem or the masterpieces of the painter and the musician. They are human, and if we follow the laws of creative effort we can interpret them; but in subjecting the mountains to the soul, in interpreting them as we enter into the works of man, how do we find the thread of intelligence that leads us to the comprehension of their motive, their feeling, their part in the plan of Nature, their kinship with the mind of man? The key is ready for the hand that knows how to use it, and many a one has turned it through the wards of the lock that opens to us the divine order which prevails no less in the inorganic than in the organic world.

Nothing in the outer realm is without its laws, its combinations, its sympathies, and when you begin to see and feel them, whether in the dew-drop or in the uplifted mountain, you have caught the thread of intelligence

that leads you into the inner kingdom of Nature and gives the suggestion that turns the earth and the water and the sky into vital instruments in the hands of God. In knowing and feeling this one begins to have a reverent spirit toward the mountains with a sufficient cause. The imagination is as true a part of the intellect as the reasoning faculty, and it is with the imagination that we best enter into the life of the mountains and learn how to bring them into proper relations with the human soul.

At first Mount Washington said nothing to me. It was a great pile of broken rock, desolate, passionless, without appeal, without response, and the outlook was so vast and unusual that I could do nothing with it. The key to its grand life was not given; there was nothing to compare it with, and even the naming of the peaks within the reach of the eye brought no relief. Ordinarily the ascent of a mountain gives pleasure, but Mount Washington is haughty in its mood and will encourage no familiarity. Its immense desolation is the only impression that the naked peak makes upon the new-comer, and for most persons this is all that they take home with them. So you meet with people reputed to be great in the world, and measure them from the outside; so the casual man met Goethe and took his impression of the chief modern man from the surface; but he knew not Goethe as did those who by kindred studies and like culture were prepared to share his life. It was my duty to wait in the outer courts of the temple till I could be initiated and prepared to

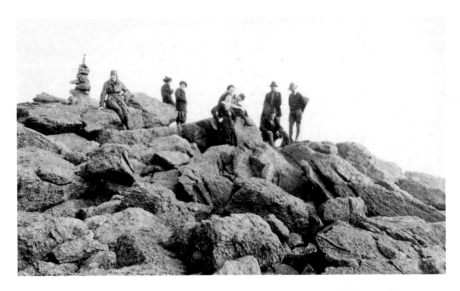

Visitors relax near the rocky summit of 6,288-foot Mount Washington. *Courtesy Dave Govatski.*

enter into the veil. I had not long to wait. Cold and passionless as the mount is to those who do not approach it with intelligent devotion, it finds its way quickly enough to those who are responsive to its grand moods. The attitude of one who is drinking in the sky and feels the exhilaration of the morning and opens his heart toward Nature—the attitude of sympathetic and intelligent approach—is the way to win the secrets of Mount Washington.

An awakening, slow and sure, as when a great thought gradually makes its way to the conquest of one's life, passed over my whole existence. I felt myself lifted into a new consciousness. I could not read; I could not stay indoors; I could not talk with friends. It seemed as if the tides of life were rising to a new altitude. The commonness of the peak disappeared; the great rough fragments of rock lost their individuality; the huge shoulders and ravines lost their terribly bleak wildness; and there came the consciousness of the grand and sublime in Nature which I had never known before. It was the unconscious exhilaration that comes to a lover of the mountains when they enter into his soul and raise his life to their level. Then Mount Washington began to speak to me in a language that I could understand; the sky and the peak kissed and embraced; then the mountains and the morning stars sang and danced together; then the mountain was instinct with life, and an awful reverence stilled the soul of its solitude. More and more this feeling, as if there were a divine Presence, came upon me and lifted everything out of common. My mind and heart were in tune with the music of the spheres, and I could hear what the mountain had to say.

It was in this mood that the glory of Mount Washington passed before me. It passed many times, and first it presented itself in this wise. The sky had been thick with haze for several days, so that the surrounding peaks lost their significance and the sunrise had given no hint that a clearing was to come in the early morning. It did not seem as if there were clouds in the air. It was rather mist than cloud. The sun stood on the horizon half an hour high, when suddenly the atmosphere was alive with movement. The shifting of the scenery of the heavens and the earth had begun. Not often do the clouds assume greater majesty or break into wilder beauty than did the cloud mists which formed in column and rose for their morning homage. They lay like immense coils of impalpable reality over the neighboring peaks which they half concealed and half revealed—so near that it seemed as if you could almost take them in your arms, and yet they moved with the majesty and order of the winged chariots of the Most High. It was as if the earth and the sky were in motion—not in the conflict of battle, but in the tremor of silent adoration. One thinks and feels intensely at such

moments. The rare displays in the life of Nature have their responses in the minds of men. It was so on this morning. I was not alone. Others were by my side enjoying the beauty of the heavens and the mountains as keenly as myself; but still I was alone. The soul was apart by itself, and would only have its own company. The pageant was as unreal as the baseless fabric of a dream, and yet it was intensely real. The clouds marched as if to the music of the morning, and the imagination was aroused to its highest sympathy with that something in the outer world that stimulates our feelings of unlimited life. In that picture, which no artist could paint, I felt as St. Paul is said to have felt when he had the ecstatic vision. I was caught up out of my usual self, and found things not ordinarily within my grasp so near that it seemed as if I had never known anything else. These are the moods that the mountains induce in the minds of those who are prepared to enter into their life. No one who has ever read Wordsworth's Excursion will doubt their reality or feel that too much is made of them by those who have the vision of spiritual things.

At morning and at evening the mountains put on their glorious apparel, and Mount Washington, slumbering like a giant at midday, is never so alive to the imagination as when the sunbeams shoot out of the east and cross the great ravines to kiss the summit, or as when, tired out with his day's work, the Sun lingers to caress the two or three peaks of the Presidential range that are most in touch with one another, while the western valley and the great table-land are almost invisible in the gathering darkness. The morning brings light and joy to the world, and on Mount Washington these may come upon the wings of the wind or break in golden color through folds of mist, or make the peak resplendent, while the ravines are sending up their incense to mark the opening of the day. No one can tell what the revelation may be. If you are watchful for the vision, it will come, but you can no more coax it then you can hurry the footsteps of the hours. One must be like Samuel, watching through the night for the divine call, if the glory of the mountain is to be his portion. If you wait on the mountain until the moment of vision comes, it is as if the glory of earth and sky had passed before your eyes.

The evening on Mount Washington touches a note different, indeed, from that of the morning, less radiant, not paling away into the noonday glare of the eternal hills, but even more accordant with one's sober experience, and with the national pulse of life. The evening, too, has the point of advantage. The Green Mountains, behind which the sun goes down, are lower than Mount Washington, and the dip is just enough to give the peak a final flash

of light before the chill of the night comes on. What a change then begins!
A few moments before there was—

> *A sense sublime*
> *Of something far more deeply interfused,*
> *Whose dwelling is the light of setting suns,*
> *And the round ocean, and the living air,*
> *And the blue sky, and the mind of man.*

Then comes the slow, lingering twilight, darkness below and the fading
light above, when the peaks seem to rise out of the dark ravines like great
created forms and advance and recede in dumb pantomime than which
nothing can be more impressive. Again and again have I watched Jefferson
and Adams and Madison, under the spell of the deepening night, just across
the Great Gulf, which is so foreshortened that you feel as if you could almost
step across it, until they had settled themselves for the night, and seemed
like giant children going to sleep. The lonely lea in the neighborhood of the
hamlet in the country has its grateful hush at nightfall, when you wait for the
darkness and are glad at its coming. The mountains in their vaster silence
and loneliness repeat the feeling at the country side with an intensity that is
proportioned to their vastness, and the human spirit clings to their summits
in the summer darkness with an indescribable sense of protection.

What a world it is which greets the eye in the starry night on Mount
Washington! The distant peaks are shut out of sight, and the welkin comes
down to your feet and you live among the lights of worlds not ours. Sit down
on one of these rough rocks and tell the number of stars, trace the courses of
the constellations, separate the planets and the great stars from the inferior
host of the sky, and identify yourself with the systems—greater than our
own—by which God ministers to his outer worlds. It is wholesome to thus
lose yourself in the universe and make a journey with the travelers in the
sky. It is thus that you live into the life of the mountains by night as by day,
and they take possession of you in such a way that in your turn you obtain
their secrets and translate their messages into a personal experience. There is
never a moment by night or by day that the mountains are not waiting upon
one with their messages, but one must empty himself of himself again and
again before the voice is heard in the deeper recesses of the spirit.

The lighting up of the clouds on the approach of sunset is one of the
moments when Mount Washington is the centre of glory. The great height
and immense horizon respond to this display of strength and beauty

and power of color with magnificent results. The combinations are like visitations of the ethereal light, and at times they surpass all the resources of expression. The splendor and the glory are as intense as they are evanescent, and the only display that surpasses the sunsets is that of the gathering of a storm from the lowlands and its march upon the mountain. Then the sublime and the grand and the awful and the terrible are all wrought up to a fearful intensity at the same moment, and when the powers of Nature are unleashed it is as if the whole world were to be devoured at once. The spirit quails at such moments before the fury of the elements. Ruskin and Wordsworth have done most to teach us how to interpret the connection of the clouds with the mountains, but neither of them has helped us to interpret them in the hours of storm. Mostly the clouds reveal their beauty in the sunshine or at the critical moments when storms begin or end, but there is a truth of life in the storm which is as important as the revelation of glory in the clouds at the altars of the morning and the evening sacrifice. Artistically, the storm refuses full expressions, but the clouds lend a strength to the storms on Mount Washington which matches the storm crisis of the human spirit at every point; and one can better understand himself after he has lived through them than he could before.

The clouds in their great throes of power and agony and fury are not beautiful. Their beauty is in their relation to the sky and the earth in the light. In the storm they are not our best symbols of the divine Will, and join with the wind and the rain to chastise the mountains. Mount Washington is always expecting this chastisement. All the world may be at peace with the higher Powers, but not so the monarch of the hills. The clouds drop their fatness in rain or sleet at the slightest invitation, and the gentle *susurrus* of the valleys becomes on the mountain summit the trumpet blast that drives all the forces of the heavens before it. There are no adequate terms to describe a storm on Mount Washington. The shrouding of the summit in mist so that day is turned into night expresses its power to create gloom. The wind blowing a gale that treats a man as if he were a feather expresses a fury that is only matched by a tempest at sea. The chained buildings, the crowding in of the mist, the feeling of the infinity of nothing that comes with it, the roar and rage of the elements, the continuous gloom, the utter helplessness of man, the sense of unmeasurable terror, make a picture of desolation in which man is nothing and the Will that rules the storm is supreme. Nothing but the mountain itself, weighted down with its millions of broken rocks, can survive the contest in which the strongest forces of Nature are engaged. Secure as one may be within the hotel, the spirit aches

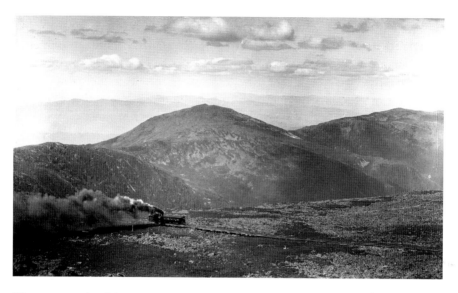

The craggy peaks of the Northern Presidentials provide the backdrop for a Cog Railway train churning its way up Mount Washington. *White Mountain National Forest archives.*

and moans and rages like the tempest outside. The battles in the air are like the battles between living men.

One feels in the great storms as if he were in command of the host; his spirit is raised to the concert pitch; it is a battle in which no one can be a disinterested spectator. Imagine the most terrible storm that you have ever witnessed in the lowlands, and then imagine it seven times as terrible as that, and you have a most imperfect conception of a storm at its height on Mount Washington. It is as if all the evil in the world were seeking to devour you; it is not the wind or the darkness or the pelting of the storm or the trembling of the hotel or the feeling that the world is up in arms, but the sense of terror, the wildness of the beasts of power, the let-looseness of everything that swells the fury of the elements; and yet all the while it is raging there is a satisfaction in this display of might and strength that is comforting; it tells you that Nature in these savage moods is only the reflex of your own unruled will tearing its way through the world in constant conflict; and when the storm subsides and the mists clear off and the old mountain is again what it was before, the gladness is not unlike the joy of one who has been through a terrible tumult in his soul and has finally risen above it and again reached tranquillity of spirit. A mountain in its expression of the moods of Nature is not unlike a man in his life with himself.

There are times when Mount Washington is simply great in its beauty and glory. This is not in its storm period, not in its revelations to the spirit at the opening and the close of the day, but in the hours of a sunny afternoon when the clouds are level with the peak and encircle the horizon and look as if they were waiting to be reviewed by the father of the hills. The forces of the sky are then in their best array. The artillery, the thunder and the lightning, are dismissed, and the great clouds are waiting for the nod of approval from the monarch of the kingdom in which they move. Then you take your seat reverently upon a great rock on the peak, or better still on top of the observatory, and watch. At the moment the universal stillness alone comes to you; but wait and watch. The clouds do not move, and yet they move. The picture is that of still pageantry, and yet it is not long before you discover that the whole welkin is quietly shifting before your eyes. Do not be in a hurry. Wait an hour or two. Turn from the clouds to the near mountains—Clay, Jefferson, Adams, Madison. They do not move. Oh no, they are the everlasting hills, and never move; and yet they have caught the enchantment of the sky and are moving too. In a bit of wood the branches bend and the leaves are in a gentle quiver when there is not a breath of air to stir them, and Emerson used to say that it was the good manners of the trees in the presence of man, and bowed his head in response. So in this glorious pantomime between the sky and the mountains, the peaks catch the manners of the silent clouds and go through their silent and graceful response, and the great ravines in their changing shadows fill the air with their spirit.

There is never a moment on this grand old summit in which God does not use it for impressions upon the sensitive mind and heart. The highest reaches of the imagination here find their adequate response, and the strongest emotions are stirred to a still stronger life. One who opens himself through all the range of his conscious life to Mount Washington, in its brightness and beauty at the ushering in of day or at the coming on of evening, or in the lingering and softening twilight, or in the hours of storm, or at the moments of the cloud majesty, or when cherubim and seraphim beam upon it through the clouds in the glory of a summer afternoon, will find himself, after his visits to this visible throne of God, so purged of the false, the evil, the untrue and the unreal that on his return to the world his face will be like the face of Moses on his return from Mount Horeb, radiant with the revelations which God gives through the mountains to the souls of men.

A DESCRIPTION OF THE WHITE MOUNTAINS

By Jeremy Belknap

From The History of New Hampshire, Vol. III, 1784

An explorer, clergyman and historian, Reverend Jeremy Belknap (1744–1798) of Dover, New Hampshire, was the author of the three-volume History of New Hampshire, *published between 1784 and 1792. Included in this early state history is an extensive accounting of the first persons to see and visit the forbidding White Mountains. Belknap, a Massachusetts native, visited Mount Washington in 1784 as part of a scientific expedition. He was accompanied by Manasseh Cutler of Ipswich, Massachusetts; Reverend Daniel Little of Wells, Maine; and several others.*

From the earliest settlement of the country, the White Mountains have attracted the attention of all sorts of persons. They are undoubtedly the highest land in New-England, and in clear weather, are discovered before any other land, by vessels coming in to the eastern coast; but by reason of their white appearance, are frequently mistaken for clouds. They are visible on the land at the distance of eighty miles, on the south and southeast sides; they appear higher when viewed from the northeast, and it is said, they are seen from the neighborhood of Chamble and Quebec. The Indians gave them the name Agiocochook: They had a very ancient tradition that their country was once drowned, with all its inhabitants, except one Powaw and his wife, who, foreseeing the flood, fled to these mountains, where they were preserved, and that from them the country was re-peopled. They had a superstitious veneration for the summit, as the habitation of invisible beings; they never ventured to ascend it, and always endeavoured to dissuade every one from the

attempt. From them, and the captives, whom they sometimes led to Canada, through the passes of these mountains, many fictions have been propagated, which have given rise to marvellous and incredible stories; particularly, it has been reported, that at immense and inaccessible heights, there have been seen carbuncles, which are supposed to appear luminous in the night. Some writers, who have attempted to give an account of these mountains, have ascribed the whiteness of them to shining rocks, or a kind of white moss; and the highest summit has been deemed inaccessible, on account of the extreme cold, which threatens to freeze the traveller, in the midst of summer.

Nature has, indeed, in that region, formed her works on a large scale, and presented to view, many objects which do not ordinarily occur. A person who is unacquainted with a mountainous country, cannot, upon his first coming into it, make an adequate judgment of heights and distances; he will imagine every thing to be nearer and less than it really is, until, by experience, he learns to correct his apprehensions, and accommodate his eye to the magnitude and situation of the objects around him. When amazement is excited by the grandeur and sublimity of the scenes presented to view, it is necessary to curb the imagination, and exercise judgment with mathematical precision; or the temptation to romance will be invincible.

The White mountains are the most elevated part of a ridge, which extends N.E. and S.W. to an immense distance. The area of their base, is an irregular figure, the whole circuit of which, is not less than sixty miles. The number of summits within this area, cannot at present be ascertained, the country around them being a thick wilderness. The greatest number which can be seen at once, is at Dartmouth, on the N.W. side, where seven summits appear at one view, of which four are bald. Of these, the three highest are the most distant, being on the eastern side of the cluster; one of these is the mountain which makes so majestic an appearance all along the shore of the eastern counties of Massachusetts: It has lately been distinguished by the name of *Mount WASHINGTON*.

To arrive at the foot of this mountain, there is a continual ascent of twelve miles, from the plain of Pigwacket, which brings the traveller to the height of land, between Saco and Amariscoggin rivers. At this height there is a level of about a mile square, part of which is a meadow, formerly a beaver pond, with a dam at each end. Here, though elevated more than three thousand feet above the level of the sea, the traveller finds himself in a deep valley. On the left is a steep mountain, out of which issue several springs, one of which is the fountain of Ellis river, a branch of Saco, which runs south; another of Peabody river, a branch of Amariscoggin, which runs north. From this

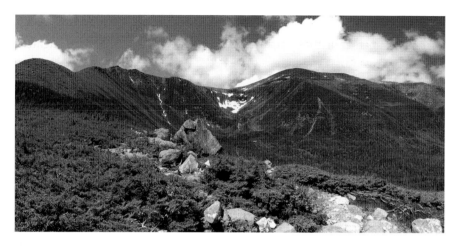

The view of Mount Washington looking northwest into snowy Tuckerman Ravine, with Boott Spur just to the left and the summit cone to the right. *Photo by Christopher Whiton.*

meadow, toward the west, there is an uninterrupted ascent, on a ridge, between two deep gullies, to the summit of Mount Washington.

The lower part of the mountain is shaded by a thick growth of spruce and fir. The surface is composed of rocks, covered with very long green moss, which extends from one rock to another, and is, in many places, so thick and strong, as to bear a man's weight. This immense bed of moss, serves as a sponge, to retain the moisture brought by the clouds and vapours, which are frequently rising and gathering round the mountains; the thick growth of wood, prevents the rays of the sun from penetrating to exhale it; so that there is a constant supply of water deposited in the crevices of the rocks, and issuing in the form of springs, from every part of the mountain.

The rocks which compose the surface of the mountain, are, in some parts, slate, in others, flint; some specimens of rock crystal have been found, but of no great value. No lime stone has yet been discovered, though the most likely rocks have been tried with aquafortis. There is one precipice, on the eastern side, not only completely perpendicular, but composed of square stones, as regular as a piece of masonry; it is about five feet high, and from fifteen to twenty feet in length. The uppermost rocks of the mountain, are the common quartz, of a dark grey colour; when broken they shew very small shining flecks, but there is no such appearance on the exterior part. The eastern side of the mountain, rises in angle of 45 degrees, and requires six or seven hours of hard labour to ascend it. Many of the precipices are so steep, as to oblige the traveller to use his hands, as well as feet, and to hold by

the trees, which diminish in size, till they degenerate to shrubs and bushes; above these, are low vines, some bearing red, and others blue berries, and the uppermost vegetation is a species of grass, called winter-grass, mixed with the moss of the rocks.[1]

Having surmounted the upper and steepest precipices, there is a large area, called the plain. It is a dry heath, composed of rocks covered with moss, and bearing the appearance of a pasture, in the beginning of the winter season. In some openings, between the rocks, there are springs of water, in others dry gravel. Here the grous or heath bird resorts, and is generally out of danger; several of them were shot by some travellers in October, 1774. The extent of this plain is uncertain; from the eastern side, to the foot of the pinnacle, or sugarloaf, it is nearly level, and it may be walked over in less than an hour. The sugar loaf, is a pyramidal heap of grey rocks, which, in some places, are formed like winding steps. This pinnacle has been ascended in one hour and a half. The traveller having gained the summit, is recompensed for his toil, if the sky be serene, with a most noble and extensive prospect. On the S.E. side, there is a view of the Atlantic ocean, the nearest part of which is fifty-five miles, in a direct line. On the W. and N. the prospect is bounded by the high lands, which separate the waters of the Connecticut and Amariscoggin rivers, from those of Lake Champlain and St. Lawrence. On the south, it extends to the southern-most mountains of New-Hampshire, comprehending a view of Lake Winipiseogee. On every side of these mountains, are long winding gullies, beginning at the precipice below the plain; and deepening in the descent. In winter, the snow lodges in these gullies; and being driven, by the N.W. and N.E. wind, from the top, is deepest in those which are situated on the southerly side. It is observed to lie longer in the spring on the south, than on the N.W. side, which is the case with many other hills in New-Hampshire.

A ranging company, who ascended the highest mountain, on the N.W. part, April 29th, 1725, found the snow four feet deep on that side; the summit was almost bare of snow, though covered with white frost and ice, and a small pond of water, near the top, was hard frozen.

In 1774, some men, who were making a road through the eastern pass of the mountain, ascended the mountain to the summit, on the 6th of June, and on the south side, in one of the deep gullies, found a body of snow thirteen feet deep, and so hard, as to bear them. On the 19th of the same month, some of the same party ascended again, and in the same spot, the snow was five feet deep. In the first week of September, 1783, two men, who attempted to ascend the mountain, found the bald top so covered with

snow and ice, then newly formed, that they could not reach the summit; but this does not happen every year so soon; for the mountain has been ascended as late as the first week in October, when no snow was upon it; and though the mountains begin to be covered, at times, with snow, as early as September, yet it goes off again, and seldom gets fixed until the end of October, or the beginning of November; but from that time it remains till July.[2] In the year 1784, snow was seen on the south side of the largest mountain, till the 12th of July; in 1790, it lay till the month of August.

During this period, of nine or ten months, the mountains exhibit more or less of that bright appearance, from which they are denominated white. In the spring, when the snow is partly dissolved, they appear of a pale blue, streaked with white; and after it is wholly gone, at the distance of sixty miles, they are altogether a sky colour; while at the same time, viewed at the distance of eight miles or less, they appear of the proper colour of the rock. These changes are observed by the people who live within constant view of them; and from these facts and observations, it may with certainty be concluded, that the whiteness of them is wholly caused by the snow, and not by any other white substance, for in fact, there is none. There are indeed in the summer months, some streaks, which appear brighter than other parts; but these, when viewed attentively with a telescope, are plainly discerned to be the edges of the sides of the long deep gullies, enlightened by the sun, and the dark parts are the shaded sides of the same; in the course of the day, these spots may be seen to vary, according to the position of the sun.

A company of gentlemen visited these mountains in July, 1784, with a view to make particular observations on the several phenomena which might occur. It happened, unfortunately, that thick clouds covered the mountains almost the whole time, so that some of the instruments, which, with much labour, they had carried up, were rendered useless. These were a sextant, a telescope, an instrument for ascertaining the bearings of distant objects, a barometer, a thermometer, and several others for different purposes. In the barometer, the mercury ranged at 22,6, and the thermometer stood at 44 degrees. It was their intention to have placed one of each at the foot of the mountain, at the same time that the others were carried to the top, for the purpose of making corresponding observations; but they were unhappily broken in the course of the journey, through the rugged roads and thick woods; and the barometer, which was carried to the summit, had suffered so much agitation, that an allowance was necessary to be made, in calculating the height of the mountain, which was computed in round numbers, at five thousand and five hundred feet above the meadow, in the valley below, and

nearly ten thousand above the level of the sea.[3] They intended to have made a geometrical mensuration of the altitude; but in the meadow, they could not obtain a base of sufficient length, nor see the summit of the sugar loaf; and in another place, where these inconveniences were removed, they were prevented by the almost continual obscuration of the mountains, by clouds.

Their exercise, in ascending the mountain, was so violent, that when Dr. Cutler, who carried the thermometer, took it out of his bosom, the mercury stood at fever heat, but it soon fell to 44°, and by the time that he had adjusted his barometer and thermometer, the cold had nearly deprived him of the use of his fingers. On the uppermost rock, the Rev. Mr. Little began to engrave the letters N.H. but was so chilled with the cold, that he gave the instruments to Col. Whipple, who finished the letters. Under a stone, they left a plate of lead, on which their names were engraven. The sun shone clear while they were passing over the plain, but immediately after their arrival at the highest summit, they had the mortification to be inveloped in a dense cloud, which came up the opposite side of the mountain. This unfortunate circumstance, prevented their making any farther use of their instruments. Being thus involved, as they were descending from the plain, in one of the long, deep gullies, not being able to see to the bottom, on a sudden, their pilot slipped, and was gone out of sight, though happily, without any other damage, than tearing his clothes. This accident obliged them to stop. When they turned their eyes upward, they were astonished at the immense depth and steepness of the place, which they had descended by fixing their heels on the prominent parts of the rock, and found it impracticable to reascend the same way; but having discovered a winding gully, of a more gradual ascent, in this they got up to the plain, and then came down on the eastern side; this deep gully, was on the S.E. From these circumstances, it may be inferred, that it is more practicable and safe, to ascend or descend on the ridges, than in the gullies of the mountain.

These vast and irregular heights, being copiously replenished with water, exhibit a great variety of beautiful cascades; some of which fall in a perpendicular sheet or spout, others are winding and sloping, others spread, and form a bason in the rock, and then gush in a cataract over its edge. A poetic fancy may find full gratification amidst these wild and rugged scenes, if its ardor be not checked by the fatigue of the approach. Almost every thing in nature, which can be supposed capable of inspiring ideas of the sublime and beautiful, is here realized. Aged mountains, stupendous elevations, rolling clouds, impending rocks, verdant woods, crystal streams, the gentle rill, and the roaring torrent, all conspire to amaze, to soothe and to enrapture.

Endnotes

1. "At the base of Mount Washington, the limits of vegetation may with propriety be fixed. There are indeed, on some of the rocks, even to their apices scattered specks of a mossy appearance; but I conceive them to be extraneous substances, accidentally adhering to the rocks, for I could not discover, with my botanical microscope, any part of that plant regularly formed. The limits of vegetation at the base of this summit, are as well defined as that between the woods and the bald or mossy part. So striking is the appearance, that at a considerable distance, the mind is impressed with the idea, that vegetation extends no farther than a line, as well defined as the penumbra and shadow, in a lunar eclipse. The stones I have by me, from the summit, have not the smallest appearance of moss upon them.

"There is evidently the appearance of three zones—1, the woods, —2, the bald mossy part, —3, the part above vegetation. The same appearance has been observed on the Alps, and all other high mountains.

"I recollect no grass on the plain. The spaces between the rocks in the second zone, and on the plain, are filled with spruce and fir, which, perhaps, have been growing ever since the creation, and yet many of them have not attained a greater height than three or four inches, but their spreading tops are so thick and strong as to support the weight of a man, without yielding in the smallest degree. The snows and winds keeping the surface even with the general surface of the rocks. In many places, on the sides, we could get glades of this growth, some rods in extent, when we could, by sitting down on our feet, slide the whole length. The tops of the growth of wood were so thick and firm, as to bear us concurrently, a considerable distance, before we arrived at the utmost boundaries, which were almost as well defined as the water on the shore of a pond. The tops of the wood, had the appearance of having been shorn off, exhibiting a smooth surface, from their upper limits, to a great distance down the mountain." MS. of Dr. Cutler.

2. The following is a journal of the appearances of the mountains, in the autumnal months of 1784, observed by Rev. Mr. Haven, of Rochester, whose house is in plain view of the south side of the mountain, distant about sixty miles.

> *Sept. 17 and 18. A N.E. storm of rain.*
> *20, Mountain appeared white.*
> *22, Of a pale blue.*
> *Oct. 3 and 4. Rain, succeeded by frost.*
> *5, Mountain white.*
> *8, Of a pale blue*
> *9, White at the west end*
> *10, White in the morning, most part blue P.M.*

22 and 24, Blue.

Nov. 2, A Spot of white at the west end

4, Uniformly white.

5, Very white

From this time, to the 23rd, when the weather was clear enough to see so far, the lower part of the mountain appeared very white; the summit involved in squally clouds.

N.B. the west end of the highest part.

3. This computation was made by the Rev. Cutler. Subsequent observations and calculations have induced the author to believe the computation of his ingenious friend too moderate, and he is persuaded, that whenever the mountain can be measured with the requisite precision, it will be found to exceed ten thousand feet, of perpendicular altitude, above the level of the ocean.

EARLY EXPLORATIONS

By Frederick W. Kilbourne

From Chronicles of the White Mountains, 1916

In 1916, Frederick Kilbourne (1872–1965) penned what is generally regarded as the finest overall history of the White Mountains. The piece that follows and one other in this volume are excerpted from that book. The native New Englander, born in Wallingford, Connecticut, attended Yale University and, following in the footsteps of early Yale president Timothy Dwight, frequently found himself exploring the scenic White Mountain country of northern New England. For many years, Kilbourne served as director of publications for the Brooklyn (NY) Library. He was also a life member of the Appalachian Mountain Club and a charter member of AMC's Connecticut Chapter. His writings on mountain history frequently appeared in AMC's journal, Appalachia.

In July, 1784, a journey to the Mountains was accomplished, which is noteworthy for the number and character of the members of the party who made it and because of the purpose for which it was undertaken. I refer to the expedition made by the Reverend Dr. Jeremy Belknap, the historian of New Hampshire, then a resident of Dover; the Reverend Daniel Little, of Wells, Maine; the Reverend Manasseh Cutler, of Ipswich, Massachusetts; Dr. Joshua Fisher, of Beverly, Massachusetts; Mr. Heard, of Ipswich, and two young collegians, Hubbard and Bartlett, who set out to make a tour of the White Mountains "with a view to make particular observations on the several phenomena that might occur." For this purpose they were equipped with various instruments, including barometers, thermometers, a sextant, and surveying compasses. They

were thus the first of a considerable line of scientific inquirers to visit these hills.

The historian has left several records[1] of the trip. Let me briefly advert to these, noting their character and provenience. In the first place, much of the Reverend Doctor's correspondence with his friend Ebenezer Hazard, of Philadelphia, has been preserved and printed in the "Collections" of the Massachusetts Historical Society.

Among these letters we find a record of Belknap's intention to make such a journey, for under date of July 4, 1784, he writes, "I expect, next week, to set out on a land tour to the White Mts., in company with several men of a scientific turn. I may write you again once before I go; but, if I live to come back, you may depend on such a description as I may be able to give." Dr. Belknap's letters to Mr. Hazard, giving an account of his tour are, unfortunately, not preserved among the Hazard letters. The want of such a narrative, however, is fully supplied, as has been intimated. There is extant, first, a memoir, "Description of the White Mountains," which was sent by him to the American Philosophical Society of Philadelphia, and to which "great attention was paid," writes Hazard. This was published in 1786, in the second volume of the Society's "Transactions," and in substance is similar to the account afterwards published in the third volume of Dr. Belknap's "History of New Hampshire." Both of these records are very different in form from the third account, which consists of the original notes kept by the doctor in the form of a diary. These have been printed with the correspondence above mentioned, and on them I shall largely rely for my summary of this notable trip. In the chapter on the White Mountains, given in the "History," the author refers to the visit to the Mountains made by a party of gentlemen in 1784, but gives no intimation that he was one of the company. A few additional particulars are, however, there given.

The historian's account of the trip recorded in his dairy is so naïve and detailed that one may be pardoned for thinking that it may be of sufficient interest to give rather fully.

At Conway the travelers found Colonel Joseph Whipple of Dartmouth (later Jefferson), and Captain Evans, who was to be their pilot, ready to go with them. Thence they journeyed through what is now Jackson and "along the Shelburne Road" to apparently about three fourths of a mile beyond the Glen Ellis Falls, where they encamped for the night. The next day, Saturday, July 24, the party undertook the ascent of "the Mountain" from the eastern side. Dr. Fisher soon gave out, owing to a pain in his side, and returned to camp, where Colonel Whipple's negro man had been left in charge of the

horses and baggage. After about two hours more of climbing, "having risen many very steep and extremely difficult precipices, I found my breath fail," says Dr. Belknap,[2] and in a consultation of the party it was decided that inasmuch as many stops had had to be made on his account and as the pilot supposed they were not more than halfway up to "the Plain," he should return. Refusing to deprive those who offered to go back with him of their expected pleasure, the good doctor came down safely alone in about an hour and a half and arrived "much fatigued," at the camp, "about 10 o'clock." It came on to rain toward night, so those at the camp repaired their tent with bark, took all the baggage into it, and anxiously awaited the return of their friends. The rain increased and continued all night, but although the tent leaked and the fire "decayed," they managed to keep the fire going and themselves dry.

It ceased raining at daylight on Sunday and soon thereafter the report of a gun partly relieved the anxiety of Drs. Belknap and Fisher. Shortly after the party of climbers arrived safely at camp. They reported that they passed the night around a fire, which was their only defense against the rain, and that "they had ascended to the summit, but had not had so good a view as they wished, the Mountain being most of the time involved with clouds, which rolled up and down in every direction, above, below, and around them." Their scientific observations were by "this unfortunate circumstance" for the most part prevented. They arrived at the pinnacle of the Sugar-Loaf at 1.06, their actual time of climbing from the tent being five hours and thirteen minutes. On the highest rock they found an old hat, which had been left there in June, 1774, by Captain Evans's party. They dined at 2 o'clock, we are told, on partridges and neat's tongue, cut the letters "N.H." on the uppermost rock and under a stone left a plate of lead[3] on which were engraved their names. The descent was a particularly difficult one, as, owing to the clouds, even the guide could not find the way down. Soon after their return to the camp they left for Dartmouth.

Their course in ascending the mountain was evidently through Tuckerman's Ravine, probably over Boott Spur, and up the east side on the cone, their route in the lower part being indicated by the stream which bears Dr. Cutler's name.[4] Dr. Cutler estimated the height of the "pinnacle" or "sugar-loaf," as Belknap calls it, to be not less than three hundred feet. From some unsatisfactory observations with the barometer, the elevation of the principal summit above the sea was computed to be nearly ten thousand feet. The party were disappointed in their attempt to measure the altitude geometrically from the base, because "in the meadow they could not obtain a

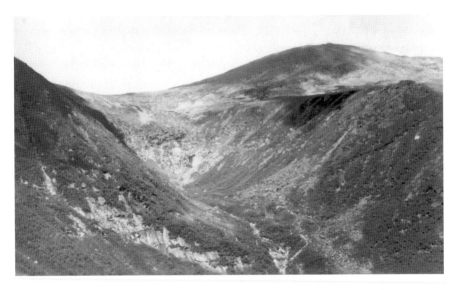

Tuckerman Ravine as viewed from Boott Spur. *Guy Shorey postcard, author's collection.*

base of sufficient length, nor see the summit of the sugar-loaf; and in another place, where these inconveniences were removed, they were prevented by the almost continual obscuration of the mountains by clouds."

"It is likely," says Professor Tuckerman, "that the plants of the higher regions were observed, and Mr. Oakes possessed fragments of such a collection made, either now or later, by Dr. Cutler, but the latter did not notice them in his memoir on the plants of New England published the next year in the transaction of the Academy,[5] nor is there any mention of them in the six small volumes of his botanical manuscripts which have come to my knowledge."

As the name of Mount Washington is found in Dr. Cutler's manuscript of 1784, it is probable that the appellation was given to the mountain by the party whose journey has just been described. The name first appears in print in Belknap's "History of New Hampshire," in the third volume, which was published in 1792.[6]

Dr. Cutler again visited the Mountains in July, 1804, this time chiefly to collect botanical specimens, in company with several friends, among whom were Dr. Nathaniel Bowditch and Dr. W.D. Peck, afterward professor of natural history at Cambridge. The party encamped on the side of Mount Washington on the night of the 27th, and on the next day Cutler, Peck, and one or two others made the ascent, arriving at 12.30. There were no clouds about the mountain, but the climbers were much chilled, and the

descent was extremely fatiguing. Barometrical observations made at this time were computed by Dr. Bowditch to give an elevation of 7055 feet for the highest summit.

Dr. Peck made during this trip a collection of alpine plants, the citations of which in Pursh's "Flora of North America," published in 1814, "enable us," says Professor Tuckerman, "to determine the earliest recognition of several of the most interesting species."

Of early travelers to the Mountains one of the most distinguished was the Reverend Dr. Timothy Dwight, president of Yale College from 1794 to 1817. Dr. Dwight made two journeys on horseback to this region, the first in 1797 and the second in 1803.[7] His companion on the first expedition ("Journey to the White Mountains") was a Mr. L., one of the tutors of Yale College, and their objects were to examine the Connecticut River and to visit the White Mountains. Their first objective point was Lancaster, whence they proposed to proceed through the Notch to their second, Portland. They reached Lancaster on the morning of September 30. They left there on October 2, stayed overnight at Rosebrook's, and on October 3 passed through the Notch, of which Dr. Dwight gives a vivid description. It is "a very narrow defile," he says, extending two miles in length between two huge cliffs, apparently rent asunder by some vast convulsion of nature. "This convulsion," he continues, "was, in my own view, unquestionably that of the deluge." He gives interesting information about the size and character of the mountain towns, describes Mount Washington and other features of the landscape graphically, and, altogether, has provided a very readable narrative of his tour. In his visit to the Mountains in 1803, President Dwight had as companion two graduates and a senior of Yale College, and their object was to ride up the Connecticut River as far as the Canadian boundary ("Journey to the Canada Line"). In the course of the tour, however, the party left the Connecticut, went up the lower Ammonoosuc, turned aside from the latter to visit Bethlehem, whence they returned to the Ammonoosuc, and then went on to the Notch, which they visited on September 30. "I renewed," says the traveler, "a prospect of all the delightful scenes, which I have mentioned in a former account." It was at this time that he gave to one of the waterfalls near the Gate of the Notch the name "Silver Cascade," which it still bears. He visited Rosebrook's, and then went by way of Jefferson to Lancaster and thence onward to Canada.

Another early scientific explorer of the White Hills, who has left us an account of his excursion and a record of his observations, and who deserves a brief mention, was Dr. George Shattuck, of Boston. He was one of a

party of six, which set out from Hanover, July 8, 1807, taking along various scientific instruments. On Saturday the 11th the members of the party started from Rosebrook's to ascend Mount Washington, at the summit of which they arrived the following day. Dr. Shattuck notes that the temperature there at noon was 66° and that the day was not very clear, the distant horizon being smoky. He describes briefly the plants, the character of the surface of the summit, and rareness of the atmosphere, and other phenomena. Unfortunately, his attempts to make barometrical observations for the purpose of estimating the height of the mountain were, he says, "defeated by an accident, the prevention of which was beyond my controul."

The next noteworthy American explorer of the White Hills was Dr. Jacob Bigelow. Botany was the particular interest of this famous Boston physician, who was born in 1797 and who lived to the ripe old age of ninety-two. His tour to the Mountains was made in 1816, in company with Francis C. Gray, Esq., Dr. Francis Boott, in whose honor a spur of Mount Washington has been named, Nathaniel Tucker, and Lemuel Shaw, Esq., afterward Chief Justice of Massachusetts. On their way they climbed Monadnock and Ascutney. The ascent of the White Mountains "was at that time," says the doctor,[8] "an arduous undertaking, owing to the rough state of the country and the want of roads or paths." "We were obliged," he says further, "to walk about fifteen miles and to encamp two nights in the brushwood on the side of the mountain." Each man of the party having carried up a stick, they were enabled to build a fire on the summit and to prepare a meal from such supplies as their guides had brought up. The day (July 2) was a fine one, but the atmosphere was hazy, so that their view of distant objects was very indistinct. The temperature at noon was 57° F. From the registration of a mountain barometer at that hour, calculations were made which gave the height within a few feet of the correct altitude. As a memorial of their achievement of the ascent they left their names and the date inclosed in a bottle cemented to the highest rock. In the afternoon they descended in about five hours to their camping place, and the following day they reached Conway.

This expedition, besides achieving the most satisfactory determination of the height of Mount Washington that had been made, was noteworthy as a natural history survey. Dr. Bigelow's article "Some Account of the White Mountains of New Hampshire," provided a statement of all that was known of their mineralogy and zoology, but is especially important from a botanical standpoint, for his lists of plants, or florula, "determined," says Professor Tuckerman, "in great measure the phaenogamous botany of our Alps."

Very appropriately Dr. Bigelow's name has been since given to a grassy plot (Bigelow's Lawn), rich in alpine plants, below the cone of Mount Washington on Boott Spur. Dr. Boott returned to the Mountains in August of the same year, and as a result of his trip added a "considerable" number of species to the botanical collection.

Another noted botanist to explore the Mountains was William Oakes,[9] who visited them, in company with his friend Dr. Charles Pickering, in 1825, again in 1826, and from 1843 on, every summer. To him we are indebted for additions to our botanical knowledge, but especially for one of the classics of White Mountain literature, his "Scenery of the White Mountains," a book consisting of descriptive letterpress accompanying large lithographic plates from drawings by Isaac Sprague.[10] His purpose of publishing a smaller volume to be called "The Book of the White Mountains" and to consist of descriptions of things of interest, a flora of the alpine plants, with the mosses and lichens, and a complete guide for visitors, was frustrated by his tragic death the year (1848) of the publication of his "Scenery."

ENDNOTES

1. Dr. Cutler also left an account of the journey, which is graphic and well written and may be found in his *Life, Journals, and Correspondence*, published in 1888. Belknap was indebted to Cutler for his information about the ascent and descent of the chief peak. Cutler's manuscript breaks off before the description of the return is finished, but the remainder is covered in an account of the tour written by Mr. Little.

2. "The spirit was willing but the flesh (i.e., the lungs) weak," he says in a letter to Hazard, and in the same letter, "You will not wonder that such a quantity of matter ('180 or 190 lbs. of mortality') could not ascend the White Mountains farther than it did."

3. The finding of this plate eighteen years later was "the source of great mystification to the villagers of Jackson" (Moses F. Sweetser).

4. Given to the river, it is said, by Dr. Cutler's express desire. According to Belknap, another tributary of the Ellis River "falls from the same mountain," a short distance to the south, and is called New River. Belknap's map makes Cutler's River flow from the present Tuckerman's Ravine. The ascent of Dr. [Jacob] Bigelow, a later explorer, agrees with this. In later maps, however, the names of the streams were transposed, the error being noticed by Mr. Sweetser, who was

confirmed in his decision in the matter by Professor Edward Tuckerman. New River got its name from the fact of its recent origin, it having been formed in October, 1755 during a great flood. Some general observations on the vegetation of the Mountains, set down by Dr. Cutler in a manuscript preserved by Belknap, are quoted in Belknap's *History* and [Timothy] Dwight's *Travels*.

5. The American Academy of Arts and Sciences, of which Dr. Cutler was a member.

6. "It has lately been distinguished by the name of *Mount Washington*," is Belknap's statement.

7. Dr. Dwight also made two horseback journeys to Lake Winnipesaukee. The first of these was made in the autumn of 1812 and the second in the same season of the next year. In both excursions he touched the fringe of the White Mountain region, passing through Plymouth in both and ascending Red Hill on the second.

8. Dr. Bigelow published an account of his journey and a list of their plants collected in the *New England Journal of Medicine and Surgery*, for October, 1816. The quotations in the text are taken from some autobiographical notes, quoted in a *Memoir of Jacob Bigelow, M.D., LL.D.*, by George E. Ellis (1880). Writing these notes about fifty years after the event, Dr. Bigelow's memory must have played him false, for he gives the year of the journey as 1815 and states that it was the 4th of July when the party was on the summit and that in celebration of the day, Mr. Gray was invited to deliver an impromptu address.

9. There is a memoir in the *American Journal of Science and Arts* for January, 1849, by Asa Gray, who calls him "the most distinguished botanist of New England." Oakes was born in Danvers, July 1, 1799, and was drowned by falling overboard from a ferryboat between Boston and East Boston, July 31, 1848, it is supposed as a result of a sudden attack of faintness or vertigo. He graduated from Harvard, where his previous fondness for natural history was developed under the instruction of professor W.D. Peck. Oakes named Mounts Clay and Jackson, sending his guide to the summit of the latter to kindle a bonfire there to celebrate the event. His own name is perpetuated in the Mountains by Oakes Gulf, the deep ravine to the east of Mounts Pleasant and Franklin.

10. There are in all sixteen full folio pages of plates. The sixteenth plate and part of the fourteenth are from paintings by G.N. Frankenstein, a well-known artist of Cincinnati, after whom a cliff and a railroad trestle in the Crawford Notch are named.

THE WHITE MOUNTAIN GIANT

By John H. Spaulding

From Historical Relics of the White Mountains, 1855

A North Country native, born and raised in Lancaster, New Hampshire, John Hubbard Spaulding (1821–1893) went on to become manager of two of Mount Washington's early summit hotels: the Tip-Top House and Summit House. It was during his tenure as hotel manager that he published Historical Relics of the White Mountains, Also, a Concise White Mountain Guide. *This early history and guide to the region went through three different editions between 1855 and 1862. Spaulding made his last visit to the mountain in 1891, when he successfully climbed to the summit at the age of seventy. He died on his seventy-second birthday in nearby Whitefield.*

The name of E.A. Crawford is deeply chiselled upon the rocks of this granite Mount built by nature (Mount Washington); and the lady who shared in life his joys and sorrows has, in her "White Mountain History," reared a testimonial to his memory. Will not my humble tribute of a stone, laid in silence upon his grave, be accepted by all who pleasantly cherish the remembrance of *"Ethan of the Hills,"* or the *"White Mountain Giant"*?

The subject of this sketch was born in Guildhall, Vermont, in the year 1792. When but a mere lad his parents moved to the White Mountains, and here he grew up a giant mountaineer, illustrating by his hardy habits, how daring enterprise and pure mountain climate nerve the man and stamp the *hero* upon mortality. Inheriting the house on the westerly end of the "Giant's Grave," with an encumbrance that made him worse than destitute of all worldly goods, he was one day shocked, when returning from hunting on the hills,

to see his home burned down, and his wife and infant sheltered only by an open shed. Twelve miles one way, and six the other, to neighbors, here he was with his little family in the wilderness, destitute of every comfort, save that of hope. The sunshine of joy, unclouded by sorrow, and the warm smiles of good fortune, seem ever attendant upon the lives of some, constantly beckoning their favorites forward to the green fields of abundance, and bowers of pleasure and ease. Others, perchance born under a less favoring star, in their growth rise up like giants, breasting manfully, step by step, the wrecking storms of adversity, and by their own heroic exertions, hew out for themselves characters deeply lined, amid the black shadows of sorrow and disappointment. Of such a mould was the spirit of Ethan A. Crawford. The inconveniences of poverty, that come like a strong man armed upon poor mortality, and sickness and the many hardships linked with every-day life in a new settlement, fell to this man's share. Yet he cheerfully performed the duties of life with an iron resolution, that stood misfortune's shocks as firmly as his own mountains stand storms and the changes of time. He was a tall, finely-proportioned man; and, though called by many the "White Mountain Giant," beneath the rough exterior of the hardy mountaineer glowed constantly, in a heroic heart, the warm fire of love and manly virtue. The artless prattle of his little children was sweet music to his spirit, and his ambitious aspirations were constantly invigorated by social comfort with his little family.

CARRYING THE KETTLE AND DEER.

The first display of Ethan's *giant strength* recorded is of his carrying on his head, across the Amonoosuc river, a potash-kettle, weighing four hundred pounds.

In 1821 he caught a full-grown deer, in a wild gorge, four miles from his home; and as the trap had not broken his leg, and he appeared quite gentle, he thought to lead him home. Failing in his attempt to do this, he shouldered him and trudged homeward, over hill and through tangled brushwood, feeling by the way, perchance, like Crusoe, with his lamas, how fine it would be to have a park and many deer to show his visitors. But his day-visions vanished; for, on arriving home, he found the deer so much injured that he died.

Another time, he *caught a wild mountain-buck* in a snare; and, finding him too heavy to shoulder, he made him a halter of withes, and succeeded in halter-leading him so completely, that, after nearly a day spent in the attempt, he arrived at home with his prize, much to the wonder of all.

THE GIANT LUGGING THE OLD BEAR.

In 1829 Ethan caught a good-sized bear in a trap; and thought to bind him with withes, and lead him home as he had the buck. In attempting to do this, the bear would catch with his paws at the trees; and our hero, not willing to be outwitted by a bear, managed to get him on his shoulder, and, with one hand firmly hold of his nose, carried him two miles homeward. The bear, not well satisfied with his prospects, entered into a serious engagement with his captor, and by scratching and biting succeeded in tearing off his vest and one pantaloon-leg, so that Ethan laid him down so hard upon the rocks that he died. That fall he caught ten bears in that same wild glen.

The first bear kept in the White Mountains for a show was caught by Ethan, while returning from the Mountain with two young gentlemen he had been up with as guide. Seeing a small bear cross their path, they followed him to a tree, which he climbed. Ethan climbed after, and, succeeding in getting him, tied his mouth up with a handkerchief, and backed him home. This bear he provided with a trough of water, a strap and pole; and here he was for a long time kept, as the first tame bear of the mountains. This was about the year 1829.

Ethan caught a wild-cat with a birch withe! Once, when passing down the Notch, he was attracted to a tree by the barking of his dog, where, up among the thick branches, he discovered a full-grown wild-cat. Having only a small hatchet with him, he cut two long birch withes, and, twisting them well together, made a slip-noose, which he run up through the thick leaves; and while the cat was watching the dog, he managed to get this noose over his head, and, with a sudden jerk, brought him to the ground. His dog instantly seized him, but was willing to beat a retreat till reinforced by his master, who with a heavy club came to the rescue. The skin of this cat, when stretched, measured over six feet.

Ethan's *two close shots* are worthy of note. One fall, while setting a sable line, about two miles back of the Notch, he discovered a little lake, set, like a diamond, in a rough frame-work of beetling crags. The fresh signs of moose near, and trouts seen in its shining waters, was sufficient inducement to spend a night by its shady shore. About sunset, while engaged in catching a string of trouts, his attention was suddenly arrested by a loud splashing in the still water around a rocky point, where, on looking, he saw two large brown moose pulling up lily-roots, and fighting the flies. Prepared with an extra charge, he fired; and before the first report died in echoes among the peaks, the second followed, and

both moose fell dead in the lake. Ethan labored hard to drag his game ashore; but late that evening bright visions of marrow-bones and broiled trouts flitted like realities around him. That night a doleful dirge rose in that wild gorge; but our hero slept soundly, between two warm moose-skins. He cared not for the wild wolves that scented the taint of the fresh blood in the wind. That little mountain sheet is now, from the above circumstance, known as *"Ethan's Pond."*

Ethan was always proud to speak of how he *carried a lady two miles down the mountain on his shoulders.* It was no uncommon affair for him to shoulder a man and lug him down the mountain; but his more delicate attempts to pack a young lady down the steep rocks, he seemed to regard as an important incident in his adventurous career. Miss E. Woodward was the name of the lady who received from the Mountain Giant such marked attention. By a wrong step she became very lame, and placing, as well as he could, a cushion of coats upon his right shoulder, the lady became well seated, and he thus brought her down to where they left their horses.

By Adino N. Brackett's Journal, published in Moore's His. Col., vol. 1st, page 97, it appears that Adino N. Brackett, John W. Weeks, Gen. John Willson, Charles J. Stuart, Esq., Noyes S. Dennison, and Samuel A. Pearson, Esq., from Lancaster, N.H., with Philip Carrigain and E.A. Crawford, went up, July 31st, 1820, to name the different summits. Gen. John Willson, of Boston, is now, 1855, the only survivor of that party. "They made Ethan their pilot, and loaded him with provisions and blankets, like a pack-horse; and then, as they began to ascend, they piled on top of this load their coats." This party had a fine time; and, after giving names of our sages to the different peaks, according to their altitude, they drank health to these hoary cliffs, in honor to the illustrious men whose names they were, from this date, to bear; then, *curled down among the rocks,* without fire, on the highest crag, they doubtless spent the first night mortals ever spent on that elevated place. In the morning, after seeing the sun rise out of the ocean far, far below them, they descended westerly from the apex about a mile, and came to a beautiful sheet of water (Lake of the Clouds), near a ridge of rocks, which, when they left, they named *"Blue Pond."* It doubtless looked blue to them; for something they carried in bottles so weakened the limbs of one of the party that Ethan was, from this place, burdened with a back-load of mortality, weighing two hundred pounds, down to the Amonoosuc valley. Thus we find Ethan most emphatically the *"Giant of the Mountains."* He never hesitated to encounter any danger that appeared in his path, whether from wild beasts, flood, or mountain tempest.

The *First Bridle-path* on the White Mountains was made in 1819. As there had got to be ten or twelve visitors a year, to see these mountains, at this date, Ethan thought, to accommodate his company, he would cut a path as far as the region to scrub vegetation extended. It had been very difficult to go without a road, clambering over trees, up steep ledges, through streams, and over the hedgy scrub-growth; and accordingly, when the act of a path being made was published, the fame of this region spread like wild-fire. This path was started at the head of the notch near Gibbs' House, and, extending to the top of Mount Clinton reached from thence to the top of Mount Washington, nearly where Gibbs' Path now is. Soon after the completion of this path, the necessity of a cabin, where visitors could stop through the night, was perceivable by Ethan; and accordingly he built *a stone cabin*, near the top of Mount Washington, by a spring of water that lives there, and spread in it an abundance of soft moss for beds, that those who wished to stop here through the night, to see the sun set and rise, might be accommodated. This rude home for the traveller was soon improved, and furnished with a small stove, an iron chest, and a long roll of sheet-lead;—the chest was to secure from the bears and hedge-hogs the camping-blankets; and, according to tradition, around that old chest many who hungered have enjoyed a hearty repast. That roll of lead was for visitors to engrave their names on with a sharp iron. Alas! *that* tale-telling old chest was buried by an avalanche. How all things pass away!

In 1821 the first ladies visited Mount Washington. This party, of which these ladies numbered three, had Ethan for its guide, and, proceeding to the stone cabin, waited there through a storm for several days, that they might be the first females to accomplish the unrecorded feat of ascending Mount Washington. This heroic little party was the Misses Austin, of Portsmouth, N.H., being accompanied by their brother and an Esq. Stuart, of Lancaster. Everything was managed as much for their comfort as possible; the little stone cabin was provided with an outside addition, in which the gentlemen staid, that their companions might be more retired and comfortable. This party came near being what the sailor might call "weather-bound." They were obliged to send back for more provisions; and at last the severe mountain-storm passed away, and that for which they had ambitiously endured so much exposure was granted them. They went to the top, had a fine prospect, and, after an absence of five days, returned from the mountains, in fine spirits, highly gratified with their adventure. This heroic act should confer an honor upon the names of this pioneer party, as everything was managed with so much prudence and

The grave site of Ethan Allen Crawford can be found in Bretton Woods, New Hampshire, not far from the site of his former home in the White Mountains. *Photo by author.*

modesty that there was not left even a shadow for reproach, save by those who felt themselves outdone; so says record.

In the summer of 1840 the first horse that ever climbed the rocks of Mount Washington was rode up by old Abel Crawford. The old man was then seventy-five years old, and, though his head was whitened by the snows of many winters, his blood was stirred, on that occasion, by the ambitious animation of more youthful days. There he sat proudly upon his noble horse, with uncovered head, and the wind played lightly with his venerable white locks. Truly that was a picture worthy an artist's skill. Holding that horse by the rein, there stood his son Ethan, as guide to his old father. The son and the parent!—worthy representatives of the mighty monument, to the remembrance of which, their pioneer exertions have added fadeless fame. From that day a new era dawned on these mountains. Forget not the veteran Abel, and Ethan *"the White Mountain Giant."*

The White Mountain Guides should all be remembered. In our lengthy notice of Ethan, *the White Mountain Giant*, we do not mean to eclipse the worthy deeds of other noble mountain spirits, who have followed his old path, and even made new ones for their own feet. This mountain region is truly haunted, as it were, by peculiar influences, that call to its attractions as dauntless men for guides as our New England mountain-land can boast. Ethan A. Crawford came here when this was a wilderness-land, unknown to fame. The fashionable world knew nothing of its peculiarities. He spent much time, even the energies of his life, exploring the wild gorges and dangerous peaks of the mountains, and became a mighty hunter. He was, in fact, the bold pioneer who, with his old father, opened the way whereby the "Crystal Hills" became known to the world. "Honor to whom honor is due!" Then let us not be unmindful of Ethan, who grappled with nature in her wildness, and made gigantic difficulties surmountable; and let us remember the names of "Tom Crawford," "Hartford," "Hall," "Cogswell;" "Dana, and Lucius

M. Rosebrook," "Leavitt," "Hayes," and others, who have followed piloting for a series of years on these mountains. These are all men in whose hands the tourist was comparatively safe; and, though the most of the above names are with the past, others are on the stage, who have an ambitious desire to outdo, even, in skill and management, those whose footsteps they follow. We will not praise the living guides of the White Mountains; their actions speak monuments of honor to their own names. Have confidence in their integrity; and may they never betray their trust.

DOLLY COPP AND THE GLEN HOUSE

By F. Allen Burt

From The Story of Mount Washington, 1960

Like his father and grandfather before him, Frank Allen Burt (1885–1971) had a passion for Mount Washington and the White Mountains, and that passion led to the 1960 publishing of the book The Story of Mount Washington *(Dartmouth College). Burt's epic biography of New England's most celebrated peak was a natural project for him to undertake, seeing how his grandfather Henry M. Burt and his dad, Frank H. Burt, were the editors of the summit newspaper,* Among the Clouds, *from its inception through the great mountaintop fire of 1908. Drawing on the wealth of documents his family had gathered over the years, along with his extensive personal experiences on the mountain, Burt was able to write the definitive history of the mountain. Frank Burt was also a well-known Boston writer, teacher and advertising expert who was affiliated with both Boston University and Northeastern University. Prior to penning the Mount Washington history, Burt wrote several other books, mostly about advertising.*

Although the Crawfords in the early 1800s were making the valley to the west of Mount Washington popular with tourists, it was not until 1827 that anybody had the hardihood to settle in the wilderness on the eastern slope of the great mountain, then known as the "Eastern Pass," now "Pinkham Notch" or "The Glen."

Even the early owners of the Glen made no effort to settle there. During the French and Indian Wars Thomas Martin served the English Crown so faithfully as a purchaser of military stores for the British army that King George III in 1775 deeded to him a tract of land in the Glen along the banks

of Peabody River. Contained in Martin's Location is the now famous Dolly Copp Camp Grounds five miles south of Gorham on the Glen Road.

Jackson, the first town near the lower end of Pinkham Notch, was first settled by Benjamin Copp, in 1778. The original name given the town was New Madbury, for the early settlers came from Madbury, New Hampshire. In 1800 the town was incorporated as Adams. Some years later its name was changed to Jackson, all of its voters but one being for Jackson, when the question was whether he or Adams should be president.

Little is known of Copp and his family. They lived entirely alone in a vast wilderness for twelve years before any other inhabitants joined them. Then in 1790, a year before Abel Crawford moved into Nash and Sawyer's Location, Captain Joseph Pinkham, of Madbury, with four neighboring families, migrated to New Madbury and its rich lands on the lower part of Ellis River.

But the real pioneer of what was to become Pinkham Notch—the man who single-handed, hewed a home out of the virgin forest—was a young fellow twenty-four years of age, small of stature, with bent, sloping shoulders, a shapely head under a curling shock of yellow hair, pale blue eyes set deep under shaggy brows, a sound heart in a barrel chest, and long arms with rippling muscles. Born in 1804, in Stow, Maine, near the New Hampshire line, Dodifer Hayes Copp was the son of Lieutenant Samuel Copp of Lebanon, Maine, and the former Hannah Hayes. Christened "Dodovah Hayes Copp," he later changed the spelling to "Dodifer." Most generally he was known as Hayes, or "Haze," by his intimates. Whether or not Hayes Copp was related to Benjamin is uncertain.

Hayes Copp, before he was twenty, had made his way through Fryeburg to the blooming farm lands of Bartlett and Jackson. There he heard tales of the rich black soil seventeen miles up the notch from Jackson, where wealth was waiting only for the axe, the torch, and the plowshare.

Even then young Copp was a hard, unyielding man, whom neither hardship nor danger could turn from his determined course. Negotiating with the New Hampshire Legislature, he secured a deed to a future farm in the forest lands of Martin's Location. In place of money, of which he had none, the boy pledged wheat, oats, and barley, to be raised when the land was ready, and which through years of toil he paid to the last bushel.

It was in 1827 that Hayes Copp, a pack on his back, his long-barreled flintlock gun over his shoulder, his axe in his hand, set off up the blazed trail that followed the Ellis River up the Notch and then went down the Peabody River, crossing the stream where later was built the Dolly Copp Bridge,

since removed. Somehow he found the surveyors' blazes on the trees, telling him that here along the river was the land which was to be his farm and home. And here he built his shelter, a lean-to of poles, roofed, and walled on three sides with strips of hemlock bark. In front of the open side he built a great fireplace of flat stones—his cook stove and his only source of warmth through the long winter nights that lay ahead of him

Food was abundant: trout in the brooks, bears in the berry thickets, deer coming morning and night to drink in the river, and game birds aplenty. Salt pork, Indian meal, salt—the pioneer's priceless commodities—he traded for on infrequent trips to Jackson, carrying down in exchange the furs he had dressed.

In the Glen the summer is short. The snow lies late into the spring in this deep valley, and comes again early in winter. Those few weeks of warm weather between snow and snow were filled with grinding toil, felling, piling, and burning the great trees. The second spring Hayes "scratched in" round the blackened stumps in his little clearing turnip and pumpkin seeds and perhaps a few patch of wheat. The black soil, the humus of ages of fallen trees, awoke in the sunshine and gave the toiler a harvest.

Where a butternut once shaded the road, the young man "rolled up" a one-room log cabin, and a little nearer the river a log barn for the sheep and cows he hoped to soon buy. No one driving up the smooth road from Jackson to Gorham can picture the savagery with which nature fought back at this invader of the Glen. It took from three to five years for him to wrest from the wilderness a farm and a home. Then he was ready for a helpmate.

On one of his rare visits down the notch Hayes had met Dolly Emery, a girl just his own age, small in stature, with flaxen hair, light blue eyes that had a flash of keenness, and glib tongue. They were married in Bartlett 3 November 1831.

In 1824 Durand, six miles beyond the mountain wall to the west, was incorporated as the town of Randolph, known for its prosperous farmers and lumbermen. To link Randolph with Jackson, early in the thirties the legislature of New Hampshire made a contract with Daniel Pinkham to build a wagon road along the old blazed trail. It was rough going, the work of several years, with few laborers and fewer tools. It taxed the resourcefulness of a man, who as a boy, had taught his pig to haul a sled, but he carried it through. Daniel received a grant of land on both sides of the road, extending from just above Glen Ellis Falls to Emerald Pool in the Peabody River, and embracing the present-day site of the Appalachian Mountain Club's Pinkham Notch Camp, the Notch having been given its name from

this grant. So the road came to the Copps' farm, and made just a bit lighter the life of this man and woman whose perfect health, great strength, and unconquerable will fitted them for the everlasting battle to enlarge their clearing and make for themselves and their flocks more lands to till and wider pastures for grazing. As George Cross tells us:

> *But they needed all their strength and pluck to fight the bears from the young lambs in spring, the wolves from the young cattle in the fall, the foxes, coons and skunks from the poultry yards, the deer from the ripening grain. They must expect the late and early frosts of the too-short summers. They must face the intense cold, terrific winds and deep snows of the always long winters. And they well knew that every year the fight with some of these enemies would be a losing battle.*

But year after year their farm and their flocks increased. The one-room log cabin gave place to a long low frame house, neatly painted and connected by an ell with a roomy frame barn.

As for Dolly Copp's part in this household—in the spring she saw to the setting of the hens and raised fine broods of chickens. She helped Hayes shear the sheep, cleansed and carded the wool, spun the snowy rolls into yarn, wove the yarn on her clumsy loom into cloth or knit it into socks for the whole family. In the corner of the ell room stood the brass kettle in which in the fall she made hundreds of "tallow dips." Ranged along the barnyard wall were the barrels and tubs, and the kettle swung over the outdoor fireplace where in the early spring she made the year's supply of soap. In the winter evenings, by the light of her tallow dips burning on the light stand before the fireplace, she knit or darned and made or mended the garments of the whole family.

A tradition says that Joseph Jackson brought on his back from Canterbury, New Hampshire, a sackful of little apple trees to grow into the first apple orchard in Shelburne Addition (now Gorham). Dolly's orchard, now rows of gnarled and decaying tree trunks, was started not long after Jackson planted his first trees. But she found her trees in the woods along the river banks, the "Johnny Appleseed" trees that grow everywhere. From the "wildings" she selected the best, and by care and cultivation they grew to great size and bore apples of many fine varieties.

During the forty years that the Pinkham Notch road was the only highway from Jackson to Randolph, the Copps' home served as an inn for the wayfarers who stopped for a meal or for the night. Dolly's comfortable beds

and good food became widely known. The price was "a shilling all round"—that is, twenty-five cents for a meal, the same for a bed for each person, and a quarter for the feed and care of a horse.

In 1836 Shelburne Addition became the town of Gorham. A good wagon road took the place of the old blazed trail from the Copp farm to this prosperous town. In 1852 the Atlantic & St. Lawrence Railway (operated first by the Grand Trunk Railway and now a part of the Canadian National System) connected Gorham with Portland. At the same time the Boston, Concord & Montreal Railway pushed up as far as Conway. Daily mail stages started running through Pinkham Notch between these two mountain towns.

A little earlier, a family of English descent by the name of Barnes built their home and farm a quarter of a mile up the Randolph road from the Copps'. Soon after, Patrick Culhane took up a claim about midway between the Copp and Barnes farms. Across the river in Green's Grant had settled Frederick and Sally Spaulding with their four lively youngsters, who were a little older than the Copp children. After so many years of neighborless isolation, the pioneers of the Glen were to know neighbors and human friendship.

Mail coaches and trains meant travelers. In 1852, quick to see the future possibilities of the Glen, came John Bellows to build the first hotel at the eastern base of Mount Washington.

Colonel Joseph M. Thompson, who in 1853 succeeded John Bellows as owner of the Glen House, had learned the hotel business as proprietor of the Casco Bay House in Portland, Maine. At the time of his purchase at the Glen he was living in New Gloucester, Maine. Under his genial and able management—aided materially by the excellence of Mrs. Thompson's cooking—the Glen House became increasingly popular, and required enlargement.

Dolly was ready to reap her own harvest from this new summer-visitor business. Her own little inn was full of city folk summer after summer. And besides she found a ready market at the Glen House for her bolts of woolen homespun, her yards of linen, her dyes of delicate blue, her golden butter, rich cheese, and maple syrup.

Among summer folk there was a belief that the one perfect view of the profile on Imp Mountain, then becoming known as "Dolly Copp's Imp," was to be had in the dooryard of the Copp farm. So the great six-horse stages, as they rolled along the Glen road laden inside and out with eager sightseeing visitors, usually turned aside, crossed the river, and drew up before the Copp house. There the smartly-dressed vacationers divided their attention

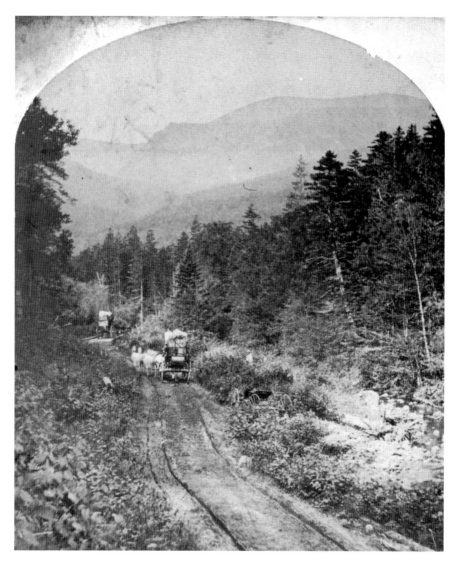

An early stereoscopic image of the wagon road through Pinkham Notch. *Author's collection.*

between Dolly's Imp, standing out clear against a screen of white cloud, and Dolly herself and her modest family gathered shyly about, the father with his pinched, hard face wearing the grim smile of years of endurance, Dolly standing in the doorway, clad in her pale blue dress of homespun, nervously fingering her gold beads, pretty Sylvia shyly peering out over her mother's shoulder, small Daniel clinging to his mother's skirt, Jerry and Nat modestly

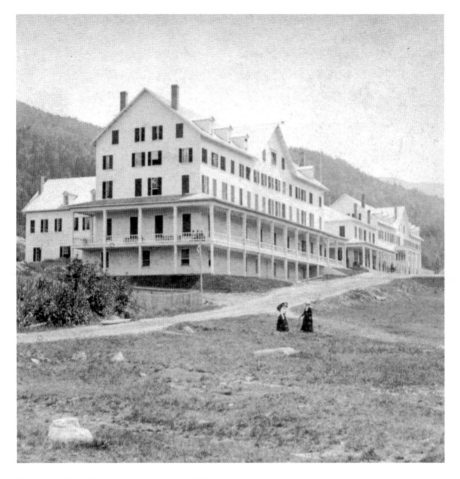

The first Glen House was erected in 1850 and enlarged many times during its years of operation. It was destroyed by fire in 1884. *Author's collection.*

answering a babel of questions. Thus the name and fame of Dolly Copp and her family went forth throughout New England and far beyond.

One of Colonel Thompson's early improvements was the building of the Glen Bridle Path up Mount Washington, climbing to the summit in seven miles by the ridge on which the carriage road was afterwards built. The zigzag route of the path through the woods for the first few miles has long since been wiped out and forgotten, but between the Halfway House and the summit much of the course may still be traced, some portions in a deep trench among the rocks, others in thickets of scrub. Within a mile of the top it crossed a broad, grassy area called the Cow Pasture, where are still

seen the stone walls of a corral in which cows were kept during one summer before 1860 to supply the Tiptop House with milk.

For the stage lines to Gorham and North Conway and for riders on the Glen Bridle Path, Thompson needed a large number of horses. In his great stable at New Gloucester he kept a splendid array of animals, and their departure for the mountains each summer was one of the great events of the village. A long rope was laid along the principal street, a pair of fine horses harnessed as leaders at one end, with a rider on one of them. Then at regular intervals the remaining horses were tied to the ropes in pairs, one on each side, a carriage with driver bringing up the rear. As there were as many as a hundred horses in all, they were divided into several bunches, each group tied to a long rope. It is said that the cavalcade would be two or three days in reaching the Glen House.

Landlord Thompson had much of the showman in his make-up. His big Concord coaches of the tallyho variety, which met the Grand Trunk trains at Gorham, were drawn by eight perfectly matched white horses. His expert driver had his arrival so timed that just at the moment the passengers commenced to alight from the train at the Gorham station, they were surprised and fascinated by the sight of the great coach, often loaded with departing guests, sweeping in a great circle up to the platform, the eight beautiful horses on a full gallop, brought to a standstill directly in front of the train.

Colonel Thompson continued to run the Glen House with increasing patronage until his death by drowning in 1869 during a terrific rainstorm and flood in the Peabody River.

In December of 1874, their children having married, Dolly and Hayes Copp once more were left alone in the home they had fought so hard to build in Martin's Location. The wilderness was tamed. Their work as pioneers was finished. They were approaching the Golden Jubilee of their marriage. It would have seemed a fitting time for relaxing and contentment and joy. But this couple were like sunlight and storm. Dolly was a dynamo of happy energy, her twinkling blue eyes seeking needs for service her ready hands might perform, her wide mouth turning up at the corners in mirthful appreciation of the fun of living.

But Hayes was a dour character who, in all his life, had never had time for fun. His gimlet eyes were always boring into some problem that was to mean hard, laborious work. His forehead was puckered up above his hawk nose, while his straight bitter lips slanted downward at each end towards the unrelieved hardness of his jaw. There is no story told of Hayes being

unkind to his family, but it was not in such a nature to be sympathetic or kindly or to have the least fun in life. And it is not mere coincidence than an old timer in Gorham recalled that "Haze Copp was the meanest man I ever knew in all my life."

Dolly was not one to speak ill of any one, least of all her husband of fifty years. All she told her friends was: "Hayes is well enough. But fifty years is long enough for a woman to live with any man."

So, without rancor, and with scrupulous care, they divided between them the savings of a lifetime. Leaving the fields, the orchard, and the garden they had made together, they separated and went their chosen ways. Hayes returned to his native town of Stow, while Dolly found a home with her daughter Sylvia in Auburn, Maine. There, far from each other, and far from the scenes of their life work, they lived out their remaining years.

It was in 1915 that the Federal Government added to the White Mountain National Forest the old farms in the Glen, and laid out the Dolly Copp Recreational Area, which has become a favorite vacation spot for hundreds of campers. In the spring of 1951 it was placed under the management of the Appalachian Mountain Club, to become the largest of its camping facilities.

In 1933 citizens of Gorham joined to erect a monument to the memory of Hayes and Dolly Copp, the Pioneers of the Glen.

SUMMIT HOSPITALITY

By Frederick W. Kilbourne

From Chronicles of the White Mountains, 1916

The steps in two connected enterprises—one the supplying of shelter for visitors to Mount Washington and the other the providing of means of making the ascent for others than persons coming on foot or on horseback—form perhaps the most interesting series of events in White Mountain history. The joint story covers a long period of time and is a record worthy of the strong men who by their courage and energy have made New Hampshire famous. I have already told of the building of the earlier footpaths and the bridle path and of the first shelter erected on the Mountain. This latter, it will be recalled, consisted of Ethan Allen Crawford's three stone cabins, which, soon after their erection in 1823, were abandoned. Mr. Crawford followed these with a large tent, which he spread near a spring of water not far from the Summit and which was provided with a sheet-iron stove. Because, however, of the violent storms and wind, this new shelter could not be kept in place and soon wore out.

Soon after the bridle path was opened, a rude wooden shelter of about a dozen feet square was built, but its existence was short,[1] and it is not known what became of it. This is the "Tip-Top House," that Dr. Edward Everett Hale tells of entering, in September, 1841.

The first hotel on Mount Washington was built in 1852, and owed its construction to the enterprise of Nathan R. Perkins, of Jefferson, and Lucius M. Rosebrook, and Joseph S. Hall, both citizens of Lancaster. This difficult

work was begun in May, and on July 28 the hotel, the "Summit House," was open to the public.

All the lumber for the sheathing and roof had to be carried upon horses from a sawmill near Jefferson Highlands. A chain was hung over the horse's back and one end of each board was run through a loop at the end of the chain, two boards being carried on each side of the horse. The drivers, D.S. Davis and A. Judson Bedell, walked behind carrying the farther ends of the boards. Mr. Rosebrook, it is said, carried the front door up the Mountain on his back from the Glen House. Such were the obstacles that were overcome by these energetic men.

This structure, which stood on the north side of the peak, was built largely of rough stones blasted from the Mountain and was firmly secured to its rocky foundation by cement and large iron bolts. Over the low, sloping gable roof passed four stout cables. It was enlarged the following year, when Mr. Perkins was in charge and a half-interest had been sold to Nathaniel Noyes and an associate, and an upper story with a pitched roof was added. It withstood the storms of winter for more than thirty years, being used, after the building of the second Summit House, as a dormitory for its employees until 1884, when it was demolished.

The success of this undertaking led to the erection of a rival house, the famous Tip-Top House, which was opened in August, 1853. Samuel Fitch Spaulding, of Lancaster, was the builder, and his associates in the project and in the management of the hotel were his sons and a nephew, John Hubbard Spaulding, the author of "Historical Relics of the White Mountains." It was built of rough stones, similarly to the Summit House, measured eighty-four by twenty-eight feet, and had originally a deck roof, upon which the visitor might stand and thus have an unobstructed view. A telescope was kept there in pleasant weather. Competition between the two hotels was keen the first common season, but in 1854 Mr. Perkins disposed of his interest in the Summit House to the Spauldings, who managed the two houses for nine seasons. Mary B. Spaulding (Mrs. Lucius Hartshorn), daughter of Samuel F. Spaulding, managed the Tip-Top House for three seasons. In a letter written a few years ago she gives a vivid description of the difficulty of managing a hotel on the Mountain at that day. Everything had to be brought on horses' backs from the Glen House, and fresh meat, potatoes, milk, and cream were absent from the menu. Among the supplies kept on hand were bacon, ham, tripe, tongue, eggs, and rice, and pancakes, johnnycake, fried cakes, and varieties of hot bread and biscuit were served. The number of guests for dinner was very uncertain and could be roughly estimated only from

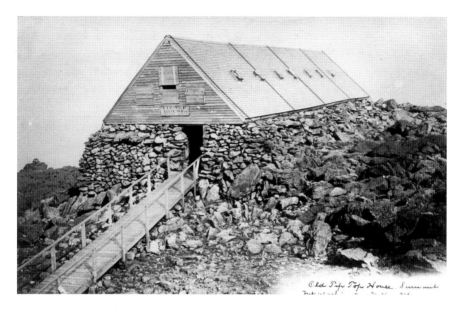

The Tip-Top House on the summit of Mount Washington was built in 1853 by Samuel F. Spaulding. The pitched roof here was added a number of years later. *Author's collection.*

the number of visitors at the foot of the Mountain and from the weather conditions. Among her guests she names Jefferson Davis, Charles Sumner, Horace Greeley, and William H. Seward.

C.H.V. Cavis, engineer for the carriage road, was for one year manager of the Tip-Top House. In his day, according to Mrs. Cavis, in order to estimate the number of guests for dinner, some one went to what is known as Point Lookoff, overlooking the Lakes of the Clouds, and counted the ponies in the cavalcade coming along the bridle path from Crawford's. Others came from the Glen and Fabyan's. Landlord Cavis kept some cows on the plateau, since known as the "Cow Pasture," near the seven-mile post of the carriage road.

The first woman to sleep in the house after its opening in August, 1853, was a Mrs. Duhring, of Philadelphia, who came up on horseback from the Crawford House and walked down. Twenty-four years later she revisited the Mountain.

From 1862 to 1872, the lessee of the Tip-Top House and Summit House was Colonel John R. Hitchcock, who was also the proprietor of the Alpine House in Gorham. He paid a rent of two thousand dollars a year after the first year. Colonel Hitchcock connected the two houses, and, after the completion of the carriage road, an upper story containing seventeen little bedrooms was added to the Tip-Top House. Mrs. Atwood, the housekeeper

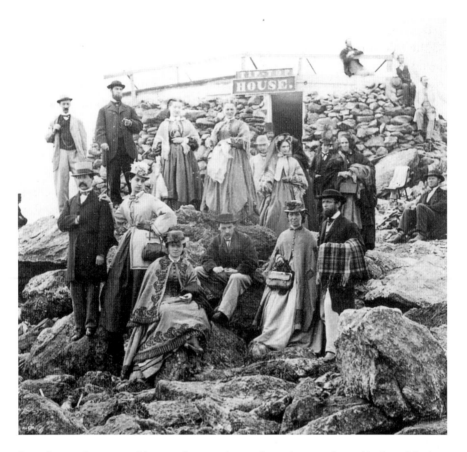

Late nineteenth-century visitors to the summit pose for a photograph outside the original Tip-Top House. *Author's collection.*

of the Alpine House, had charge of the Summit hotels, visiting them twice a week in a specially constructed light two-horse carriage. During the Hitchcock regime, in which baked beans, brown bread, and other simple dishes were chief features of the bill-of-fare, the business, especially after the building of the railway, far outgrew the accommodations. After the building of the new Summit House, the Tip-Top House was used by hotel and railway employees for a few years. From 1877 to 1884, the printing office of *Among the Clouds* was in the old hotel, its front room being equipped for that purpose in the former year. After that use of it ceased, the building, owing to dampness, fell somewhat into decay and came to be visited only as a curiosity. In 1898, an observatory was constructed at the western end to afford a good place from which to watch the sunsets.

But this ancient landmark was not destined to remain a curiosity only. As the sole survivor of the fire which devastated the Summit just before the opening of the season of 1908, the venerable structure had necessarily to be restored to its original purpose of a place of entertainment and shelter. As such it continued to be used until the opening of a new Summit House in 1915.

The next structure to be built on the Summit after the erection of the Tip-Top House was an observatory. Built in 1854, by Timothy Estus,[2] of Jefferson, it was a framework forty feet high supported by iron braces at the corners. It was provided with a sort of elevator operated by a crank and gearing and capable of accommodating eight persons at a time. This observatory, which cost about six hundred dollars, was abandoned as a complete failure after being used a part of the first season. It stood until the summer of 1856, when it was torn down.

No further buildings were erected on Mount Washington until after the building of the carriage road and of the railway, when the necessary structures for carrying on the operation of these means of visiting the Summit were erected. Soon the increase of business due to these agencies for making the peak more accessible necessitated the provision of greater accommodations for the shelter of visitors. From time to time, also, buildings for various other uses were added to the Summit settlement. The recording of the history of the later hotel and of the other structures referred to, however, properly follows the stories of the carriage road and the railway, and will be set down in due course after the latter have been related.

The construction of the first-named means of access to the summit of Mount Washington is a work which bears eloquent witness to the enterprise, courage, and persistence of its projector and builders. The road, which extends from the Pinkham Notch Road, near the site of the Glen House, to the Summit, is eight miles long and makes an ascent of forty-six hundred feet, the average grade being one foot in eight and the steepest, one foot in six. To General David O. Macomber, of Middletown, Connecticut, belongs the credit for originating this undertaking. The Mount Washington Road Company was chartered July 1, 1853, with a capital of fifty thousand dollars. The company was organized at the Alpine House, in Gorham, on August 31 of that year, General Macomber being chosen president. The road was surveyed by Engineers C.H.V. Cavis and Ricker. Two incidents of the surveying period have been preserved by John H. Spaulding. One is the measurement of the height of the Mountain by actual survey made by the engineers in 1854, who arrived at 6284 feet as a result. The other incident

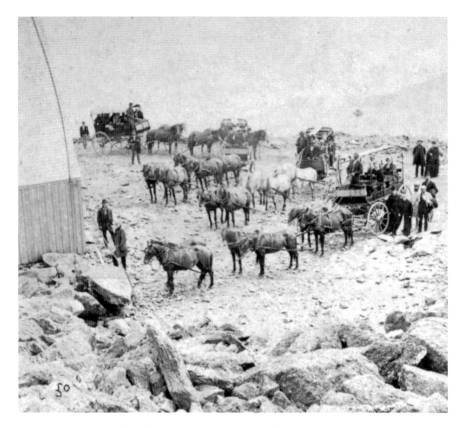

Horse-drawn wagons ferried many early visitors along the Mount Washington Carriage Road. The road was officially opened to travel in August 1861. *Author's collection.*

was the dining, on July 16 of that year, of President Macomber, Engineer Cavis, and Mr. Spaulding in the snow arch. It was then two hundred and sixty-six feet long, eighty-four feet wide, and forty feet high to the roof. Mr. Spaulding records that, during the time spent in this somewhat rash action, icy cold water constantly dripped down around them and a heavy thunderstorm passed over them.

Construction was begun by Contractors Rich and Myers in or about the year 1855,[3] and within a year two miles were completed and further construction was under way. The section ending at the Ledge just above the Halfway House, a total distance of four miles from the beginning, was finished in 1856. Then the pioneer company failed, because of the great cost of construction. A new company, the Mount Washington Summit Road Company, was, however, incorporated two or three years later, and this

company finished the road in 1861. Joseph S. Hall, one of the builders of the Tip-Top House, was the contractor for this work, and John P. Rich, the first contractor, was the superintendent. The road, which is splendidly built and which winds up the Mountain in long gradual lines of ascent, places where there are steep grades being rendered safe by stone walls on the lower side, was opened for travel on August 8, 1861.

The first passenger vehicle which arrived at the Summit—an old-fashioned Concord stage-coach with eight horses—was driven by George W. Lane, for many years in charge of the Fabyan House stables.[4]

The memory of Mr. Rich, who had so much to do with the construction of the road and who died in California in 1863, has been preserved by a tablet set in a rock by the roadside near the Glen and bearing a suitable inscription. Witness to the excellence of the engineering and construction work on the road, as well as of the care with which it has been maintained, is borne by its use for now more than fifty years and its well-preserved condition

Striking as was this achievement in rendering the top of New England's highest mountain more accessible, it was soon to be surpassed in boldness of conception and skill and successfulness of execution by another undertaking directed to the same end. I refer to the building of the Mount Washington Railway, the first railway of its kind in the world. The projector of this enterprise was Sylvester Marsh, a native son of New Hampshire and a Yankee genius. The idea that it was wholly practicable to apply the principle of the cog rail to a mountain railroad and the carrying out of the conception was only one of this ingenious New Englander's services to the world. Having gone West in the winter of 1833–34, when thirty years old, Mr. Marsh became one of the founders of Chicago, prominent in the promotion of every public enterprise there. He was the originator of meat-packing in that city and the inventor of many of the appliances used in that process, especially those connected with the employment of steam. The dried-meal process was another of his inventions.

When on a visit to his native State in 1852, he one day made an ascent of Mount Washington with a friend, the Reverend A.C. Thompson, of Roxbury. It was while struggling up the mountain, or perhaps a little later, that the idea came to him that a railway to the Summit was feasible and could be made profitable. Very soon he set to work and invented the mountain-climbing mechanism, and then with characteristic energy and perseverance he fought his project through to completion against much opposition and ridicule. In 1858, he exhibited a model of the line to the State Legislature and asked for a charter to build steam railways up Mount Washington and

Mount Lafayette. The charter was granted on June 25 of that year, one legislator, it is said, suggesting the satirical amendment that the gentlemen should also receive permission to build a railway to the moon. Pecuniary support for so apparently ridiculous a proposal was difficult to obtain, and before anything could be done the breaking-out of the Civil War postponed action for several more years. Finally a company was formed, the necessary capital being furnished by the railroads connecting the White Mountain region with Boston and New York. At the outset, however, Mr. Marsh had to rely chiefly on his own resources, but little encouragement being received until an engine was actually running over a part of the route. Construction of the railway was at length begun in May, 1866, nearly eight years after the granting of the charter. In order to render its starting-point accessible, a turnpike from Fabyan's to the Base was begun in April of that same year.

As the railway is so important in the history of mountain railways a brief description of its mechanical features may not be out of order. The road is of the type known as the "cog road," or the rack and pinion railroad. The indispensable peculiarity of the invention is the heavy central rail, which consists of two parallel pieces of steel connected by numerous strong cross-pins or bolts, into the spaces between which the teeth of the cog wheels on the locomotive play. As the driving wheel revolves, the engine ascends or descends, resting on the outer rails, which are of the ordinary pattern and which are four feet seven inches apart.

The first locomotive, which was designed by Mr. Marsh and was built by Campbell and Whittier, of Boston, was used until entirely worn out. Exhibited at the World's Fair in Chicago in 1893, it is now in the Field Museum of Natural History. It had a vertical boiler and no cab, and thus resembled a hoisting engine in appearance. The present type of locomotive was designed by Walter Aiken,[5] of Franklin, New Hampshire, who was the man to work out the practical details of Mr. Marsh's idea and who supervised the construction of the road. The engine is furnished with two pairs of cylinders and driving gears, thus guaranteeing ample security in case of accident. The car is provided with similar cog wheels to those on the engine and with brakes of its own, insuring safety independent of the engine. There are separate brakes on each axle of the car and an additional safety device on both it and the engine in the form of a toothed wheel and ratchet. This latter mechanism affords the greatest protection against accident, as it prevents the wheels of the car or of the engine from turning backward. It is, of course, raised during the ascent, but it can be dropped instantly into place in an emergency. The car is pushed up the Mountain and descends

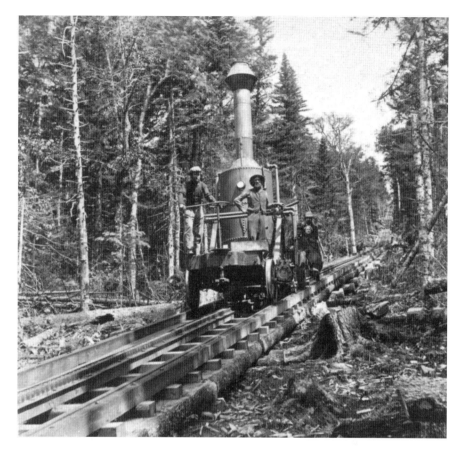

The Cog Railway's first mountain-climbing engine, Peppersass, carries a small load of passengers up the mountain, probably during the early stages of construction in 1866 or 1867. *Author's collection.*

behind the locomotive, and is not fastened to it. The train moves very slowly, so slowly, indeed, that a person can easily, if necessary, step on or off while it is under full headway. Seventy minutes are required to make the trip up. The safety appliances, the powerfully constructed locomotive, the moderate speed, the constant inspection, and the experienced men concerned in the operation of the road have eliminated the element of danger from the trip. No passenger has yet been injured in all the years since the road's opening.

The route was surveyed and located by Colonel Orville E. Freeman, of Lancaster, New Hampshire, a son-in-law of the pioneer, Ethan Allen Crawford. Very appropriately, the course of the railway is substantially that of the latter's early path to the Summit. The length of the road is about three

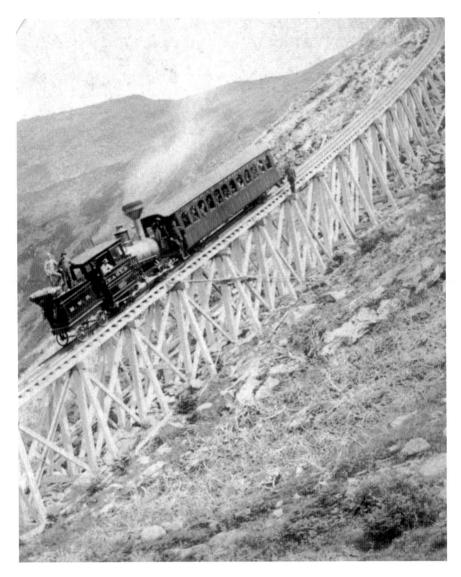

A Cog Railway train works its way along Jacob's Ladder, the steepest section of track in its three-mile length from Marshfield Station to the summit. *Author's collection.*

and one third miles, and the elevation overcome is about three thousand seven hundred feet. The average grade is one foot in four and the maximum thirteen and one half inches in three feet, or one thousand nine hundred and eight feet to the mile. With the exception of the railway up Mount Pilatus in Switzerland, the Mount Washington railway is the steepest in the world

of the type of which it is the pioneer. The road is built on a wooden trestle all the way except a short distance near the Base, where the track lies on the surface of the ground.

But to return to its history. The first quarter of a mile was finished in 1866, and a test was made which demonstrated the practicability of the invention. A half-mile more was completed in 1867, and on August 14, 1868, the railway was opened to Jacob's Ladder.[6] Before work on it stopped that year, construction was carried to the Lizzie Bourne monument. The road was finished the following year, being opened to the Summit for business in July. The cost of construction and equipment was $139,500.

At the time of its completion, the nearest railroad station was at Littleton, twenty-five miles distant. Every piece of material for the construction of the railway and the locomotive and cars, had to be hauled through the woods, it should be remembered, by ox teams.

I have spoken of the beginning of the construction of the turnpike to the Base. This was completed in 1869, and for many years afforded the only means of access to the railway, passengers being brought by stage over it from Fabyan's. It was owned for some years by the Boston and Maine Railroad, but has recently been turned over to the State.

A word more as to the railway's projector and inventor. Leaving Chicago, he returned to live in New Hampshire, settling at Littleton in 1864. He passed the closing years of his life in Concord, where he removed in 1879 and where he died in December, 1884, at the age of eighty-one, a public-spirited and highly respected citizen. He was asked to build the railway up Rigi in Switzerland, which is patterned to some extent after the Mount Washington Railway, but he declined.

During the latter's construction, a Swiss engineer[7] visited the American railroad, and he was allowed to take back with him drawings of the machinery and track.

After the Swiss railroad was completed (1871), Mr. Marsh said of it, "They have made a much better road than mine. Mine was an experiment. When proved to be a success, they went ahead with confidence and built a permanent road."

A noteworthy incident of the first season of the Mount Washington Railway was the visit of President Grant, whose first term had begun the previous March. His trip up Mount Washington was made in the course of a tour through the Mountains that summer with Mrs. Grant and some of their children. Another episode of this excursion has been preserved.[8] The general, as is well known, was a great lover of horses. One can imagine,

therefore, his keen enjoyment, as he sat on the box with the driver, Edmund Cox, of a stage-coach which traveled, drawn by six horses, from the Sinclair House in Bethlehem to the Profile House, more than eleven miles, in fifty-eight minutes.

Accidents on the carriage road, so strong are the vehicles and horses used and so careful and reliable the drivers employed, have been few. The first by which any passengers were injured, and the only serious one I have found recorded, occurred on July 3, 1880, about a mile below the Halfway House. A company of excursionists from Michigan had been visiting the Summit that day, and the last party of them to descend, consisting of nine persons, were thrown violently into the woods and on the rocks by the overturning of the six-horse mountain wagon in which they were riding. One woman was instantly killed and several other occupants were more or less injured. The husband of the dead woman was riding at her side and escaped with a few bruises.

It seems that the driver, one of the oldest and most experienced on the road and one who had himself uttered the warning, "There should be no fooling, no chaffing, and no drinking on that road," had failed to practice what he preached, and, while waiting for his party at the Summit, had indulged in liquor. This lapse, most serious under the circumstances, was discovered shortly after starting, and the passengers thereupon left the wagon and walked to the Halfway House, four miles down. There, on being assured by one of the employees of the Carriage Road Company that there was no dangerous place below that point, and on his telling them further that he thought it would be safe for them to ride the remainder of the way with the same driver, they resumed their seats, only to meet, a few minutes later, in rounding a curve at too great a speed, with the sad mishap that has been described.

As has been already stated, no passenger has ever been even injured on the Railway. The only mishap of any consequence, and a most peculiar one, occurred about the middle of July, 1897, when a train consisting of a locomotive, passenger car, and baggage car was wrecked. A heavy gust of wind struck the train, which was standing near the Summit, with such force as to start it off down the line. It was found that about a quarter of a mile down the engine and baggage car had jumped the track, had turned over and over while falling a hundred feet or more into the gulf, and had become total wrecks. The man sent out to investigate on a slide-board reported that he saw nothing of the passenger car, but it was later discovered that this had left the track at a curve near Jacob's Ladder, had

turned over, and had been completely demolished. Fortunately no one was on board.

Mention has just been made of the slide-board. This interesting contrivance was invented to meet the need of rapid transit for the workmen employed in track repairing and the like. By this means an experienced rider can go from the Summit to the Base in three minutes. The slide-board is about three feet long, rests lengthwise on the center rail, and is grooved so as to slide on it. The braking mechanism, by which the board is kept under such perfect control that it can be stopped almost instantly whenever necessary, is very simple. On either side of the board is pivoted to it a handle,

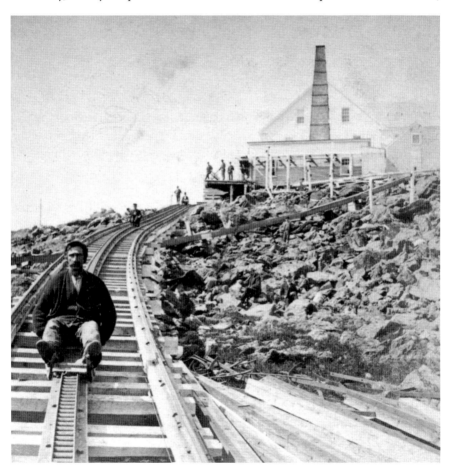

Slideboards like the one seen here were frequently utilized by railway employees who needed to get down the mountain in a hurry or make repairs or track inspections. *Author's collection.*

to which is attached, near the pivot, a piece of iron bent in a peculiar form so as to project underneath the rail. By pulling up the handle this piece of iron is made to grip the flange of the rail very tightly.

It was formerly the practice for the roadmaster or his assistant to descend on a slide-board before the noon train every day, going slowly enough to make a careful inspection of the track. The death of an employee in performing this hazardous act a few years ago, which accident cost the Railway Company several thousand dollars in damages and made evident the liability to mishaps of this kind, has caused the discontinuance of the use of this dangerous means of conveyance.

A picturesque employment of the slide-boards in former days was as a "newspaper train." This novel enterprise was carried on in the early nineties, when the coaching parades at Bethlehem and North Conway were at their height, and there was thereby created a great demand for the issues of *Among the Clouds*, which contained accounts of the festivities. So that readers of those towns might have copies of the paper at their breakfast tables, some of the skillful coasters used to transport the morning edition down the Mountain before daylight.

After the completion of the railway, steps had immediately to be taken to remedy the woefully inadequate provisions for feeding and sheltering visitors, and, accordingly, in 1872, was begun the building of the second "Summit House," the famous structure which for thirty-five summers entertained so many people of various walks in life,—guides, trampers, railroad officials, scientific and literary men and women, clergymen, and just ordinary persons,—and which had a wealth of associations connected with it, and especially clustered about its office stove. The undertaking was financed by Walter Aiken, manager of the Mount Washington Railway, whose tall, stalwart form and sterling manhood is one of the memories of the early days, and President John E. Lyon, of the Boston, Concord, and Montreal Railroad, whose contributions to the development of the Mountains have already been mentioned. The hotel, which was completed early in 1873 and opened in July of that year, was of plain outward appearance, but of the most rigid and solid construction possible of a wooden building. The difficulties of erecting so large a structure—it could accommodate one hundred and fifty guests—on a site where severe weather often prevails, are obvious as well as are the necessities for strong construction and for anchorage by bolts and cables. Two hundred and fifty freight trains were required to carry up the lumber, and the cost of the hotel, exclusive of the expense for freight (estimated at $10,000) was $56,599.57.

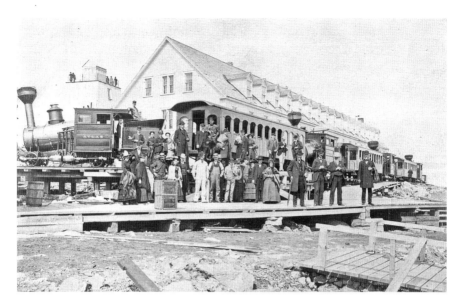

Cog Railway passengers and trains line up for a photograph in front of the fabled Summit House. *Courtesy Littleton Area Historical Society.*

The excellence of the construction is evidenced by the fact that the solid frame withstood gales of one hundred and eighty-six miles an hour by actual record by the anemometer and very likely of higher unrecorded rates when no instrument or observer was there to tell the tale. Its cheerful office, with its great stove, was a welcome place to many a traveler arriving by railway, by carriage road, or by trail. Many a day weather conditions were such that visitors were marooned in the office during their entire stay on the Summit and were devoutly grateful for the hostel's hospitable shelter. Almost every evening of the season found a group of travelers whiling away the time enjoying the genial warmth of the stove and exchanging experiences of their mountain trips.

Notables who made longer or shorter stays there at various times, as recalled by Editor F.H. Burt of *Among the Clouds*, were Lucy Larcom, the poet; William C. Prime, editor, traveler, author, and angler; his sister-in-law, Annie Trumbull Slosson, entomologist and author, who came year after year for longer and longer sojourns and who latterly regarded the hotel as her home; the botanist, Edward Faxon; the entomologist, J.H. Emerton; E.C. and W.H. Pickering, the astronomers; the naturalist and author, Bradford Torrey; and among the cloth, Rev. Dr. W.R. Richards and Rev. Dr. Harry P. Nichols.

Day visitors of prominence were legion. Some names of such, culled from the pages of *Among the Clouds* in 1877, are those of President Hayes[9] and Mrs. Hayes, who, accompanied by William M. Evarts, Charles Devens, and D.M. Key, of the Cabinet, made their visit to the Summit on August 20; the Reverend and Mrs. Henry Ward Beecher on the same day; Vice-President Wheeler, on August 29, and in September, Sir Lyon Playfair, the eminent British statesman and scientist. Other noted visitors whose names are found in the records of later years were P.T. Barnum, General Joseph Hooker, General McClellan, Lord Chief Justice Coleridge, of England, who came on August 30, 1883, Phillips Brooks, Speaker Cannon, Lieutenant Peary, and Señor Romero, the Mexican Minister. In 1880, the eminent Scottish professor, William Garden Blaikie, spent "a night on Mount Washington," an account of which experience he gave in a typically British article with this title, published in *Good Words* in June, 1881. He went up by train and walked down the carriage road. As there was a cloud on top when he arrived, he walked down below to see the view and the sunset. "Nothing could be finer," he declared, than the dawn he witnessed.

The versatile English writer and scientist of Canadian birth, Grant Allen, was another foreign visitor to Mount Washington who deserves a passing mention. From his graphic and often facetious account of his brief visit to the Mountains in 1886, written for *Longman's Magazine*, we learn that he made the ascent by train and that he was much interested in the botany—his specialty—and the gastronomy of the region.

The first proprietor of this new Summit House was Captain John W. Dodge, of Hampton Falls, New Hampshire, who also became postmaster by Government appointment when the Mount Washington post-office was established July 1, 1874, and who died in June of the following year. For nine seasons, a period ending with 1883, his widow, Harriet D. Dodge, successfully managed the house. Charles G. Emmons, had charge for the two following seasons, and from 1886 to the end, the hotel was leased to the Barron, Merrill, and Barron Company by the railway company into whose hands, after the deaths of Mr. Aiken and Mr. Lyon, their interest passed. The Summit House was enlarged by the addition of an ell in 1874 and extensive improvements were made in 1895, 1901, and 1905.

From time to time, as need arose or circumstances required, buildings for various uses were erected on the Summit until a considerable summer settlement had been created. Besides such essential structures as the train shed, built in 1870 and subsequently blown down in a winter gale and rebuilt,[10] and the stage office, erected in 1878 by the owners of the carriage

road for the accommodation of the agents and drivers of the stage line and sometimes used as sleeping quarters by trampers, several buildings came into existence for special purposes, which structures demand more attention than mere mention, either because of their uses or because of their associations.

When in May, 1871, the Government took up the work of maintaining weather-bureau service on the Summit, the observers, who were at that period detailed for this duty year round by the Signal Service of the Army, were quartered in the old railway station, but in 1874 a wooden building, one and a half stories high, the so-called "Signal Station," was erected for their use.

At the beginning of 1880, the buildings on the Summit were the old Summit House, which, as has been stated, was then used as a dormitory for the hotel employees, the old Tip-Top House, the front room of which then served as the printing-office of *Among the Clouds*, the stage office, the train shed, the Signal Station, and the Summit House. Two more buildings were added to the group during the years soon following, to stand with the others until the fateful evening in June, 1908, when the results of so many years' development were reduced in a few hours to ashes and blackened ruins.

In the year first named the railway company erected a strong wooden tower, twenty-seven feet high and of pyramidal shape, on high ground near the southwest corner of the Summit House. It overlooked all the buildings and became a favorite observatory. For several summers it was used by the United States Coast and Geodetic Survey in the triangulation of the region. In 1892, the tower was carried up another story and, during that season only, a powerful searchlight was operated on it. Having fallen into decay and having become unsafe, this, the second observatory built on the Mountain, was pulled down in 1902.

Four years after the erection of the tower came the last addition to the group of buildings. This was a home for the Mountain newspaper, *Among the Clouds*, which had outgrown its headquarters in the old Tip-Top House. In the autumn of 1884 was built the compact and cozy little office so well known to visitors for nearly twenty-five years. It contained a fully-equipped printing plant, with a Hoe cylinder press and a steam engine (superseded a short time before the great fire by a seven horse-power gasoline engine). Many a tourist here saw for the first time a newspaper plant in operation.

The same year saw another change in the Mountain buildings, for, as has been recorded before, the old Summit House was that year taken down, a wooden cottage being erected in its stead. Mention having just been made of the printing-office of *Among the Clouds*, and the establishment of

that newspaper belonging chronologically to the period now under review, accounts of this unique journalistic enterprise and also of another similar undertaking may perhaps be interjected at this point.

The distinction of being the first and for many years the only newspaper printed regularly on the top of a mountain, and the further distinction of being the oldest summer-resort newspaper in America, belong to Mount Washington's daily journal. In was founded in 1877 by Mr. Henry M. Burt, of Springfield, Massachusetts, who had been connected with the *Springfield Republican* and various other papers, among them the *New England Homestead*, which he founded. In 1866, Mr. Burt published "Burt's Guide to the Connecticut Valley and the White Mountains," the preparation of which brought him first to Mount Washington. While spending a stormy day at the Summit House, in 1874, the thought of printing a newspaper on top of the Mountain came to him, resulting in the starting of *Among the Clouds* three years later, the first issue appearing on July 18, 1877. This unique and daring undertaking gained the admiration of all visitors, and the paper with so peculiarly appropriate a name soon filled a recognized position in White Mountain life. For eight summers it was printed in the old Tip-Top House. Thereafter until 1908, it was published in its own building, the erection of which in 1884 has been recorded. The genial editor, during the twenty-two years in which he conducted the paper, gained a host of personal friends among those frequenting the White Mountains and those carrying on business in the region. Since his death in March, 1899, his son, Frank H. Burt, has been its editor and publisher.

Before the great fire of 1908 deprived *Among the Clouds* of its well-equipped and appropriately located home, two editions were printed daily, the principal one being issued in the early morning. At 1 p.m. the noon edition, containing a list of names of visitors arriving by the morning train, was ready for purchase as a souvenir by the traveler before the train departed on the downward trip.

Besides recording all events of interest relating to Mount Washington, together with news of the leading Mountain resorts, many articles of historical and scientific value have appeared in its columns, all of which contents have combined to make a complete file of *Among the Clouds* at any time, and now especially after the fire, a treasure indeed.

In view of the staggering blow that the paper received in the loss of its home and equipment before the opening of the season of 1908, it was thought best to omit for that summer the daily edition, which was done. Thus, for the first time in a generation the history of the summer's

events had to go untold. The enterprising editors, however, far from being discouraged and from giving up all for lost even that season, showed their quality by preparing a "magazine number," containing a very complete and interesting record of the fire by pen and camera, and many facts and reminiscences concerning Mount Washington.

The failure to rebuild the settlement upon the Summit is responsible for *Among the Clouds* not being able to regain its ancient and proper seat, but publication was resumed on July 5, 1910, and the paper is now temporarily established at the base

The only White Mountain summit other than Mount Washington, upon which anything more than a temporary shelter exists to-day, is Mount Moosilauke. The beautiful Mount Kearsarge[11] of the Bartlett-Conway region formerly bore upon its top a small hotel, in 1848 or 1849,[12] by Caleb Frye, Nathaniel Frye, John C. Davis, and Moses Chandler, which was kept open for several years and then fell into disuse. Andrew Dinsmore bought it in 1868 or 1869, put it in thorough repair, and reopened it. The weather-beaten old structure was blown down in a tempest in November, 1883. Mr. Dinsmore collected the fragments and rebuilt the structure on a smaller scale. This has been abandoned of late years and is rapidly falling into decay. It is now the property of the Appalachian Mountain Club, the building and ten acres on the summit having been given to the Club in 1902 by Mrs. C.E. Clay, of Chatham, New Hampshire. A small one-room house of logs and poles was built on Mount Moriah by Colonel Hitchcock, of the Alpine House, probably in 1854. A road up having been constructed under his auspices, that mountain for a time rivaled Mount Washington in popularity. In the sixties a rude house for the protection of climbers stood on the crest of Mount Lafayette, but, except for the low stone walls, it had disappeared by 1875.[13]

ENDNOTES

1. Colonel Charles Parsons, of St. Louis, who visited Mount Washington in 1900 for the second time, remembered that this shelter was in existence in 1844, when he walked up the Mountain. (From his "Reminiscences" in *Among the Clouds*.)

2. So Spaulding. Professor Hitchcock, in *Mount Washington in Winter*, gives the builder's name as Timothy Eaton.

3. Mr. Spaulding notes that in June, 1855, the road is "in rapid progress towards completion."

4. Landlord Thompson, of the Glen House, drove to the Summit in a light wagon with one horse, just before the road was completed, thus beating his rival for the honor, Colonel Hitchcock. Two men assisted in keeping the wagon right side up as he drove over the uncompleted last section of the road. Landlord Thompson was also in the first coach driven up.

5. From an article by Mr. Aiken in *Among the Clouds* for September 1, 1877, it appears that Herrick Aiken, of Franklin, about 1850 conceived the idea of ascending Mount Washington by means of a cog railroad. He went so far as to build a model of a roadbed and track with the cog rail and to make two ascents of the Mountain on horseback for the purpose of determining the feasibility of the route, etc.; but he was dissuaded from undertaking the project by prominent railroad men whom he consulted and who thought it impracticable and unlikely to be profitable.

6. This name was transferred to the railroad from the path, having been given to the steep crag at this place, many years before the building of the railway.

7. This was Mr. Nicholas Riggenbach, then superintendent of the Central Swiss Railway, who took the first steam locomotive into Switzerland in 1847, and who appears to have independently conceived the idea of a new system of track and locomotives for the ascent of mountains. On August 12, 1863, he took out a patent for a rack railway and a locomotive for operating the same, but nothing further seems to have been done with the idea by him until after the visit to America mentioned in the text. On his return he associated himself with two others, got a concession, and built the road up the Rigi. The rack rail designed by Riggenbach is a distinct improvement upon that used by Marsh. Instead of a round tooth, it employs a taper tooth, which experience has shown to be preferable, inasmuch as it not only insures safe locking of the gear at different depths, but resists more efficiently the tendency of the gear-wheel to climb the rack—a further security against derailment. Riggenbach's type of tooth, with modifications, is that now used on rack railways. (From F.A. Talbot's *Railway Wonders of the World*, 1913.)

8. Recorded by Alice Bartlett Stevens in the *Granite Monthly* for February, 1903.

9. This was President Hayes's fifth visit to the summit.

10. A third train shed—the one burned—was built about 1890. The second one, having become disused and dilapidated, was taken down in 1904.

11. Now to be called, in accordance with a decision (1915) of the United States Board of Geographic Names, "Mount Pequawket."

12. So Mrs. Mason. Sweetser says, "built in 1845."

13. The substantial Peak House on Mount Chocorua, which was built in the early nineties, was not located on the summit, but at the base of the cone. This house was blown down on September 26, 1915.

FIRST TO DIE ON MOUNT WASHINGTON

By Frank H. Burt

From Appalachia, *June 1936*

An Appalachian Mountain Club member for sixty-six years and a frequent contributor to the club's journal, Appalachia, *Frank Burt (1861–1946) was as connected to Mount Washington and the White Mountains as his father, Henry Burt, founder of the summit newspaper,* Among the Clouds. *The younger Burt assumed editorship of the paper in the summer of 1899 following his father's unexpected death. He ran the paper for the next eight seasons, or until a great summit fire of 1908 destroyed the paper's mountaintop office. During his long tenure with AMC, Burt held down several important positions within the club, including councilor of topography and councilor of publications.*

The story of Mount Washington's first tragedy, the death in 1849 of Frederick Strickland, second son of sir George Strickland, Bart., M.P., at the age of twenty-nine, has been told many times but never in full and usually with much inaccuracy.

On a day now fixed as Friday, October 19, 1849 (but usually given as 1851), Strickland and another Englishman set out with guide and saddle horses from the Notch House, against advice, to climb Mount Washington. They found the snow so deep that when Mount Pleasant was reached the guide refused to risk himself and his horses further. Despite the urgent appeals of his companions Strickland left them, intending to continue alone to the summit of Mount Washington and go down by the Fabyan path to the Mount Washington Hotel, near the site of the present Fabyan House. The Fabyan path, originally located by Ethan Allen Crawford in 1820, was

improved for horses soon after 1840 by Horace Fabyan, who had succeeded Crawford as landlord of the latter's hotel. The cog railway follows the same general course as this path.

Strickland reached the top of Washington safely and passed over the most dangerous parts of the descent, only to lose his path in the woods. Two days later his frightfully bruised body was found in the rocky bed of the Ammonoosuc. Unaccompanied, climbing a strange path, he had made the first recorded ascent of Mount Washington under winter conditions, but, like the first aviator to fly over the Alps, he died almost within reach of safety.

Students of the tragedy have heretofore relied for information upon two books published in 1855: *Incidents in White Mountain History* by Rev. Benjamin Willey, once minister of the North Conway Congregational Church and brother of Samuel Willey Jr., who perished in the famous slide in the Crawford Notch; and *"Historic Relics" of the White Mountains* by John H. Spaulding, then of Lancaster, landlord for many years of the Tiptop House. Either book might well have passed as absolute authority. Yet they differ by eleven years as to the date of the event, Spaulding putting it in 1851 and Willey setting it back, perhaps by a slip of the pen or a printer's error, to 1840. Spaulding omits to mention the name of the victim, incorrectly calling him "an English baronet."

Beside the doubt as to the date, several other questions occurred to me as I studied the stories. How came Strickland to be in the mountains at a season so unusual for tourists? Where did he lose the path? Where was he found? Where buried? What was his early history? The British *Who's Who* revealed a Major Frederick Strickland, World War hero, heir to a baronetcy and residing in Yorkshire; Burke's *Peerage* proved that he was nephew to the Frederick lost on Mount Washington and gave the date of death of the latter as October 13, 1849. A letter to the nephew brought a most cordial response but the admission that he knew practically nothing of his uncle's death except that he had been "lost in the snow in America." A search of the files of New England newspapers, made practicable as soon as the correct year was known, revealed a surprising wealth of material[1] from which it was easy to reconstruct a fairly full story.

Frederick Strickland and both his brothers, Sir Charles and Henry, were graduates of Trinity College, Cambridge.[2] With his brother Henry, Frederick arrived in Boston about the first of October, 1949, after travelling for several months in this country, and they stayed about two weeks at the Tremont House. Coming, in the quaint phrase of the *Boston Advertiser*, "most respectably introduced," Frederick, "had become known

to a considerable number of persons in this city and vicinity, by whom he was highly respected as a gentleman of amiable character, ardently devoted to literary and scientific pursuits." "He brought letters to some of our most distinguished citizens," says the *Transcript*, "and was advised to visit the White Mountains by several gentlemen of science and taste in our community." No newspaper that I have seen gives the names of any of Strickland's Boston friends, but a possible clue to their identity has come into my hands. The register of the Granite House, an old-time hotel in Littleton, New Hampshire, for the years 1842–50, a long cherished possession of Mr. George C. Furber, who for many years published the *White Mountain Republic* in Littleton, shows on July 30, 1849, the arrival of the following party, nearly all of whom were members of the Harvard faculty and pursuing the scientific study of the White Mountains: Louis Agassiz and his thirteen-year-old son, Alexander, Arnold Guyot, then lecturing at Harvard, Benjamin Pierce, professor of mathematics and astronomy, C.C. Felton, afterwards president of the college, George P. Bond, then connected with Harvard observatory and author of one of the first maps of the White Mountains, Ernest Sandos, Franklin E. Felton, and S.M. Felton. On August 2 there are again registered Agassiz, father and son, the three Feltons, Pierce, and Bond, also W.W. Gould of Boston. Such men as these the young Englishman would naturally have sought out, and it is a fair guess that among this group were those who advised him to visit the White Mountains and who later saw that proper honor was paid to his memory.

Henry Strickland left for home by the steamer *Canada* from New York, leaving Frederick to make the White Mountain trip alone. The latter travelled by stage via North Conway[3] and Crawford Notch, stopping on the way at the Mount Crawford House, kept by Abel Crawford near the present Notchland Inn.

On arrival at the Notch House on Thursday, October 18, Strickland expressed his wish to ascend Mount Washington. There must have been a very heavy snowfall throughout the region a few days before, for we read in the Dover (New Hampshire) *Gazette* of the same week: "White Mountains. We learn by a gentleman from that neighborhood, that the mountains were covered with snow 3 feet deep. The tops of Gilford Mountains [the Belknaps] were covered with snow on Monday morning, 15th instant."

Thomas Crawford assured him it could not be done; the snow was too deep for horses to get through. "I can walk where no horse could go" was the substance of the young traveller's reply. Crawford finally consented to

let him have a horse and guide, and seems to have advised him, in case he did proceed to the top of Washington on foot, to go down by the Fabyan path. "He at first refused to take any provision with him," says the Portland *Advertiser*, "stating that he should return before night—and it was only by earnest entreaty that he finally received a couple of crackers." Another Englishman joined him, probably a chance acquaintance, for he drops out of the picture before Strickland's death was discovered. The party started out by the Crawford bridle path on Friday morning, the 19th of October, and Strickland's guide and the other traveller were fully justified in turning back and urging him to return with them.

The weather must have been fine on the 19th to lure Strickland onward and there could have been no snowfall the day following, or his tracks would have been hopelessly buried.

Mr. Crawford, learning that Strickland was to go down to Fabyan's hotel, sent his trunk thither the same night. Driving over the next morning, he learned that he had not been seen. Fearing the worst, he ordered a searching party sent up his own path, while he and Fabyan, with others to aid, hastened to the foot of the mountain and started up a path by which Frederick was to have come down. A mile up the mountain they found his tracks, which showed that he had lost the path and after various wanderings had turned southerly and probably followed a little brook until it joined the Ammonoosuc River.

The *Transcript* account states that at a spot where the stream, normally not over two feet wide and six inches deep, spread out in a pool two or three feet deep, were found Strickland's trousers and drawers. Why did he discard them? Similar strange acts have been performed by others lost in the woods who have become hysterical and even temporarily insane on realizing their plight. It may have been that he fell into the stream and the garments having frozen to his legs he tore them off in desperation, a trail of blood marking the rest of his agonized movements.

Nightfall interrupted the search. On Sunday morning, with a much larger group, Fabyan and Crawford made an early start and about ten o'clock "found the body," says the *Transcript*, "about one mile from the spot where the clothes were discovered. The body bore many bruises and the legs were terribly lacerated. Mr. Strickland must have fallen several times and it was evident that when he fell for the last time, he made no effort to rise....He did not walk more than seven miles," continues the account, "and a greater portion of that distance, the walking was tolerably good. His overcoat and gloves were not found."

Several important details are supplied by the *New Hampshire Patriot and State Gazette* (Concord, N.H.) for November 1, 1849, in which, after quoting an account of the tragedy from the *Boston Post*, the editor proceeds:

"We have a letter from a gentleman living in the vicinity of the Mountains, giving a particular account of this occurrence. He states that the guide left Mr. S. on the top of Mount Washington [*sic*]. The snow was in many places very deep, and in his wanderings he crossed the road twice, and also crossed his own track, leaving blood upon the rocks and ground where he dragged himself along, and having crawled through a 'brush pile' and down a steep ledge of rocks, he appeared to have fallen, and was found with his face wedged in between two rocks, his legs, face and hands being much scratched and bruised. He was buried, with appropriate funeral exercises by Rev. B.D. Brewster, which were attended by a large number of people from the neighboring towns.

"Our correspondent speaks highly of the conduct of Mr. Fabyan in the search for the lost man, &c., and says that he furnished gratuitously a splendid supper to those who attended the funeral. He says this is the second hunt this season for a lost man. The other was found alive, about midnight, in a tree where he had climbed for safety; and he advises persons unacquainted with the country there to procure guides to accompany them in their ramblings."

Strickland's Boston friends at once sent for the body and on its arrival a thorough surgical examination was made.[4] On Monday, the 29th, a second funeral was held in Trinity Church on Summer Street, the structure which went down in the great fire of 1872. The Right Reverend Manton Eastburn, D.D. Bishop of Massachusetts, officiated, with George F. Hayter at the organ. The British Consul, Mr. (afterwards Sir) Edmund Arnout Grattan, and the vice-consul, with Mayor John P. Bigelow and many of Strickland's friends, formed the procession to the vault under the chapel, where the body was laid to await instructions from the father in England.

The circumstances attending Sir George's decision are unknown, but on May 8, 1850, Frederick was buried in Mount Auburn Cemetery, Cambridge,[5] off Green Briar Path, a few moments' walk west of the main gateway and close by the monument to William Ellery Channing. A tall, square, cross-topped monument of brownstone, beautifully wrought, is inscribed:

SACRED
to the memory of
FREDERICK STRICKLAND
an English traveller,

who lost his life
October 20, 1849,
While walking upon the
White Mountains.
He was the second son of
Sir George Strickland, Bart.,
A member of Parliament
In England.

The name of the maker, "A. Cary," appears below in small letters. The date of Frederick's ascent is fixed beyond all question as Friday, the 19th, and it seems improbable that he could have survived even until midnight; possibly Sir George was misinformed as to the date of his son's death.

In an effort to locate the point where Strickland lost the path, an Appalachian party comprising Messrs. Paul R. Jenks, Charles W. and Henry Blood, and the writer made an exploring trip on August 7, 1943, and succeeded in following a long session of the Fabyan path near the cog railway, between Waumbek Tank and Jacob's Ladder. Overgrown with grass, weeds and wild flowers, it was easy to identify a deep trench once travelled by saddle horses from Fabyan's Mount Washington Hotel. Near the so-called Cold Spring (which supplies a faucet for drinking water at the Waumbek Tank) was found a small brook, fitting the *Transcript*'s description of the stream in which Strickland's garments were found:

> *It appears from his track that he followed the Ammonoosuc River some distance. His pants and drawers were found in a hole in the river. The stream at this point is not more than two feet wide and six inches deep, but occasionally there will be a little pond formed where the water will be two or three feet deep. In one of these ponds the clothes were found.*

Messrs. Blood and Jenks, who have long been familiar with the Ammonoosuc, state that its volume is too great to conform to this description, which probably refers to some tributary stream. The brook we discovered lies in part of the track of a landslide dating from 1912 or 1913 and flows into the Ammonoosuc a little above the tablet marking the place where Herbert J. Young died December 1, 1925.

The party studied the entire terrain from the ridge at the foot of the steep and winding portion of the path once known as Jacob's Ladder (south of the railway trestle to which the same name was later given) to the Ammonoosuc

River and thence to the Marshfield station. They were satisfied that Strickland would not have lost the path in the higher section, because (unless he lost it exactly at the foot of Jacob's Ladder) to reach the river he would then have had to climb up a steep ridge at the left of the trail, when the obviously easier way was to keep to the path as it swung northerly toward Burt Ravine, at his right. It seems clear that he stuck to the path until well below timber line and finally lost it in the woods, whereupon he followed the brook to the Ammonoosuc, where, overtaken by darkness and suffering repeated falls, he at last succumbed.

This theory received support from the discovery, later, of the article in the *New Hampshire Patriot* (*supra*) which stated that "in his wanderings he crossed the road twice, and also crossed his own track." This could not have happened on the sharp ridge above timber line, but where the ridge spreads out above the Waumbek Tank there was ample space for a lost traveller to go around in circles. A clearing has been made there recently by the men of the C.C.C., through which can be seen the Southern Peaks and other parts of the range; but Strickland could have had no such aid to orient himself.

It is pathetic that such a tragedy as that of Frederick Strickland,—young, scholarly, brilliant, the heir of a noble race—should have been so nearly forgotten. In writing these pages it has been my hope that his prophecy expressed in the *Transcript* (Oct. 26, 1849) may be fulfilled:

> *This is the first instance, we believe, that a death has occurred among the visitors to those mountains, and the circumstances attending this calamity will doubtless be rehearsed to thousands upon thousands of those who will visit the region in coming years. The exalted station, accomplishments, and personal history of the deceased, will afford ample scope for the imagination to invest the story with romantic interests; and many a traveller will silently sigh over the interesting incidents connected with the last hours of him who was*
> "*By strangers honor'd and by strangers mourn'd.*"

ENDNOTES

1. The first story appeared in the *Daily Evening Transcript* of Boston on Wednesday, October 24, based largely upon a letter from "Thomas J. Crawford, Esq., the popular proprietor of the Notch House." The next day the *Herald* printed a letter

from Horace Fabyan, who, with Mr. Crawford, led the searching party that found the body. This is a full and clear account.

2. Trinity College Admissions, 1801–50, p. 465.

3. *Portland Daily Advertiser*, October 26, 1849.

4. *Transcript*, October 29, 1849: "The body was subjected to a minute surgical examination on Saturday, and all suspicions of a self-inflicted death were removed thereby...he had thrown off the clothes glued to his skin by the frost, excoriating his legs in the act."

5. The problem of Strickland's place of burial baffled me for months. Public records in New Hampshire and Massachusetts were silent. Finally came word from the family that he was doubtless buried in America. But where? The answer dawned upon me—there was but one place which his Harvard friends would have chosen. I telephoned Mount Auburn Cemetery. To my question there came in a moment the reply: "Yes; Lot 1747, Green Briar Path; date of death, October, 1849; interment, May 8, 1850; lot stands in the name of Sir George Strickland." Within an hour I had found and photographed the monument.

Such heartfelt interest did Major Strickland express in my research that I was grieved to learn of his sudden death before my studies were finished. In his last letter to me he related the surprising fact that his uncle Henry, Frederick's companion in America, died at the age of 89 in consequence of a fall from his horse when hunting—another instance of the indomitable Strickland spirit.

A MELANCHOLY OCCURRENCE ON MOUNT WASHINGTON

By Floyd W. Ramsey

From Shrouded Memories, *1994*

Retired English teacher Floyd W. Ramsey (1931–) is a northern New Hampshire native who has been writing about true historic events of the North Country for more than three decades. Ramsey, who lives in Littleton, self-published a collection of twenty such historical pieces in the popular book Shrouded Memories, *which debuted in late 1994. This selection is one that appears in that volume.*

On Tuesday, September 18, 1855, the funeral planned for beautiful twenty-three-year-old Elizabeth Greene Bourne of Kennebunk, Maine, had to be canceled for one day due to heavy rain. Five days earlier she had died on the summit of Mount Washington under circumstances that also played a role in the death of her well-known uncle, George Bourne, fifteen months later.

Prior to the tragedy, George Bourne had been highly successful in the Bourne family shipbuilding firm. Financially secure, he had retired in 1852, while only in his early fifties. From that time, until the death of his niece, he had shared his zest for life with his family, friends, community and church. He was also an active and influential member of the local Sons of Temperance, a group that favored complete abstinence from intoxicating beverages.

Following the tragedy, he was a broken man.

Today Elizabeth Bourne is remembered as the first person to perish on the summit of New England's highest peak. But, just what were the

circumstances surrounding her death there on the night of Thursday, September 13, 1855, that so deeply affected her genial Uncle George?

On the date in question, George Bourne, accompanied by his wife Jane, his twenty-five-year-old daughter Lucy, and his niece Elizabeth, checked in at the Glen House at the base of the mountain. It was early afternoon, and they had just completed their 120 mile journey from Kennebunk.

Elizabeth, or "Lizzie" as she was affectionately called, possessed a playful, coaxing manner. Despite her father Edward's concern for her fragile health, which was caused by a heart defect, she was able to obtain his permission to share in the holiday trip. He knew that, like her uncle, she possessed a love for the outdoors. Adding to her enthusiasm for going was also the prospect that a climb up Mount Washington in those days provided unparalleled adventure.

Though Lizzie knew that food and lodging could be obtained on the summit at both the Tip Top House and the Summit House, her primary purpose for making the climb was to witness the spectacle of sunrise from the top of New England's highest peak. This was a spectacle that she had heard a great deal about from friends, so she did not want to miss out on the opportunity to see it for herself.

With the carriage road still under construction, hikers had to use either existing footpaths or the bridle path. For a fragile girl like Lizzie Bourne, these choices posed a daunting challenge. However, she evidently felt equal to it because she talked her Uncle George and Cousin Lucy into making the climb that very afternoon instead of waiting until the following morning.

When the trio began the eight-mile ascent at about 2 p.m., tragically none of them recognized the need for a guide. Their plan was to spend a warm, comfortable night at the Summit House, and be up at daybreak so that Lizzie could see the sunrise from the top of the 6,288-foot peak. As fate would have it, they were rushing to keep a rendezvous with death.

Within two hours of their departure, they reached the end of the Carriage Road construction. Soon after leaving it, they came to the "Camp House at the Ledge," which is now known as the Halfway House. At this point they were 3840 feet above sea level. Because Lizzie was showing signs of tiredness, they stopped for a brief rest.

While visiting with workmen who were staying at the camp, they were told word had just been received from the summit that there were signs of a storm brewing. With the mountain's reputation for sudden, arctic-like storms, they were advised to turn back.

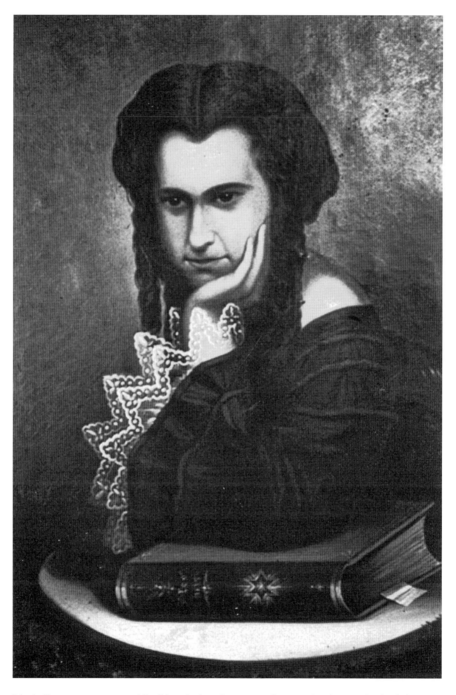

Lizzie Bourne, as portrayed in this painting done several years after her tragic death in 1855. *Courtesy Floyd W. Ramsey.*

Unfortunately, because the weather was mild at that particular level, the girls insisted on continuing. With the best of intentions, George yielded to their arguments. This set the final stage for the tragedy that was soon to follow.

As they continued to use the remaining daylight to work their way up the bridle path, the late hour soon brought them to the "point of no return." Then when they were two miles below the summit, a strong wind suddenly whipped up that made further climbing extremely difficult.

With the mountain now wrapped in twilight, the wind reached gale proportions and the temperature dropped dangerously low. To make matters worse, Lizzie was also showing signs of exhaustion. George and Lucy were struggling to keep her moving. While assisting her up what they thought was the last steep slope, a thick cloud settled over the summit and created the illusion of an even higher climb. Momentarily discouraged, they halted.

Nine days later George would write of this experience: "To our sorrow another mountain stood before us, whose summit was far above the clouds."

And so it was, without the guide that they so badly needed they had no idea of where they were. The next day, when they found out, it was a shock from which George never recovered.

Before long they started upward again, but what little progress they were making ceased altogether as they became enveloped by the dark of the night and the wind's paralyzing cold.

Fighting back panic, George had the shivering girls stop and lie down on the path while he feverishly built a rock wall from the life-threatening cold. Occasionally he laid down to rest, and to share his body warmth.

Sometime later, when the wall was finally completed, it gave him the encouraging feeling that now they would all survive. Clinging to this hope, periodically he left the shelter to restore his body warmth by thrashing his arms and by stamping his feet.

However, whenever he was outside the wall, the roaring wind and bitter cold quickly engulfed him. Minutes later, gasping for breath, he would be forced to crawl back to the girls. At no time throughout the entire ordeal did he leave them alone for more than ten minutes.

As the hours passed slowly, he began to suffer miserably. Then around ten o'clock, as he lay down next to Lizzie, he reached for one of her hands. It was icy cold! Trembling, he touched her forehead. That was cold, too! He shouted to her. She did not respond.

When he wrote about this moment, he simply said, "She was dead. She had uttered no complaint, expressed no regret or fear, but had passed silently away."

A stone monument marking the spot where Lizzie Bourne perished was erected soon after her death. As evidenced here, she died just a few hundred yards below the mountaintop. *Author's collection.*

Driven by grief, over the next eight hours George spared no effort to keep his daughter alive.

At dawn the two survivors left the shelter to seek help. And this was made when they found the soul-shattering discovery that they had spent the night only one hundred yards from the Tip Top House. What an agonizing moment this must have been for George Bourne.

Immediately after the owners and guests had been awakened and alerted to the tragedy, two men and two women rushed down to the rock sanctuary to retrieve Lizzie's body. On returning to the house, for four hours they tried every method imaginable to restore life to her. In George's words, "For four hours they labored with hot rocks, hot baths, and used every exertion to call back her spirit, but all in vain."

Just before noon Lizzie's body was placed in an open, shallow pine box which was slung from a long pole. She was then carried off the mountain by two men, with two others acting as relief. Brokenhearted, George and Lucy traveled with them.

At the Glen House, while the grief-stricken Bournes were completing final arrangements for the journey home, early newspaper accounts of the tragedy were heralding the fact that Lizzie's persistent eagerness to view the "splendid sunrise" produced a "Melancholy Occurrence" which left her in a pine box and destroyed her uncle's health.

Before the story ran its course, it was a tragedy that stunned all of New England.

On Saturday evening, September 15, George, Jane, and Lucy Bourne somberly arrived back in Kennebunk, and Lizzie's body was delivered to her father's house.

The day after the delayed funeral, Edward Bourne wrote a letter to the Summit House proprietors expressing his wish "that no material change be made to the wall thrown up by my brother as I hope to place there some more enduring monument to the memory of my daughter."

To this day, this "more enduring monument" has never reached Mount Washington's summit. The Mount Washington Road Company suffered financial failure after constructing the first four miles of the Carriage Road, and this bankruptcy removed the only route by which the marker could have been hauled to the site of the tragedy. Having no other alternative, Edward Bourne had the stone placed at Lizzie's grave in Kennebunk's Hope Cemetery. It is still there.

As evidence of the family's unwillingness to accept Lizzie's death, they had four portraits done of her by 1858 from daguerreotypes that she had sat for in the early 1850s. Three of them graced the walls of the Bourne Mansion for more than 109 years. As for George Bourne, following the funeral his health continued to deteriorate. Within fifteen months he became the second victim of that terrible night on the mountain. Referring to that fact, his brother Edward wrote, "The suffering of that night, both mental and bodily, without doubt, very seriously impaired

George's physical constitution so that it became more accessible to attacks and ravages of disease."

Which it did. Thirteen months after the tragedy George was stricken with typhoid fever. Following two months of almost continuous bed confinement, he died on December 7, 1856. His grotesque nightmare that started on New England's highest peak was finally over.

A MOUNTAINTOP SPECTACLE

By Thomas Starr King

From The White Hills: Their Legends, Landscape, and Poetry, *1859*

Long regarded as one of the "classics" in White Mountain literature, The White Hills: Their Legends, Landscape, and Poetry *was written by Unitarian minister and inveterate mountain explorer Reverend Thomas Starr King (1824–1864). The book, which primarily features a collection of dispatches previously published in the* Boston Evening Transcript, *was first published in 1859 and is credited with attracting many thousands of first-time visitors to the Whites. Starr King was among the first group of trampers to explore the great ravine north of Mount Adams in the Presidential Range, back in 1854. This ravine, long known as King Ravine, and Mount Starr King in the nearby Pliny Range are named for Reverend King. Similarly, a mountain in the Yosemite Valley of his adopted state of California also bears his name.*

There are three paths for the ascent of Mount Washington,—one from the Crawford House at the Notch, one from the White Mountain House, five miles beyond the Notch, and one from the Glen.

The path from the White Mountain House requires the shortest horseback ride. Parties are carried by wagons up the side of Mount Washington to a point less than three miles from the summit. The bridle-path, however, is quite steep, and no time is gained by this ascent. The rival routes are those from the Notch and the Glen. Each of these has some decided advantages over the other. The Glen route is the shortest. For the first four miles the horses keep the wide and hard track, with a regular ascent of one foot in eight, which was laid out for a carriage road to the summit, but never completed. This is

a great gain over the corduroy and mud through the forests of Mount Clinton, which belong to the ascent from the Notch.

When we rise up into this region where the real mountain scenery opens, the views from the two paths are entirely different in character, and it is difficult to decide which is grander. From the Notch, as soon as we ride out of the forest, we are on a mountain top. We have scaled Mount Clinton, which is 4,200 feet high. Then the path follows the line of the White Mountain ridge. We descend a little, and soon mount the beautiful dome of Mount Pleasant, which is five hundred feet higher. Descending this to the narrow line of the

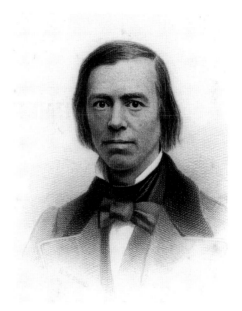

Thomas Starr King, author of *The White Hills, Their Legend, Landscape and Poetry*. *Author's collection.*

ridge again, we come to Mount Franklin, a little more than a hundred feet higher than Pleasant, less marked in landscape, but very difficult to climb. Beyond this, five hundred feet higher still, are the double peaks of Mount Monroe and then winding down to the Lakes of the Clouds, from whence the Ammonoosuc issues, we stand before the cone of Mount Washington, which springs more than a thousand feet above us. The views of the ravines all along this route, as we pass over the sharpest portions of the ridge, are very exciting. And there is great advantage in this approach to be noted, that if Mount Washington is clouded, and the other summits are clear, travellers do not lose the sensations and the effects produced by standing for the first time on a mountain peak.

Sometimes on the path from the Notch over the ridge, the cloud-effects add unspeakable interest to the journey. We have in mind, as we write, an attempt which we once made with a small party to gain the summit of Mount Washington, on a day when the ridge was clouded, though the wind was fair. We started in hope, and were attended by sunshine nearly all the way through the forest. But on the top of Clinton there is rain and shoreless fog. Compelled to descend, we return after reaching the lower sunshine, in the belief that the squall has passed. But it is raining more

The sharp peak of Mount Monroe rears up above the Appalachian Mountain Club's Lakes of the Clouds hut, less than two miles from Mount Washington's summit. *Photo by Chris Whiton.*

furiously; yet this time we press on, although unable to see a rod ahead, assured by the guide that it will clear within an hour. A slow and chilling ride for half a mile on the rocky ridge has begun to dishearten us. We think of returning. But what is this? How has this huge cone leaped out of the gray, wet waste, and whence can it catch this flush of sunlight that sweeps over it? It is the dome of Mount Pleasant which our horses' feet had just begun to climb. Hardly can we swing our hats and scream our cheers, when it is hidden. The frolicsome west wind tears open the curtain at our left, and shows Fabyan's, so snug in its nest of green. But see, on the right the vapors melt under our feet, and the unbroken forests start up as if created that instant in those vast valleys. They are concealed as soon as shown; but the dull cloud about our heads is smitten with sunshine, and we are dazzled with silver dust. Now look up,—the whole sky is unveiled, and we stand in an ocean of vapor overarched by a canopy of blazing blue. The bright wind breaks the clouds in a hundred places, scatters them, rolls them off, rolls them up, chases them far towards the horizon, mixes them with the azure, shows us billow after billow of land, from the Green Mountains to Katahdin, and at last sweeps off the mist from the pale green

dome of Washington, and invites us to climb where the eye will traverse a circuit of six hundred miles.

By the Glen route we cross no subordinate peaks, and do not follow a ridge line from which we see summits towering here and there, but steadily ascend Mount Washington itself. In this way a more adequate conception is gained of its immense mass and majestic architecture. After we pass above the line of the carriage road to the barren portion of the mountain, there are grand pictures at the south and east of the Androscoggin Valley, and the long, heavily wooded Carter Range. Indeed, nothing which the day can show will give more astonishment than the spectacle which opens after passing through the spectral forest, made up of acres of trees, leafless, peeled, and bleached, and riding out upon the ledge. Those who make thus their first acquaintance with a mountain height will feel, in looking down into the immense hollow in which the Glen House is a dot, and off upon the vast green breastwork of Mount Carter, that language must be stretched and intensified to answer for the new sense awakened. Splendid, glorious, amazing, sublime, with liberal supplies of interjections, are the words that usually gush to the lips; but seldom is an adjective or exclamation uttered that interprets the scene, or coins the excitement and surge of feeling. We shall never forget the phrase which a friend once used,—an artist in expression as in feeling, and not

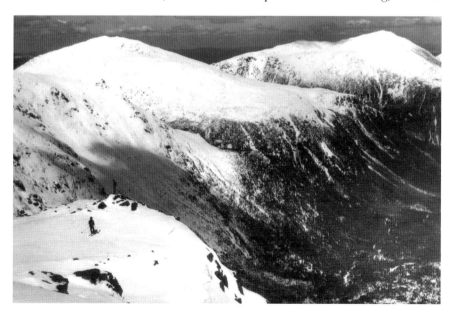

The snow-capped Northern Presidentials as viewed across the Great Gulf. *Author's collection.*

given under strong stimulant to superlatives,—as he looked, for the first time, from the ledge upon square miles of undulating wilderness. "See the tumultuous bombast of the landscape!" Yet the glory of the view is, after all, the four highest companion mountains of the range, Clay, Jefferson, Adams, Madison, that show themselves in a bending line beyond the tremendous gorge at the right of the path, absurdly called the "Gulf of Mexico," and are visible from their roots to their summits. These mountains are not seen on the ascent from the Notch, being hidden by the dome of Mount Washington itself. On the Glen path these grand forms tower so near that it seems as though a strong arm might throw a stone across the Gulf and hit them. There should be a resting-place near the edge of the ravine, where parties could dismount and study these forms at leisure. Except by climbing to the ridge through the unbroken wilderness of the northern side, there is no such view to be had east of the Mississippi of mountain architecture and sublimity. They do not seem to be rocky institutions. Their lines have so much life that they appear to have just leaped from the deeps beneath the soil. We say to ourselves, these peaks are nature's struggles against petrifaction, the earth's cry for air. If the day is not entirely clear, if great white clouds

Are wandering in thick flock among the mountains,
Shepherded by the slow, unwilling wind

the shadows that leisurely trail along the sides of these Titans, or waver down their slopes, extinguish their color, as it blots the dim green of their peaks, then their tawny shoulders, then the purple and gray of their bare ledges, and at last dulls the verdure of their lower forests,—thus playing in perpetual frolic with the light,—are more fascinating than anything which can be seen from the summit of Mount Washington itself, on the landscape below.

But let us not begin by disparaging at all what is to be seen on the summit. Suppose that we could be lifted suddenly a mile and a quarter above the sea level in the air, and could be sustained there without exertion. That is the privilege we have in standing on the summit of Mount Washington, about sixty-three hundred feet above the ocean. Only the view is vastly more splendid than any that could be presented to us if we could hang poised on wings at the same elevation above a level country, or should see nothing beneath us but "the wrinkled sea." For we are not only upheld at such a height, but we stand in close fellowship with the noblest forms which the substance of the world has assumed under our northern skies. We estimate

The peaks of the Carter Range pop out of the cloud tops as an undercast envelops the valley east of Mount Washington. *Photo by author.*

our height from the ocean level, and it is on a wave that we are lifted,—a tremendous ground-swell fifteen miles long, which stiffened before it could subside, or fling its boiling mass upon the bubbling plain. We are perched on the tip of a jet in the centre of it, tossed up five hundred feet higher than any other spout from its tremendous surge, and which was arrested and is now fixed forever as a witness of the passions that have heaved more furiously in the earth's bosum than any which the sea has felt, and as a "tower of observance" for sweeping with the eye the beauty that overlays the globe.

It may be that this billow of land was cooled by the sea when it first arose, and that these highest peaks around us were the first portions of New England that saw the light. On a clear morning or evening the silvery gleam of the Atlantic is seen on the southeastern horizon. The waves, that form only a transitory flash in the landscape which the mountain shows its guests, once broke in foam over the rocks that now are beaten only by the winds which the Atlantic conjures, and covered by the snows that mimic the whiteness of the Atlantic surf, out of which their substance may have been drawn. And, since the retreat of the sea, what forces have been patiently at work to cover

the stalwart monarchs near us with the beauty which they reveal! We call them barren, but there is a richer display of the creative power and art on Mount Adams yonder than on any number of square miles in the lowlands of New England equal to the whole surface of that mountain. The noblest trees of New England are around its base, and there are firs on the ledge from which its peak springs that are not more than two inches high. Alpine and Lapland plants grow in the crevices of its rocks, and adorn the edges of its ravines. Since the sea-wave washed its cone, the light and the frosts have been gnawing the shingly schist, to give room and sustenance for the lichens that have tinted every foot of its loosely-shingled slopes with stains whose origin is more mysterious than any colors which a painter combines,—as mysterious as the painter's genius itself. The storms of untold thousands of years have chiselled lines of expression in the mountain, whose grace and charm no landscape gardening on a lowland can rival; and the bloom of the richest conservatory would look feeble in contrast with the hues that often in morning and evening, or in the pomp of autumn and the winter desolation, have glowed upon it, as though the whole art of God was concentrated in making it outblush the rose, or dim the sapphire with its flame.

The first effect of standing on the summit of Mount Washington is a bewildering of the senses at the extent and lawlessness of the spectacle. It is as though we were looking upon a chaos. The land is tossed into a tempest. But in a few minutes we become accustomed to this, and begin to feel the joy of turning round and sweeping a horizon line that in parts is drawn outside of New England. Then we can begin to inquire into the particulars of the stupendous diorama. Northward, if the air is not thick with haze, we look beyond the Canada line. Southward, the "parded land" stretches across the borders of Massachusetts, before it melts into the horizon. Do you see a dim blue pyramid on the far northeast, looking scarcely more substantial than gossamer, but keeping its place stubbornly, and cutting the yellowish horizon with the hue of Damascus steel? It is Katahdin looming out of the central wilderness of Maine. Almost in the same line on the southwest, and nearly as far away, do you see another filmy angle in the base of the sky? It is Monadnoc, which would feel prouder than Mont Blanc, or the frost-sheeted Chimborazo, or the topmost spire of the Himalaya, if it could know that the genius of Mr. Emerson has made it the noblest mountain in literature. The nearer range of the Green Mountains are plainly visible; and behind them Camel's Hump and Mansfield tower in the direction of Lake Champlain. The silvery patch on the north, that looks at first like a small pond, is Umbagog; a little farther away due south a section of the

mirror of Winnipiseogee glistens. Sebago flashes on the southeast, and a little nearer, the twin Lovell lakes, that lie more prominently on the map of our history than on the landscape. Next, the monotony of the scene is broken by observing the various forms of the mountains that are thick as "meadow-mole hills,"—the great wedge of Lafayette, the long, thin crater of Carter, the broad-based and solid Mount Pleasant, the serrated summit of Chocorua, the beautiful cone of Kiarsarge, the cream-colored Stratford peaks, as near alike in size and shape as two Dromios. Then the pathways of the rivers interest us. The line of the Connecticut we can follow from its birth near Canada to the point where it is hidden by the great Franconia wall. Its water is not visible, but often in the morning a line of fog lies for miles over the low land, counterfeiting the serpentine path of its blue water that bounds two states. Two large curves of the Androscoggin we can see. Broken portions of the Saco lie like lumps of light upon the open valley to the west of Kiarsarge. The sources of the Merrimack are on the farther slope of a mountain that seems to be not more than the distance of a rifle-shot. Directly under our feet lies the cold Lake of the Clouds, whose water plunges down the wild path of the Ammonoosuc, and falls more than a mile before the ocean drinks it at New Haven. And in the sides of the mountain every wrinkle east or west that is searched by the sunbeams, or cooled by shadows, is the channel of a bounty that swells one of the three great streams of New England.

> *Fast abides this constant giver,*
> *Pouring many a cheerful river.*

And lastly, we notice the various beauty of the valleys that slope off from the central range. No two of them are articulated with the mountain by the same angles and curves. Stairways of charming slope and bend lead down into their sweet and many-colored loveliness and bounty.

LIFE ON THE SUMMIT

By Joshua H. Huntington

From Mount Washington in Winter, Or the Experiences of a
Scientific Expedition Upon the Highest Mountain in New England,
1870–71, *1871*

During the winter of 1870–71, a team of four men took up residency on top of Mount Washington for the purpose of observing and recording the weather on the summit of New England's highest mountain. This expedition, which found the observers living in a small mountaintop building just constructed that fall by the Mount Washington Railway, was the brainchild of state geologist Charles H. Hitchcock and his assistant, Joshua H. Huntington. The two had conceived the idea more than a decade earlier, but it took years before the expedition was economically feasible. Huntington had spent the previous winter atop another White Mountain summit, Mount Moosilauke, with fellow expedition member Amos F. Clough of Warren, a photographer. This 1869–70 venture served as a warm-up act for the following year's Mount Washington stay, which again saw Huntington and Clough take part, along with a Concord photographer, Howard A. Kimball, and an extra observer, S.A. Nelson of Georgetown, Massachusetts. Charles Hitchcock, meanwhile, monitored events of the winter occupation with a direct telegraph line from the summit to his Dartmouth College office in Hanover. Mount Washington in Winter, *first published in 1871, chronicles the experiences of the intrepid Mount Washington adventurers, with all four participants (plus Hitchcock) contributing pieces to the book. The following excerpt was written by Huntington, for whom the great glacial ravine on Mount Washington's eastern face is named.*

Most persons suppose life on Mount Washington in winter must be gloomy, and gloomy enough it would be, at times, when the summit is enveloped in dense clouds for weeks, if it were not for the cheering click of the telegraph instrument. They might suppose also that time would be extended indefinitely; that at night we should wish it is morning, and that in the morning we should long for night to come, and thus drag out a weary existence. If the time of any persons in excellent health is wholly occupied in a pursuit that is congenial they are rarely gloomy, and are almost unconscious of the flight of time. But here, besides good health and time occupied, there is an excitement found nowhere else.

THE EXCITEMENT OF LIVING ON A MOUNTAIN SUMMIT.

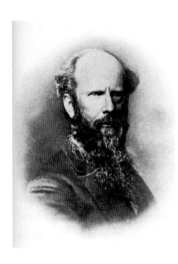

Joshua H. Huntington was one of the men to occupy the summit of Mount Washington during the winter of 1870–71. *Courtesy of Mount Washington Observatory.*

One gorgeous sunrise throwing a flood of light across a sea of clouds, one glorious sunset tingeing the clouds with crimson and gold, and as the sun descends leaving the blush of day upon these snowy summits, or a storm unprecedented at lower elevations, infuse into our life enough that is grand and sublime to occupy the thoughts for weeks. With such surroundings, a person, on account of the intense excitement, may live too fast to have life extended to full threescore years and ten; but there is a pleasure in it that would fully compensate for as few days cut off from the number to which life might be lengthened if passed in some quiet retreat, undisturbed by anything that arouses the whole being, and carries the mind into ecstasies of delight. So days and weeks pass, and we are almost unconscious of time.

Our Arrangements
for Comfort and Convenience.

But this record would not be complete without something specific being said of our habitation and our daily life, and it cannot be told better than in the language of "Ranger," the excellent correspondent of the "Boston Journal."

As the lessee of the Tip-top and Summit houses raised objections to the occupancy of either of those buildings, Mr. Huntington and his companions obtained permission from the Railway Company to set up their lonely habitation in the newly erected depot. The depot was built last summer, and occupies a site of the same elevation as the Tip-top and Summit houses, northeasterly of these structures, upon the verge of the little plateau forming the summit of the mountain. The building, unlike the two diminutive public houses, whose sides are of stone, is constructed wholly of wood. It is sixty feet long by twenty-two feet wide, and stands nearly north and south. It has eleven-feet posts, and the elevation of the ridge-pole is twenty-five feet, the roof being of the same form as the roofs of ordinary buildings. The apartment inhabited by the party is situated in the southwest corner of this edifice. It is a room about twenty feet long, eleven feet wide, and eight feet high. The larger portion of the depot forms a sort of vestibule to this room and is wholly inclosed except at the easterly end of the northern face, where the outer door is situated. The little room was formed in the following manner: 1st, there was the thick plank floor of the depot itself, which constituted a good foundation to build upon; 2d, a course of sheathing paper was laid over the original floor; 3d, an additional floor of close-fitting boards was then laid down; 4th, two thicknesses of sheathing paper were placed on the top of the second floor; 5th, a layer of carpet lining was added; 6th, a thick woolen carpet was made the uppermost layer of all. The inside of the outer walls was covered first with tarred paper, then with boards, a layer of sheathing paper was added, and wall paper was spread upon this. The ceiling is formed of two thicknesses of boards with sheathing paper between, and the inner walls consist of single thicknesses of boards, sheathing paper, and wall paper. There are two double windows—or rather half windows—on the westerly side of the room, and these are protected by strips of board without. The door of the room is of ordinary size, but the outer door is nothing but a little opening two feet square, some two feet from the floor. After the last observation is taken at ten o'clock p.m., the little aperture is closed by means of two sliding boards, but at all other times is

left open. Very little additional cold finds its way into the building through this aperture, and its elevation from the floor prevents the snow from blowing in to any great extent. More snow finds its way through the crevices between the boards upon the sides of the building than through this hole. Contrary to what ordinary experience would seem to teach, the north side of the building is less exposed to the fury of the elements than any other.

We have thus far described none of the precaution taken to prevent the building from being torn to pieces by terrible winter tempests, or from being blown away altogether. The frame-work is of the strongest

Members of the first winter occupation team included Joshua Huntington *(far right)*, plus Sergeant Theodore Smith of the U.S. Signal Service, photographers Amos Clough and Howard A. Kimball and weather observer S.A. Nelson. *Courtesy of Mount Washington Observatory.*

possible kind, and is fitted together in the best manner. The sills extend beyond the walls eight or ten feet, and every means are taken to fasten the whole structure down to its rocky base. Within, bolts, iron rods, and wooden braces add strength to the walls, and three strong iron chains, securely fastened to the rocks, pass over the roof. Notwithstanding all these provisions the building rocks and bends before a furious wind-storm in a manner well-calculated to create consternation and dismay. An ordinary house would stand no longer before such terrific blasts than would a house of cards before an ordinary wind. The great gale in December awakened the fears of the party for the safety of the depot, but as the structure stood that frightful assault it was thought no further danger on that score need be apprehended. It was nevertheless thought best to strengthen the walls with additional braces and supports.

Young couples about to enter upon the responsibilities of housekeeping might learn some useful hints from these dwellers of the clouds. The little snuggery is made to serve not only as a kitchen, dining-room, sleeping-room, sitting-room, parlor, library, and study, but also as an observatory and telegraph office. Every inch of space is utilized. The telegraph instrument, battery, and other appurtenances of lightning communication with the outside world, are in one corner of the cozy apartment, beneath one of the windows. At the same end of the room is a bedstead, while above it is a wide bank, arranged after the manner of an upper berth in a steamboat. The most prominent objects that greet one upon entering the door are two stoves, which occupy the middle of the floor. One is an ordinary cook-stove, and the other a Magee parlor stove. The latter is prized very highly on account of its marvelous heating properties. A story was published not long since to the effect that it required seven dampers to regulate the draft, and also that considerably more than one half of the coal was already consumed. Neither of these statements are true. The stoves are easily enough governed by single dampers, and as for fuel, Mr. Huntington has enough on hand to last until next summer. The dining-table, which is generally covered with books, papers, and writing materials when not otherwise in use, occupies one corner of the room, while between it and the telegraph instrument is a well-filled book-case and several shelves. Shelves, in fact, appear everywhere, and they contain a general assortment of everything, while clothing, and at least an hundred articles of utility, hang suspended from pegs and nails. A writing tablet is hung upon the wall near the head of the bed, and upon this the observations are bulletined until they can be telegraphed, copied into the record books, or placed in the blank forms

provided by the Smithsonian Institution. Beside it are two barometers, from one of which observations are made, and further on is a formidable row of smoking pipes. Some waggish member of the party has hung the tin sign of the old telegraph office over Sergeant Smith's seat, and also inscribed something of similar import on the door without. During the early part of the winter the corner of the room now occupied in part by the telegraph was used by Messrs. Clough and Kimball as a "dark room" in their photographic operations. The anemometer—the curious little instrument for measuring the velocity of the wind—is in a state of quietude on a shelf over the table. Beside the book-case, upon a projecting beam, is a coffee-mill, affording a striking exhibition of the combination of the scientific and practical. Among the other wall ornaments are a pair of snow-shoes, a hand-saw and other mechanical implements, an infinitude of tin dishes, a map of Paris and its fortifications, the photograph of a young lady, etc. The floor is made the receptacle of numberless articles which cannot be put anywhere else. There seems to be, in short, "a place for everything," but it not always happens, I believe, that everything is found in its place. In the absence of the female element of a well-regulated household, the scientific gentlemen content themselves with following out one half of the apothegm. They all complain that it is the easiest place to lose anything in they ever saw. In justice, however, it should be said that the apartment in general is in a very neat and tidy condition. A rocking-chair and three or four common chairs and stools, together with the table and beds, comprise all the movable furniture, while an ingenious member of the party has constructed a reclining seat upon one of the wooden braces. Most of the provisions are kept in the open part of the depot without,—about all, in fact, that freezing does not affect. Frozen pieces of fresh meat and of salt pork are suspended from the roof of this commodious refrigerator.

THE MOUNT WASHINGTON CARRIAGE ROAD

By Moses F. Sweetser

From Chisholm's White Mountain Guide-Book, *1887*

The first guidebook to contain route descriptions to many of the White Mountains' major peaks first appeared in 1876 and was written by Moses F. Sweetser (1848–1897). His trademark red, leather-bound guides provide the best information on the hiking paths and routes used by late nineteenth-century mountain explorers. Joshua H. Huntington, who just a few years earlier had assisted in the state geological survey led by Charles H. Hitchcock, assisted Sweetser in preparing the text for the first edition of this guidebook. Sweetser's guides were issued in fifteen different editions between 1876 and 1896. Especially useful for trampers were the foldout panoramic view guides included in the guidebook. Sweetser was also the author of Chisholm's White Mountain Guide, *a more tourist-driven guide to the region that was also published in numerous editions through the years. The following piece is excerpted from the 1887 edition of this guide.*

Starting out from the Glen House, across the meadows of the Peabody, the adventurous climber soon enters the dark and luxuriant woods which clothe the heavy eastern shoulder of the mountain, and so fares upward along the firm white road for nearly four miles, while the trees gradually dwindle until they become hardly more than shrubbery, and at last disappear altogether, leaving the mountain above the Half-Way House, four miles up, almost entirely bare, except for the dead white trees which cover considerable areas, and bear the name of buck's-horn, or bleached bones. A little way above is the Ledge, or the Cape of Good Hope, where the road suddenly doubles on itself, ever rising at a high grade, and revealing one of the most

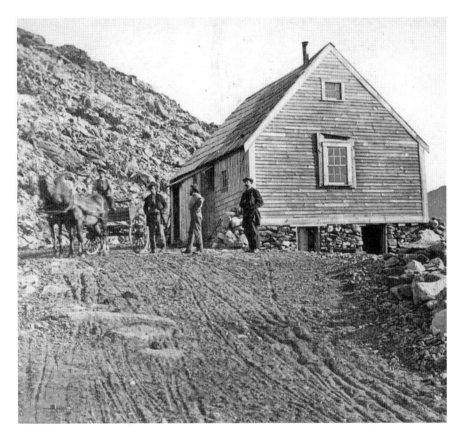

A wagon team takes a break at the Halfway House along the Mount Washington Carriage Road. *Author's collection.*

awe-inspiring views of the profound and shadowy depths of the Great Gulf, almost under foot, with the splendid peaks of Jefferson, Adams and Madison looming high above, across the chasm. Downward, to the east, is the long green wall of the Carter Range, at whose base is a rectangular dot, in which the outlines of the Glen House are recognizable. The prospect continually varies, as higher levels are gained, and as the road turns from side to side, and faces now the south, and the Saco-Conway region, now the east, and the rising peaks and silvery lakes of Western Maine, and now the north, with dainty bits of distant landscape, plaided meadows and white villages, framed between the great dark peaks so near at hand. The grandeur of mountain architecture is more evident from this route than from the railroad, as the firm white highway ascends by the five great spurs to the eastward, looking down into the dark ravines, and out along the little Labrador of the Alpine

Garden. On one side or the other, the topographical map of Northern New England is continually outspread, basking in the vivid sunshine, or dappled with deep cloud-shadows. At last the panting horses, or the weary pedestrian, who has become all knees and lungs, clamber up the final high grade, and reach the top of the last cone,—the crest of Mount Washington.

The valleys toward the Androscoggin first meet the view, as the slow ascent is made; and when higher grades come, the Saco Valley and its tributary plains of Western Maine are unrolled like a vast map. When the ridges of Mount Clay are overlooked, from the upper reaches of the road, the Ammonoosuc Valley appears, on the west, opening away towards the distant Connecticut River, and girt with rolling highlands.

Routes to the Glen House

The routes to the Glen House are three: by stage from Gorham, 8 miles north; or from Glen Station, 14 miles south; or from the summit of Mount Washington, 8½ miles south-west. Without doubt, the stages, horses, and drivers of the Glen-House corps form the best establishment of the kind this side of the Rocky Mountains, affording transportation at once swift, sure, and safe. The ride upward from Glen Station, through Jackson City, and along the ascending grades of the Pinkham Notch, is full of interest; the mountain-road is altogether exciting; and the drive from Gorham is more beautiful than either,—leading up long glens, by the rushing stream, with the great mountains coming out, one by one, to be seen and admired of every clear eye.

The Glen House

About two-thirds of the way from North Conway to Gorham, by the Pinkham-Notch road, stands the Glen House, which ranks high among the mountain-hotels in the grandeur of the view from its verandas, and is one of the first in respect to the position of its guests. Let us also bluntly state a conspicuous fact, somewhat alien in kind to the *belles-lettres* of guide-books, in saying that the *menu* at the Glen House is one of the best and most wholesome in New Hampshire; and also that the tables are waited on by polite college-

students, competent to take orders in the language of the Horatian odes, or of the sonnets of Petrach, or of the theses of Schleiermacher. This vast hotel, with its parlor covering more than an acre, its copious and peculiar water-supply, its book-and-picture shop, telegraph and post-offices, billiard and bowling-rooms, tennis-court, archery-lawn, and furlongs of piazzas, is able to accommodate five hundred guests at one time, and to satisfy them with aesthetic, social, and gastronomical luxuries.

But even such a Sybaris would fail on the Lynn marshes or the Newark meadows; and so the success of the Glen House must be attributed to its peerless situation, *vis-à-vis*, with the five noblest peaks east of Colorado, separated from them only by a narrow valley, and surrounded by many choice bits of scenery in ravine, peak, and waterfall. These things are sometimes casually alluded to by the summer-correspondence parasites; but let us look upon them as the reason for being of the Glen House.

The Glen, therefore, is an open square in the great street of the eastern hills, bounded on the north by the approaching ridges of Mount Carter and Mount Madison, on the south by Wild-Cat, Mount and Washington, on the east by the tangled and inaccessible Carter Range, and on the west by the great Presidential Range. It is 1,632 feet above the seas,—a height which is well above the hay-fever line, and within the domain of almost perpetual coolness,—with air perfumed by the surrounding forests, and made musical by the rushing streams, the sighing foliage, and the songs of countless birds, not less than by the merry waltzes of the hotel-band. Below the great inn are the verdant meadows of the Peabody River, with dark forests beyond, and over them the Great Gulf,—a vast bowl-like ravine opening deep into the heart of the Presidential Range, filled with curving forests and silent lakelets, and sheltering milliards of speckled trout in the dark pools of its mountain streams. (*En passant*, who that has visited the Glen House does not remember the great salmocide, Josh Billings, deep-eyed and hirsutely aureoled, and talking much of trout in language which, even in its spoken form, reveals how preciously distinct, subtle, and blessed its orthography must be?) Across the Great Gulf, then, rises the crown of New England,—the five-pointed star which is visible from Monhegan to the Adirondacks, and from Massachusetts to the St.-Lawrence Valley. Let us begin on the north, with the least and lowest of the group, and observe the rugged crest of Mount Madison, with its long slopes falling into the Androscoggin Valley; and then the clear and shapely pyramid of Mount Adams, cutting sharply into the blue sky, or repulsing the gray mists from its iron-bound shoulders, and in some way typifying the coldness and loftiness, the firmness and permanence,

of the noble family from whose ancient head it was named. Next, to the left, is the ponderous rocky peak of Mount Jefferson, with the strength of Adams, but without its quality of fineness; and sustained on the south by the apparently low crags of Mount Clay, for which mountain-climbers have devised the name of "humps," as if the Sage of Ashland was represented as a petrified dromedary. Mount Washington is almost concealed by a huge foot-hill, almost an Alp in itself, over which spur after spur of the sovereign mountain is seen, falling away towards the eastern valleys, with the ultimate peak visible over all, and crowned—not by a temple to Apollo, or to St. Benedict, but—by the favorite American shrine, a spacious white hotel. If this prospect is not enough, you may climb Mount Wild-Cat, behind the Glen, by a path an hour-long, and look into the ravines under the peaks; or even take the new path up Mount Madison, four miles long, and trample over all the northern line of summits. Or, if you prefer figurines to these colossal statues of the immortals, descend the old Randolph road to Dolly Copp's, and see the Imp, carved in profile on the Carter Range; or study the Garnet Pools, a mile northward, on the Peabody River, where countless ages of falling waters have whirled the rounding stones on the submerged ledges, until they have worn deep circular basins, brimming with translucent mountain dew; or clamber up to Thompson's Falls, two miles to the southward, just off the North-Conway road, where one of the brightest of brooks falls down the steep side of Mount Wild-Cat, with infinite play of white foam, roaring plunges, and deep dimpling pools, stretching for a half-mile through the woods, and from its summit looking into the heart of Tuckerman's Ravine; or sit down by Emerald Pool, close by, and see the busy Peabody River, fresh from its dance among the boulders and ledges, idling for a moment in a broad deep basin, overhung by rich foliage, and reflecting delicious dark colors from its shadowy depths in the seclusion and tranquillity of the forest.

THE CRYSTAL CASCADE

The lover of Nature will find it profitable to go down the North-Conway road for three miles, and then diverge to the right, by a convenient guide-board, for a half-hour's stroll up a woodland path, among grand old trees, mossy rocks, and the sights and sounds that were once heard "eastward in Eden," to the Crystal Cascade, the first-born daughter of Mount Washington, where

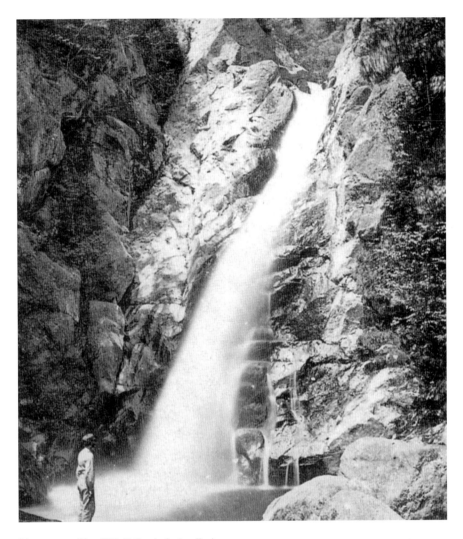

Picturesque Glen Ellis Falls. *Author's collection.*

the stream which flows out of Tuckerman's Ravine falls over a cliff of dark slate, 80 feet high, gracefully and merrily, filling the woods with the voice of its going. There is a little rustic bridge below, whereby one crosses to the right bank, and gains a vantage-ground of opposing cliff from which the whole sweep of the fall is charmingly visible.

THE GLEN-ELLIS FALLS

are about a mile beyond the Crystal Cascade, where another friendly guide-board indicates the divergence of a path to the left. These are the most beautiful and impressive falls in the State, and have been ardently admired by poets and painters and the rank and file of humanity for over half a century. The name *Glen Ellis* has much prettiness; but the ancient name, *Pitcher Falls*, was closely descriptive, and might well have been retained. It is thus that the water is gathered—the delicious frosty water from the Snow Arch—as if by the contracting edges of a great rocky pitcher, over which it pours in a solid and compressed column, 70 feet high, or twice the height of the Senate Hall at Washington. The grooves in the side of the cliff give a singular spiral twist to the water, and slightly deflect it from a direct downward course. Above are lapsing rapids; below, a deep dark pool gathering the white column of light, and wreathed with prismatic mists; overhead are the rugged slopes of Mount Wild-Cat; and all around are the forest-arches. So much for the details of mensuration, with which a volume of this kind must be content, leaving the soul of the scene, the Arethusa spirit, to be interpreted by Shelley and Coleridge, Bryant and Lovell, or the spark of poetic fire which lingers in every heart.

TUCKERMAN'S RAVINE

Cutting deep into the elephantine mass of Mount Washington, on its south-east side, and so marked a feature as to be visible even in Portland, on a clear day, is this vast gorge, which bears the name of one of the most honored early explorers of the White Mountains. The abrupt promontory of the Lion's Head, projecting from the Alpine Garden, enwalls one side; and the rocky plateau of Boott's Spur forms the other wall; while at the head is a line of formidable cliffs, from which descends the so-called Fall of a Thousand Streams. In the floor of this vast natural cathedral, paved with shattered rocks and perfumed by dwindling shrubbery, are the two dark and silent Hermit Lakes; and the chancel is fitly furnished with the glittering tracery of the Snow Arch, from which flows waters purer than those of the Sacramental Lake. Here the snows of winter accumulate to a depth of hundreds of feet, compacting into ice, and eaten away by the stream beneath until there is formed a deep cavern, whose sides and roof are of

crystalline beauty. Although it vanishes by late August, this is a true glacier, showing (in small) all the phenomena of the *Mer de Glace*, the moraines, and the scratchings on the bed-rock.

There is a sort of path from the Crystal Cascade into the ravine, but the best route is by a newly-cleared bridle path which leaves the Mount-Washington carriage-road about two miles up, and enters by Hermit Lake. One may traverse the ravine, ascend its head-wall, and reach the top of Mount Washington, in from five to seven hours from the Glen House. But the best way to enjoy and comprehend the scene is to pass the night in the Appalachian camp near Hermit Lake, with good store of blankets and a roaring fire. Then the sunset, the gloaming, the solemn starlight, even the red glare of the camp-fire, and the swift sunrise, add infinite charms to the varying hours. Solitude, a sense of strangeness, a feeling of amazing other-world-ness, fill the soul; and the shop, the study, the boudoir, seem removed by infinite eons and impassable spaces. Do not take merry men in there to encamp under those majestic cliffs. Rabelais should not intrude in the Homeric realm.

THE GLEN HOUSE FIRE

From The White Mountain Echo and Tourists' Register, July 22, 1893

A rival paper of the better-known Among the Clouds, *which was printed atop Mount Washington,* The White Mountain Echo and Tourists' Register *was published each summer in Bethlehem beginning on July 13, 1878. The paper was founded by Markinfield Addey, who served as its editor for twenty seasons. After Addey had to give up his editorial duties due to blindness, C.E. Blanchard ran the paper for the next thirty years. The* Echo *was devoted to covering not just its busy hometown but the entire White Mountain tourist community. Its editors were never reluctant to take stands on the major issues of the day, and during the time when the nearby hills and valleys were being denuded by the great lumber barons of the late nineteenth and early twentieth centuries, the paper often denounced the work of the "wood butchers."*

The famous Glen House is no more. That greedy and devouring fiend, fire, has drawn it into its powerful and destructive grasp with such attractive force that all that remains of this, one of the handsomest of White Mountain hotels, is a smouldering mass of ruins, and the tall, weird-like forms of the chimneys, two or three of which have already added their pile of bricks to the debris. The dreaded enemy stopped at nothing, but swept the establishment from the face of the earth as grass falls beneath the sharp blows of the scythe. The ice house was the only one of the attacked buildings that dared to oppose the advent of the fiend, and when I left the scene at two o'clock Monday morning that bade fair to succumb.

While the Sunday evening service was in progress at Wentworth Hall, the telephone rang, and on answering it myself I was informed that the Glen House was on fire, the operator at the Glen, Mrs. Burnell, whose husband is the efficient agent of the Maine Central at Glen Station, having notified her husband immediately the fire broke out. Soon after learning this the operator at the Hall was informed by the operator at Fabyans that the structure had been burned to the ground. In order to keep up the reputation of *The Echo* for being one of the first to get hold of the news, I immediately interviewed *The Echo*'s enterprising agent here, Mr. C.H. Hurlin, whose horses I knew had not been out during the day, while the horses at the Hall had each made two trips, and he at once placed his clever little pair of blacks at my disposal. I was fortunate enough to secure the services of "Dick" McInnis, one of the General's trusted drivers, and he drove me over to the Glen and back in good shape.

It was just about half-past nine when we started, the balmy air making the trip most pleasant. Nothing of interest occurred till we were half way up Spruce Hill, when a short distance off loomed up two big high lights and a low one. We immediately decided that it was one of the Glen coaches making for the Hall for the night, and pulling into the bank we awaited its coming. It was a gruesome spectacle. It was nearly eleven, the night was inclined to be dark, we were in the midst of thick woods, with these immense lamps, apparently without any visible support, looking like gigantic fire flys. I don't think either of us will ever forget the impression it made upon him. We hailed them and they halted while I extended to them a cordial welcome to the Hall. Holding the ribbons over the six sturdy grays we could discern the rugged form of the veteran "Jim" McCormick, whose set face was a sure sign that he appreciated the responsibility he bore. Mr. Burnell, who had hastened to the hotel immediately on receipt of his wife's message, led the way with a lantern, his wife occupying a seat on the couch.

Wishing them God-speed we continued on our way till we reached the last turn in the road before the Glen comes into view, and then what a scene met our eyes. Thick volumes of white smoke rose in the air, forming an effective background for the thin, spare forms of the tall chimneys. Where the noble structure had stood the flames rose in most fantastic shapes, dancing in wild glee at the terrible work they had accomplished. The scene closely resembled a field of tall, wavy grass blown about by the wind. Scattered all around were the big tally-hos, trunks, furniture, carriages of all descriptions, mountain wagons, harness, in fact everything that could be carried off before the flames gained too strong a headway. Picking our way carefully through these

obstructions, we reached the stables, put up our horses, and then proceeded to make a tour of the place.

On the little lawn in front of the house stood the sprinklers just as they had been performing their duties when the fire broke out, only the flames had destroyed the hose and cut off their water supply. Near them I picked up several smoked knives, forks and spoons, which in the confusion had evidently been hastily thrown out. The picturesque rustic summer houses in front of the hotel had fallen a prey to the fire, as had the lofty flag staff, part of which had fallen while the remainder stood there a charred piece of timber. Some one with more ambition than wisdom had drawn out from the office the fancy scales, which mockingly stood there badly scorched, but yet true to their purpose as they correctly recorded our weights. Stretched out in all directions were the wires that were formerly in use when the house was lighted by electricity. Smoke continued to pour from the furnace smokestack.

Moving round to the back of the establishment, the destruction was more apparent. The engine, which ran the machinery for the laundry, still kept its position, while the machinery it supplied lay scattered in the wreck. Everywhere could be seen the gas and hot water pipes twisted by the heat into all variety of shapes. In another corner, upside down, the printing press was visible. Outside of these objects all that could be distinguished was a gigantic heap of ashes, so thoroughly had the flames done their awful work. They had licked up everything that came within their reach; but though they made several attacks on the stables and employees' quarters, they were repulsed each time.

From the inquiries I made from several of those present when the flames broke out, I gathered that at about half-past six, just as supper was about to be served, smoke was seen issuing from the roof of the house, and an alarm was immediately turned in. When the hose was attached to the hydrants, it was found that owing to the lowness of the streams, or to some other cause which has not yet been ascertained, the water would not reach to the second story. It would not have made much difference, however, for in a very short space the whole structure was completely enveloped in flames, and it being at once apparent that it was doomed; efforts were made to save the rest of the buildings, from which the contents had all been removed to a safe distance.

Most of the personal property of the guests and of those employees who had rooms in the main house, was saved, as was as much of the furniture as could be removed in the short period that intervened in which the blazing building could be entered without danger. The famous Windsor Castle rug was safely removed, as was a large quantity of the silver. But the fire spread so rapidly that very little could be rescued.

C. R. MILLIKEN, Proprietor.

An advertising piece for the second Glen House, which burned to the ground in July 1893. *Author's collection.*

The cause of the conflagration is unknown. It is supposed that sparks from the smokestack of the engine room fell on the dry and inflammable roof and speedily ate their way into it before there was any outward indication of danger. This is merely a supposition, however, on the part of those connected with the hotel. As the house is so completely destroyed it is very doubtful if the true origin of the disaster will ever be discovered.

Most of the guests, accompanied by Mr. C.B. Milliken, the proprietor, and his family, and Mr. O.L. Frisbee, the manager, passed the night in Gorham, while the rest, as I have said before, journeyed to Wentworth Hall.

A large number of the employees are thus thrown out of engagement for the season. It is to be hoped, however, that their position will attract attention, and that places will not be wanting for them.

As both Mr. Milliken and Mr. Frisbee had left for Gorham before I arrived at the Glen, I was unable to ascertain what the loss would probably amount to, but was informed by several that it would be fully covered by insurance. Of course I was equally unable to ascertain Mr. Milliken's intentions as to rebuilding or as to the continuance of the stage line. And being pretty well tired I was not sorry about two o'clock to retrace my steps homeward.

J.M.C.

Jackson, N.H., July 17, 1893

FURTHER PARTICULARS

As most of our readers are aware the magnificent hotel that has fallen prey to the flames was an entirely modern structure and the only one of its kind in the mountains that possessed any degree of uniformity. It was not like many others, originally a moderate sized house whose capacity had been enlarged by numerous additions. It is now more than forty years ago that its site was occupied by a country inn, adapted to the wants of the mountain travellers of that period. This in time gave away to a larger structure, destroyed by fire on October 1, 1884, that was also owned by Mr. Milliken. Before that gentleman came into its possession it was the property of Mr. Thompson, whose name has been given to some neighboring falls and who was accidentally drowned during a freshet that occurred in the vicinity of the hotel.

After the destruction of the hotel in 1884, Mr. Milliken set to work to rebuild and by the following season had a considerable portion of the house just destroyed ready for the accommodation of guests; but it was not entirely completed until 1887.

The Glen House was one of the finest of the many handsome houses in the mountains. It was of the English cottage style with the roof line constantly broken by gables, and having octagonal towers at each corner in front. The roof, with its gables, dormers, and towers, presented a picturesque look and a splendid frontage, which extended nearly three hundred feet. The hotel was three stories high above the basement and covered an area of 1700 feet, exclusive of verandas which were 16 feet wide and 450 feet long, and were, without doubt, the best covered promenades in the White Mountains.

It is very fortunate that the stables and the cottage as well as the bowling-alley were saved, although more than once the roof of the cottage was ignited by sparks. The teams of horses and the carriages being thus preserved, the celebrated stage line from the summit of Mount Washington by the Glen to the Glen Station will continue to run as usual throughout the season.

The hotel was, it is stated, insured for $130,000; but Mr. Milliken estimates his loss at $175,000. The help were mostly paid off on Monday, when many of them returned to their homes.

It will not be possible to rebuild the hotel the present season, and it is yet uncertain whether or not it will ever be rebuilt by Mr. Milliken, who, it is reported, will dispose of the real estate. The location is, however, one of such surpassing beauty that the site now disfigured by charred ruins must before long be covered by a new and an elegant structure.

VICTIMS OF THE STORM

From Among the Clouds, *July 12, 1900*

Among the Clouds, *the mountaintop tourist newspaper published daily during the summer months from atop Mount Washington, was founded by Henry M. Burt in 1877. The idea of publishing such a newspaper came to Burt in 1874, while he was storm-bound atop the mountain's Summit House. Burt, whose previous newspaper publishing experiences found him in Boston, Massachusetts, and Bellevue, Nebraska, among other places, served as editor of* Among the Clouds *until his death in March 1899. His son, Frank H. Burt, took over as editor/publisher that summer and stayed with the newspaper until a devastating 1908 summit fire destroyed the paper's summit offices. The paper was revived in 1910 by Reginald Buckler, a former* Among the Clouds *employee. Operating from the Cog Railway Base Station, he ran the paper until its final year of publication in 1917.*

A day of fiercest hurricane and cold. Two stalwart men, each a trained athlete—W.B. Curtis, age 63, and Allen Ormsbee, about 30—both of New York, are pushing bravely up the Crawford bridle path. A night of gloom and fury overtake them, and after a desperate battle with the storm, a temporary refuge is found in a clump of scrub. A final effort is made to reach the Summit, but the older man, chilled and exhausted, falls stunned and helpless to perish in the path two miles from the top. Ormsbee, struggling onward against fearful odds, strives with all his might to reach safety and summon assistance. He wages a heroic yet hopeless fight with the tempest, suffering fall after fall on the icy rocks, until at last, with only a few rods more

to shelter, bruised and bleeding and crippled, he too falls to rise no more. Human power has done its utmost,—"For the Angel of Death spread his wings on the blast,"—and the dauntless spirit takes its flight. A struggle such as no other person ever passed through on Mount Washington ends in defeat and death.

Such was the tragedy of Saturday night, June 30. Not for ten years before had a life been lost on Mount Washington, though dozens of untrained and venturesome climbers make the ascent. For two vigorous athletes, accustomed to long and hard walks and mountain climbs, no one would have looked for a disastrous outcome. Except for the storm which was encountered, the severity of which exceeded anything ever known at this time of year by any one now familiar with the mountain, the climb would have been easy and safe.

William B. Curtis, the elder of the two unfortunate men, was for many years one of the finest amateur athletes in this country and was one of the founders of the New York Athletic Club. He was known as the father of athletics in America, and was looked upon as final authority on all athletic questions. Giving up active sports some 18 years ago, he had taken all his exercising in mountain climbing and tramped and climbed extensively. He was perfectly fearless and would climb alone and in all kinds of weather, so confident was he in his strength and skill. He was a man of splendid physique, deep-chested and of the finest type of athlete.

His companion, Allen Ormsbee, was likewise a trained athlete and was a member of the Crescent Athletic Club of Brooklyn.

Messrs. Curtis and Ormsbee with Mr. Fred D. Ilgen of New York came to the White mountains about a week in advance of the Appalachian excursion, which they proposed joining at the Summit House on its arrival. Mr. Curtis alone of the three was a member of the club, in which, however, he had never taken an active part. A fourth friend in the excursion was Prof. H.C. Parker of Columbia University, who came directly to Mount Washington with the club.

The three companions passed several days pleasantly in ascents of Lafayette, Whiteface, Passaconaway, Sandwich Dome and Tecumseh and on Friday night, June 29, found themselves at Rosebrook Inn, Twin Mountain.

On Saturday they had intended to go to the Crawford House and climb Mount Willard, after which they were to walk up the bridle path to Washington. But Mr. Ilgen had never climbed Twin Mountain, and he finally decided to leave his friends for that purpose, planning to meet the Appalachians that same afternoon and go to Mount Washington with them

by rail. So, Saturday morning being fine, Messrs. Curtis and Ormsbee took an early train for Crawford's, while Mr. Ilgen climbed the Twin, joining the club excursion for Mount Washington at night.

Reaching the Summit House, the Appalachians found a furious storm raging, as elsewhere told, and no word of Curtis and Ormsbee. Mr. Ilgen's story at once aroused anxiety, and telephone inquiries were at once made at the Crawford House. The answer was that nothing had been seen or heard of them at the hotel, and that no one was known to have started the path. Messages were sent elsewhere, but nothing could be learned of their whereabouts. The guides with the Appalachian party, Vyron and Thaddeus Lowe, took interns and started for the path, but the wind put out the lights in an instant. To proceed over the icy rocks in darkness and in that fearful gale would have been to go to almost certain death, with scarcely a chance of finding the missing men. Meantime the Club leaders had learned of the arrival of Rev. Mr. Nichols and son over the Montalban Ridge, and of the fact that their guides had started down the Crawford path early in the afternoon. The conclusion was quickly reached that these guides must have met Curtis and Ormsbee and warned them of the terrible weather above, so that they would surely have gone down. Fears were allayed, the guides were recalled from their desperate undertaking, and all were confident that the first fair day would bring Mr. Ilgen's friends.

Sunday passed without news. On Monday morning a large party of the Appalachians went to Tuckerman's Ravine while another went to Madison Hut to pass the night. Mr. Louis F. Cutter of Winchester, however, set out alone down the Crawford path, and about 11:15 the worst fears were realized by his finding the body of Mr. Curtis close to the path, near the Lake of the Clouds.

Mr. Curtis lay in the shelter of a large rock, his head resting on a projected part of the same rock. The left temple rested upon a blunt point of the rock. At the point of contact there was an indentation in the temple.

He had a light crash cap, which had fallen off, and wore a coarse woolen coat, not very thick, a shirt which seemed to be partly cotton, long trousers and heavy, hob nailed boots.

After making the dreadful discovery Mr. Cutter spent some time looking for Mr. Ormsbee. At a point in the lee of Mount Monroe and near the edge of Oakes' Gulf he came upon a camera in the path, and beside it an empty bottle which had contained milk. Close by was an improvised shelter in the scrub, which evidently had been a temporary refuge of the unfortunates.

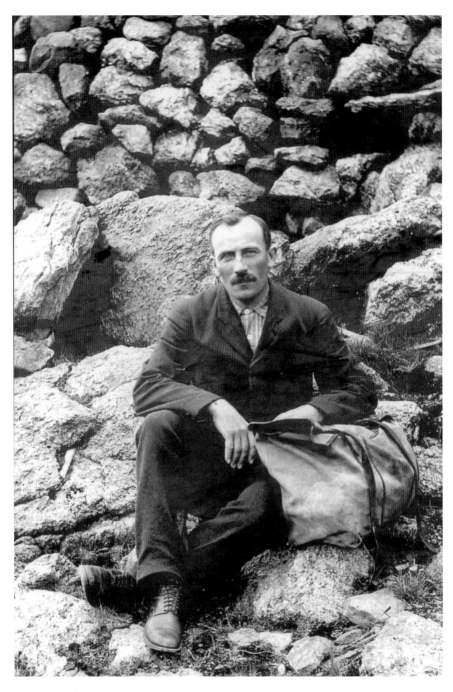

Veteran mountain guide Vyron Lowe of Randolph was one of the first to be called out to search for the two overdue AMC hikers. *Randolph Mountain Club archives.*

Mr. Cutter pursued his search as far as the north side of Mount Pleasant. Not finding Mr. Ormsbee and finding a party coming up from the Crawford who had seen no sign of him, he returned to the Summit. Near the junction of the Boott's Spur path he met three Appalachians who were setting out in that direction, Messrs. Coffin, Parker and Weed, and they started at once for the place where Mr. Curtis's body lay. Other Club members who were at the Summit went down upon Mr. Cutter bringing the news. Mr. Davis and Mr. Newhall went down the Tuckerman's Ravine path to intercept the party who would be returning from the ravine about that time, and the men of the party joined the searchers.

Messrs. Coffin, Weed and Parker proceeded to the shelter in the scrub which Mr. Cutter had described and made a thorough examination of it. It

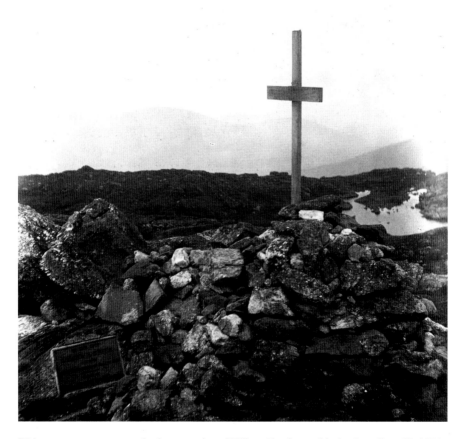

This stone monument marks the spot where William Curtis met his death on June 30, 1900. *Courtesy Dave Govatski.*

was at a point where the ground sloped sharply from the path and was densely overgrown with scrub, just enough space being left to crawl underneath. Once in it, partial shelter was afforded on all sides but the northern, and branches had been hastily broken off and laid over the exposed side. Within, wrapped in paraffined paper, were found two slices of bread and a broken fragment, and in the dryest corner was Mr. Curtis's camera. The camera in the path Mr. Parker recognized as that of his friend Mr. Ormsbee.

Having made a careful search and found no trace of Ormsbee, the three searchers weighed the probabilities of the situation in the light of their discoveries and came to the conclusion that Mr. Curtis had become exhausted and Mr. Ormsbee had started for help, leaving the older man in the shelter and placing the camera and bottle in the path to mark the spot. Mr. Curtis, they thought, had probably survived the night, and on Sunday morning his companion not returning, he had tried with his diminished strength to reach the Summit, but had succumbed to exhaustion at the spot where he was found. From his intimate knowledge of Ormsbee Prof. Parker reasoned that he would have left the path and gone straight for the top, which would take him up the more sheltered side of the mountain.

Therefore, after a brief search on the Boott's Spur path, the three left the Crawford path and set out for the Summit, keeping a little space apart but following parallel courses. Weed kept farthest to the right, passing Harry Hunter's monument; Mr. Coffin was next to him, while Prof. Parker kept to the left, nearest to the Crawford path. Thus they went slowly up the cone, zigzagging back and forth as a man bewildered by cloud and storm would have gone, and closely examining the rocks. Finally, about 4:30, when in sight of the Signal Station and only a few hundred feet below, Prof. Parker came upon the body of Ormsbee lying upon the rocks where he had fallen. His face and hands bore marks of the terrible struggle he had made with the storm, there being a gash an inch and a quarter long in one hand, besides other cuts, while in the middle of his forehead was a severe bruise.

Some of the lady members of the party happened to be at the signal station when Prof. Parker found the body and he shouted to them to tell of his discovery. The word was speedily passed around and volunteers were quickly found to bear the body to the Summit. It was a comparatively simple matter to bring poor Ormsbee's remains up the little distance he had failed to make in his struggle with the hurricane, but there remained a harder duty, for Mr. Curtis's body was to be borne some two miles up the rock-lined path, which is hard enough to traverse empty-handed.

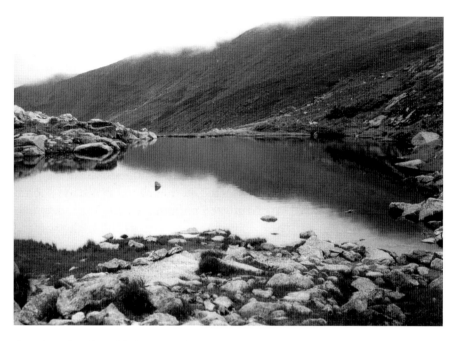

A modern-day view of Lakes of the Clouds, not far from where William Curtis perished. *Photo by author.*

Materials for making a stretcher were sent down and all the men who were equal to the task set out about 6 o'clock. Others followed after the arrival of the train and relieved the first company near the foot of the cone. There were nearly 20 in all to lend a hand, but progress was slow and it was about 8 o'clock when the Summit was reached. Those who took part in the sad duty, besides several of the Club, were John Camden and John Camden, Jr., and Etienne Gilbert, employees of the Mount Washington Railway; Nathan Larrabee, driver on the stage line, Patrick Howley, caretaker on the carriage road; George O'Brien, John St. Peter and another, linemen; Howard Langill, bellboy at the Summit House; and Charles H. Carr and G.W. Smith, attaches of *Among the Clouds* office.

Meanwhile, with his accustomed thoughtfulness and promptness, Col. O.G. Barron of the Fabyan House made all necessary arrangements below, summoning Undertakers Charles Bingham and Frank Wells from Littleton and sending them by carriage to the Base, and ordering caskets brought up on one of the evening trains. At the Summit a special train was arranged upon telephone orders from Superintendent John Horne, and left the Summit at 8:20 p.m. bearing the bodies. On the train went Mr. Ilgen, the

friend and travelling companion of Messrs. Curtis and Ormsbee, to whom fell the duty of going with the remains to New York. Prof. Parker joined him the following morning.

The remains were taken in charge by the undertakers at the Base, and were removed to Fabyan's on Tuesday morning, where they were viewed by Dr. George S. Gove of Whitefield, who certified the cause of death to be exposure and exhaustion. There were no broken bones. On the left side of Mr. Curtis's forehead was a large bruise about which the blood had settled, producing a condition of ecchymosis, but there was no fracture of the skull. This was at the point which rested on the rock when the body was found. The bruise, Dr. Gove said, could not have been caused by the mere resting on the rock, as had been suggested by observers, but was unquestionably the result of a fall. The blow, he stated, would have been sufficient to produce unconsciousness, and in that condition he would live for awhile and the blood would be effused under the skin. Dr. Gove said it was probable that the older man had become exhausted and his friend had gone forward for help, and while there was nothing in the condition of the bodies to indicate when death occurred, yet he should expect that the younger man would have been the last to die. While it was possible that Mr. Curtis lived until Sunday, yet the chances, he said, were against it, and his opinion was that he died Saturday night. He accordingly certified that both deaths occurred on June 30. The permit for the removal of the bodies was signed by the undertakers and Dr. Gove and they were taken to New York Tuesday night.

What must have been the fierceness of the tempest may well be realized by the fact of its overcoming a man of the almost unequalled strength of Mr. Curtis. His athletic record shows that he was not a man to be baffled by any ordinary storm. "Father Bill" Curtis, as he was affectionately known in athletic circles, was born in Salisbury, Vt., January 17, 1837. In his youth he acquired fame for his skill as an athlete and his wonderful feats of muscular strength. In 1868 he made a lift in harness of 3239 pounds, a record which has never been surpassed with possible exception of J.W. Kennedy's lift of 3242 pounds at Lynn in 1892. In 1868 Mr. Curtis founded the New York Athletic Club and in 1878 the Fresh Air Club. He was an active competitor in athletics until 1882 winning in almost every form of competition. He established records at 60 and 100 yards running, throwing hammer and 56 pounds weight, tug-of-war, rowing in single sculls and double and four oars, lifting heavy weight and putting up dumb bells. He also won 200 yards and quarter mile runs, 100 yard hurdle, mile walk, jumping, swimming, skating and all round gymnastic contests. He was an editorial writer of *Spirit of the*

Times, refereed the N.Y. athletic club games from the foundation of the club, was referee of the games of the Interscholastic Association for 25 years and of the Harvard-Yale games for 15 years. His lowest weight when in training for rowing was 163 pounds, and his heaviest in training for gymnastics 184 pounds. He was so thoroughly inured to cold that even in midwinter he never wore an overcoat. This habit explains the light costume which he wore up the mountain.

One fact which every one concedes is that Ormsbee would have stood by his companion to the last and never would have left him unless to summon help.

Among the Appalachians who have studied the case this week there seem to be three leading theories.

1. That Curtis staid behind exhausted in the shelter while Ormsbee pushed on for help, leaving the camera to mark the place, Curtis afterwards trying to pursue his way and perishing in the attempt.

2. That they both rested in the shelter and set out together, but were forced apart in the furious storm and unable to find one another in the dense cloud.

3. That they were together until Curtis fell, after which Ormsbee started for help.

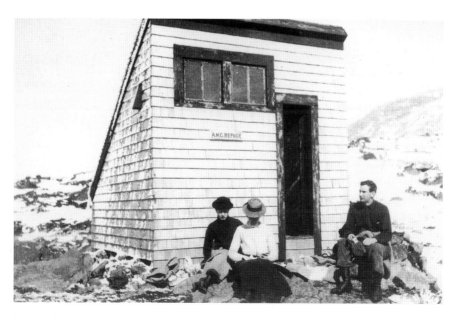

In the aftermath of the deaths of Curtis and Ormsbee, the Appalachian Mountain Club established this small refuge shelter near Lakes of the Clouds. *Courtesy Appalachian Mountain Club.*

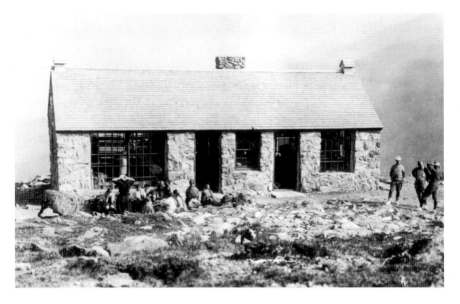

The Appalachian Mountain Club's Lakes of the Clouds hut opened in 1915 and replaced a previously built refuge shelter. *Postcard view from author's collection.*

Those who advocate the first theory are divided as to whether Curtis followed Ormsbee on Saturday night or Sunday morning. Against the Saturday night theory it is urged that he would be more likely to stay over night in comparative shelter than to set out in darkness, which must have come on soon after Ormsbee left. Against the Sunday theory it is argued that he possibly could not have lived through the night, and if he had, why was the bread left uneaten? As to the theory of their both leaving the shelter together, it is asked why did they leave their cameras behind?

There seems no doubt that Ormsbee died Saturday night. His friends Prof. Parker and Mr. Ilgen agree that with his great strength nothing less than the frightful storm of that night could have overcome him, and that had he survived till Sunday he could easily have reached the top.

An Appalachian who studied the situation carefully says, "They were fast walkers and probably came up through the woods at a high rate. On getting to the ridge and finding the storm they probably hurried and could of course, get no refuge until they had walked four miles along the range and reached the place where they prepared the shelter in the scrub. By this long pull the elder man probably became exhausted. Having been here before, he knew this was all the shelter he would get until the Summit was reached. He therefore remained, and the younger man left, probably about 4:30, when it

was still daylight. He would have reached the base of the cone about 5:30, before the lee had formed so far down this mountain; otherwise he could not have climbed so high as he did. He pushed off up the cone, and the higher he went and the later it got the colder it grew. I think he reached the place where he was found between seven and eight, by which time the ice had formed enough to prevent his climbing any higher. The surprise to me is that they did not appreciate the seriousness of this situation sufficiently to have taken a leaf from their notebook and left it in the bottle. I do not believe Ormsbee had any doubt but what he could make the Summit. "Only two miles more and only this rain to hinder—I can do it; what of it?" But as he went higher it became icy, which he could not have foreseen. As we came up the railroad that same night the first snow was seen near Jacob's Ladder, and the ice did not appear till we were near the Summit. So Ormsbee would have been on the cone before he met any snow, and I have no doubt he felt all the confidence that a powerful man would. Once on the cone there was nothing to do but keep going, and he made a gallant fight. It must have been early in the evening, for I do not believe a man of his experience would have left the shelter after dark."

The story was printed Wednesday in a Boston paper that Ormsbee's leg was broken and that when he was found it had been bound up, apparently by himself, with a branch of a tree. Although nothing of the kind was noticed by the persons who examined the bodies at the Summit, Dr. Gove and the undertakers were asked about it. Dr. Gove replied that neither leg was broken, and Wells & Brigham, the undertakers, telegraphed, in reply to a telegram from this office, "It was not bound in any way; was not broken."

On Thursday afternoon the Appalachians who visited Mount Pleasant found in the book in the Club's record cylinder this entry, doubtless the last written message from the two victims of the storm:

June 30, 1900
Wm. B. Curtis, A.M.C.
Allan Ormsbee.
Rain-Clouds And Wind 60 Miles.
Cold.

Unfortunately the writer did not think to write the hour of making the entry.

The time of their arrival on Mount Pleasant is pretty well fixed, however, by two woodsmen in the employ of Mr. Merrill of the Crawford House, who were at work on the bridle path on that day, who say that a little after 2 p.m.

they heard men on Mount Pleasant, the wind being in the direction to bring their voices where they were. They called in reply but got nothing which they considered a response.

It has also been learned that the two guides who went up with Rev. Mr. Nichols to the foot of the cone met Curtis and Ormsbee on the path and advised them very strongly not to go up, telling them how bad the weather was.

Thursday morning another link was added to the chain of circumstances by the finding of Mr. Ormsbee's glasses by Mr. T.O. Fuller of the Club.

"I was examining the place where Ormsbee was found," said Mr. Fuller. "Just where his head had pitched forward there was a hole which ran down probably two feet, and just at the point where I was told that his head lay I saw something that looked like gold wire. Reaching down and pulling it out I found it to be a fine pair of gold-bowed glasses. They are double concave glasses, so powerful as to indicate that he was very near-sighted.

"I also made barometrical measurements and found that Ormsbee reached a point within 130 feet in altitude of the platform of the hotel.

"Several of us have been today to the place where Curtis was found," added Mr. Fuller. "We are satisfied from what we saw of the place on our first examination, confirmed by our observation today, that the few stones on which Curtis's head lay had been newly placed there, so that his head might lie in an easier position. The ground where his body lay had been scooped out to make a little hollow. There is no doubt in my mind that they came to the shelter and rested a while and they must have proceeded together from the shelter until they got by the Lakes of the Clouds, where it is extremely windy, and that Curtis stubbed his toe on a rock that would weigh 100 pounds which lay in the path, and fell. I have no doubt Ormsbee laid him where he was found, placing him there as carefully as he could, and then pushing on for help. Although Ormsbee had never been here before he came straight for the top, and the point where he fell was in an exact line between the Lakes of the Clouds and the top of the mountain."

It should be added that Messrs. Weed and Coffin, who examined the body of Mr. Curtis immediately after Mr. Cutter found it, are equally positive that he lay face down where he fell, and never stirred from the spot, the bruise on the forehead resting directly on a point of the rock. They are therefore confident that Ormsbee was not with him when he fell.

It is doubtful if any more light can ever be thrown on the fate of Messrs. Curtis and Ormsbee.

For many years to come the true explanation of the undisclosed facts in the case will be sought with melancholy interest by those familiar with it, and no theory which will be advanced will ever be wholly satisfactory to every one. There remains but the indisputable fact of the brave struggle of two knightly souls, the one, who had in many years of activity done a good work for his fellow man by encouraging their physical development and helping to maintain a high standard of honor and manliness in a friendly rivalry; the other, an equally fine specimen of manhood, to whose sorrowing relatives it must always be a source of comfort to feel that he perished in a heroic effort to save his friend.

THE MOUNT WASHINGTON HOTEL

From The White Mountain Echo and Tourists' Register, *August 2, 1902*

For weeks before the opening of the mountain season to the present time when the White Hills are filled with guests from all the corners of the earth, the principal topic under discussion in office and parlor, at table and on the verandas of each and every hotel and cottage has been the opening of the Mount Washington, which the enterprise, love of his native state and the unlimited means of Mr. Joseph Stickney of New York, combined, have made a realization.

A little more than a year's time has passed since work was first begun on the great structure that is to carry off the palm of resort hotels in America, and a curious coincidence connected with its opening on Monday is the fact that on fifty years ago the same day the Summit House on Mount Washington was opened, which was the beginning of a new and prosperous era for the White Mountains of New Hampshire.

From the site of the Mount Washington, on a glacial moraine a third of a mile east of the Mount Pleasant House, is a wonderfully near and compelling view of the Presidential Range, and of the Crawford Notch as well, a combination that gives the Mount Washington precedence over any other hotel in the mountains so far as such a view combination is concerned.

The hotel itself, four stories in height with a frontage of 460 feet and overtopped by great towers, has accommodations that will please the most exacting and be as luxurious as possible in a hotel of this sort.

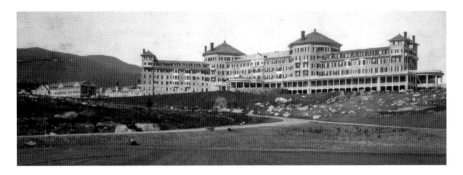

An early view of the grand Mount Washington Hotel at Bretton Woods. *Author's collection.*

Very little change was made in the original plans of the architect, with which most people interested are already familiar, the great work has been successfully and expeditiously carried on by hundreds of workmen under a corps of contractors of wonderful executive ability, as the fact that the hotel is now open so short a time after its commencement testifies.

The coming guest is driven up from the railway station and alights under the great porte cochere and enters the rotunda, which is beautifully decorated, and contains among other interesting features, an enormous fire-place, built entirely from stone selected on the grounds of the hotel. The number of colorings and variety in the stones furnishes an interesting half hour's study for the geologist, while others cannot but stop to admire its beauty.

Passing a number of small parlors and card rooms, one enters the ball room but will pause at the door spell bound for the moment at the beautiful sight of this, the largest ball-room in the country with its cream and crimson color scheme, electric lights half concealed by the cornice, the long galleries, separated by pillars from the main ball-room, thus giving the spectators an opportunity to watch the dance go on without feeling in the way or being subjected to the draught from the large ventilating windows at the top. The stage at the extreme end of the music-room is another feature, and back of it is a great landscape window, which gives opportunity to admire the hills at the same time, with the Crawford Notch in the distance and a bit of pastoral scenery in the foreground.

Behind the office is the great circular sun parlor, from which the finest view of the Presidential Range is obtainable. The wide veranda skirting the house affords a delightful opportunity for a promenade, and a new view greets the eye at every turn.

The large dining-room with its great landscape windows and galleries above, is a beautiful room and not the least pleasant feature in connection with it is the fact that it is quite cut off from the kitchen by a passageway with swinging doors that open and shut automatically, making the entrance and exit of waiters easy and keeping the odors from the kitchen entirely away.

It would take much time and space to enter into every detail of the admirable arrangement of the kitchen, serving and store rooms, but suffice it to say that the facilities for the storage of food and for preparing it as well, are of the most modern character, and that the ventilation could not be improved. There are eleven cold storage closets, a great dish-washing machine, mammoth ranges large enough for a house twice the size of this, and in short, every up-to-date appliance that experience and ingenuity could suggest. The crockery, made to order for the hotel from a special design, is green and white, with a handsome monogram.

A unique feature is the fern garden, which, on the ground floor, is reached from the banquet and dining-halls; also from the ladies' cafe and billiard rooms, as it is situated in an angle between the two wings. An electric fountain will play in the evening, in the midst of a wealth of ferns and green foliage.

The spacious offices and accommodations for transacting the business of the house are worthy of a special mention.

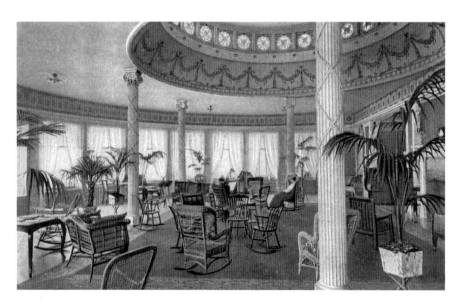

A postcard view of the interior of the Mount Washington Hotel. *Author's collection.*

It is in the basement, however, that the most novel features of the house are found, and the swimming pool, 20x65 feet, ranging in depth from four and one-half to seven and one-half feet, tiled in white, and the temperature raised by the introduction of a steam-pipe running about the bottom of the tank and guarded by a brass rail, will be, perhaps, as popular as any.

Then there are spacious play-rooms for the children, bowling alleys with deadened walls, men's cafe and grill-room, barber shop, porters' and baggage-rooms, photographer's room, and rooms for Turkish baths and masseur.

In the sleeping-rooms the exquisite taste that characterizes the furnishing of the hotel is carried out in the furniture, carpets and wallpaper, the latter artistic in design and dainty in coloring, with a large variety in the treatment. Blondes may have their blue, while the brunette will find a charming background in those hung with red, and there are combinations legion in the suites. Best of all are the great closets with plenty of hooks, room for the largest Saratogas and clothes poles for milord's wearing apparel. The baths are beautiful, with porcelain tubs and Tennessee marble bowls and glistening nickel-plated fittings. The furniture is very artistic, and the beds are about equally divided between brass and wood. Nearly every room has a mountain view and some of the suites have views on three sides. The doors are of mahogany and the woodwork of white enamel fireproof finish. Nearly every room has connecting bath, and the suites in the central tower will compare in size and elegance of appointment with those of any hotel in the world.

Between the central and western towers is the roof garden, where a most beautiful promenade may be enjoyed, and a panoramic view of the surrounding country be had from this lofty height.

In short, no feature that could be thought of has been omitted, and the Mount Washington will not only be the pride of the mountains but of all New England as well.

Mr. John Anderson has transferred his quarters to the new hotel, but Mr. Price will continue to reside at the Mount Pleasant, where he will be on hand to welcome the coming and speed the parting guest.

The heads of departments and officials will be as follows: Superintendent, Mr. G. Butler Smith; room clerk, W.S. Kenney; front clerk, James Goodrich; night clerk, C.D. Abbott; cashier, Henry L.E. Smith; secretary to Mr. Anderson, Miss Sawyer; chef, Louis Valet; steward, H.W. Chesley; head waiter, Andrew Fitzgerald; second head waiter, Karl Brackett; head bellman, Harry Annen; general stenographer, Miss Dean.

Much work still remains to be done in the perfecting of the grounds, but under the direction of the efficient landscape architect it is progressing very satisfactorily, and the results already attained are eminently pleasing, while pointing to a splendid effect when finished, as the natural beauty of the place will be preserved by the leaving of the large boulders and the planting of trees upon the hill.

A word should be given to the water supply, which, taken from a point several miles from the house toward the base of Mount Pleasant gives a fire protection unequaled in this section. A recent test was made of the hydrant streams, which were thrown higher than the roof by gravity pressure, without the use of the fire pump. The supply throws fourteen one-and-one-half inch streams to this height. The direct pressure from the reservoir is 135 pounds to the square inch.

On Monday noon, with the boom of artillery and the flaunting of flags, the doors of the Mount Washington Hotel, the youngest and the comliest of the White Mountain hotel family, were swung wide for the waiting guests and the fruition of two years of constant structural labor in the heart of the Bretton Woods was accomplished.

To the credit of the builders and the management the opening occurred exactly as scheduled—on date, July 28.

Among the first to enter the new house were Mr. Joseph Stickney, whose enterprise and capital have made possible the erection of the finest and largest summer resort hotel in the United States; Mr. John Anderson and Mr. J.D. Price, managers for Mr. Stickney of the Mount Washington and the Mount Pleasant hotels. The first to register was Mr. Clarence W. Seamans, of Wyckoff, Seamans & Benedict, of New York, an old patron of the Mount Pleasant House.

Through the afternoon, the porte cochere was the mecca for hundreds of carriages, brakes and coaches, coming from far and near. At dinner, the handsome semi-circular apartment was filled, fully 250 sitting down to the evening meal. On an adjoining banquet hall, the host was Mr. Stickney himself, who spread a feast fit for the gods and called on all his faithful servants in high places to receive his congratulations. These gentlemen, whose energy and fidelity had made possible the opening of the hotel on schedule were the guests:

Charles Ailing Gifford, William Paul Gerhard, Charles E. Knox, William G. Phillips, B.F. Robinson, E.A. Richardson, Anson S. Rice, Mr. Locke, Ray T. Gile of the construction staff; C.H. Merrill, O.G. Barron, Governor Chester B. Jordan, John Anderson, J.D. Price, G. Butler Smith, L.H.

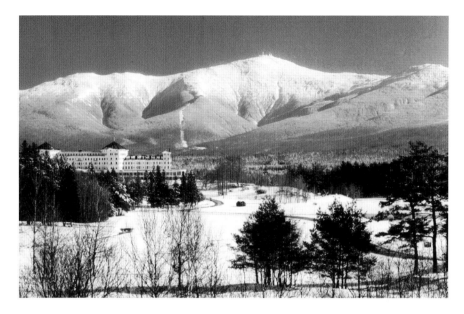

The historic Mount Washington Hotel and the Presidential Range as seen from Bretton Woods. *Photo by author.*

Bingham, Dr. J. Blake White, George E. Cummings, James J. Parks, George Lane and William G. Hannah.

In the evening, the magnificent ball room was the fitting setting for 300 of the gorgeously gowned, who came to an informal hop. Preceding the dancing, there was a brief concert, at which Mrs. Jenny-Corea-Bunn sang an appropriate selection composed for the occasion, and Prof. J. Rayner Edmands of Harvard read a dedicatory poem of his own writing. The Virginia reel of sixteen couples, led by Mr. Stickney and Miss Amy Phillips was a merry finale to the day's jubilee.

Mr. Stickney has reared a monument which has not only perpetuated his name for many years to come in the White Mountains, but he has established an enterprise in the hotel line that will be of the greatest benefit to the mountains and to New Hampshire and her citizens as well, and which will go a step farther toward perpetuating the grand old name of the builder of our Nation—"The Father of His Country."

THE ASCENT BY RAIL

By Frank H. Burt

From Mount Washington: A Handbook for Travellers, *1904*

Arriving by the early trains from every part of the mountain region, visitors bound for Mount Washington on a single's day trip find themselves at Fabyan's, seven miles from the base of Mount Washington, about 9 a.m. The Union Station of the Boston & Maine and Maine Central Railroads is a general railroad centre for the mountain district, and the early morning finds express trains coming and going in rapid succession. Passengers going up for the night usually plan to reach Fabyan's by one of the express trains arriving in the afternoon from Boston, Montreal, Quebec, or Burlington. The trip between Fabyan's and the Summit occupies one hour and fifty minutes.

The Fabyan House, near which the Fabyan station is situated, is within a few rods of the spot where stood the first White Mountain hotel, opened in 1803; and the site has been occupied by hotels during the greater part of the century that has passed.

The train which runs between Fabyan's and the Base Station is made up of observation cars, and is backed up grade by its powerful locomotive, so that the passengers have uninterrupted views of the great range, yet have no annoyance from cinders or dust. The ascent from Fabyan's to the Base is 1,200 feet, the maximum grade being 316 feet per mile. This, it should be remembered, is an ordinary surface road; but a single engine easily pushes three loaded cars up this unusually heavy incline.

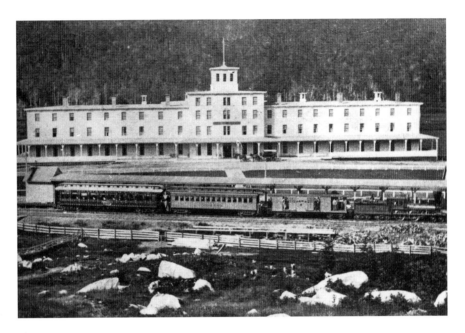

The busy rail junction near the historic Fabyan House at Bretton Woods, where the rail journey up Mount Washington began years ago. *Author's collection.*

"Train for Mount Washington!" is the announcement to which the waiting passengers at Fabyan's eagerly respond as the observation cars appear in front of the station. The seats are speedily filled, a photographer takes a quick view of the train and passengers, to be ready on their return, and the start is made. There is a stop at Bretton Woods, half a mile east of Fabyan's, to take passengers from the two hotels, the Mount Pleasant and the Mount Washington. Then the train turns to the left, passing Lake Carolyn, and moves toward Mount Washington, which now stands directly before us, supported by its brother peaks at left and right. The track of the Mount Washington Railway may be seen for two-thirds of its length from base to summit.

After a run of a few minutes through the forest the train slows down to give a view (to the left of the track) of the Falls of the Ammonoosuc. For a distance of several hundred feet the swiftly dashing stream has worn a gorge in the solid rock, leaving great basins and fantastic formations, over which the river pours in its headlong rush.

On our left are the high ridge of Mount Dartmouth and the smaller peak of Mitten Mountain, the latter separated from Mount Jefferson by the high pass known as Jefferson Notch.

This stereoscopic image depicts a foot bridge over the falls of the Ammonoosuc. *Author's collection.*

A long stretch of straight track takes the train directly toward Mount Pleasant, whose graceful dome rises higher and higher as you approach it. A solitary highway crossing is noted on this portion of the route, where the track crosses the Jefferson Notch Road, built in 1901–02 by the State with the co-operation of the hotel proprietors and others interested in the mountain resorts, and extending from the Crawford House to Jefferson Highlands.

At the Base Station the trains of the Mount Washington Railway are awaiting the arrival of the passengers, who quickly change from the observation cars to the small closed cars of the cog railway. The Base is a lonely little settlement lying directly at the foot of Mount Washington, shut in at the north by a spur of Mount Clay and at the south by great parallel ridges coming down from Mounts Monroe, Franklin, and Pleasant.

There is a group of railway buildings, including carhouse, repair shops, boarding-house, etc., and a colony of perhaps fifty people whose presence is necessitated for the operation of the railway. The spot is about 2,700 feet above sea-level.

The trains for the Summit are made up of one car to an engine, the locomotive pushing the car before it and backing down the mountain ahead of it. The cars carry about forty passengers each, and as many trains are run at a trip as travel demands, starting at intervals of three or four minutes. The mountain locomotive is a curious little affair, with boiler tilted down so as to preserve an average level on steep grades. The earliest locomotives had upright boilers, a style which was abandoned after a few years' experience.

A few minutes' ride brings the train to a trestle bridge over the Ammonoosuc, now diminished to a small mountain stream which dashes down a rocky bed. It was at this point that the building of the first section of the railway began, in 1866. The nearest railroad station was then at Littleton, twenty-five miles away; and every bit of material, including the locomotive and cars, had to be hauled through the woods by ox-teams. Indeed, up to 1876 the passengers for the mountain were brought to the Base by coach. The original railway buildings were clustered about a three-story, unpainted

and unclapboarded "depot," with sleeping rooms above for the employees. On the hillside was a boarding-house, the Marshfield House, the place being known as "Marshfield," in honor of Sylvester Marsh, the projector of the road. The name was too pretentious for the spot, however, and the "Base" it always has been called and will doubtless remain.

In 1876 the road was extended down grade a third of a mile to meet the branch built that year from Fabyan's. The old buildings were burned in the spring of 1895.

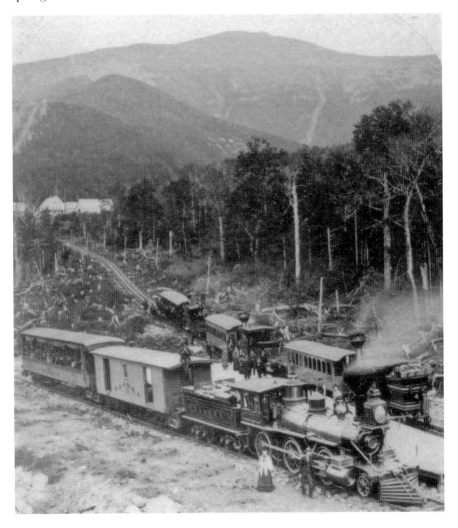

Passengers bound for the summit switched trains at the Cog Railway base station. Here, three Cog engines sit idly by as passengers make the transfer from a Boston & Maine train that has arrived from Fabyan's. *Author's collection.*

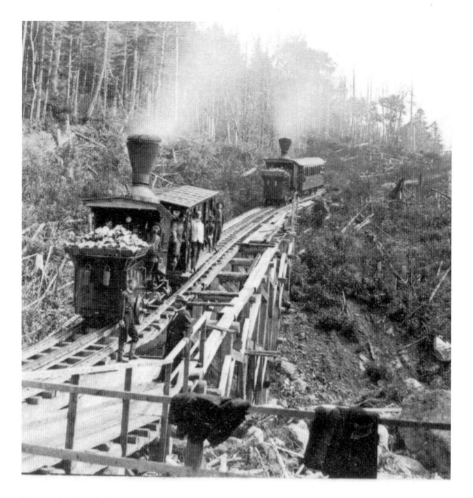

Two early Cog Railway locomotives begin the long ascent to the summit. These upright boiler engines actually predate Burt's article by some thirty years. *Author's collection.*

Crossing the bridge and making a slight turn, we see a slope, nearly a mile long, up which the track ascends at a grade which from this point of view is startling. When near the brow of this pitch—known as Coldspring Hill—we are climbing nearly 1 foot in 3. Far above us the track is seen winding upward above the tree line, and we now begin to discern the varied surface of the upper portion of the range, which looks so smooth from below. Thus far the forest keeps us company, though the railway location is cleared some rods on either side of the track, giving a steadily widening view of rare beauty as we go upward. The spruces and firs of the adjacent forest are intermingled with birch and other hard woods.

Over the brow of Coldspring Hill is the "Waumbek Tank," where the first stop for water is made. A few minutes are allowed us to step out and enjoy the view. We look down into a vast valley, embracing the region of Fabyan's and Bretton Woods, the range which includes Mounts Deception, Dartmouth, and Mitten on the right, and the Rosebrook Range before us. Bethlehem, some twenty miles away, is seen in the west, and far beyond it, with steep sides and flattened top, the noble peak of Camel's Hump in the Green Mountains. Over the Rosebrook Range there rise in succession Mount Hale, the North and South Twins, and Lafayette. The peaks of Monroe, Franklin, and Pleasant are now our near neighbors on the south, and gain in impressiveness as we approach nearer to their level.

Once more in the car and moving upward, we soon see marked evidences of a change of climate. The trees are shorter and shorter, and many are hung with moss, such as is seen in tropical forests. "Half-way up," the conductor tells us, as we pass a trackmen's shelter by the side of the railroad. Now we are above the forest, save only for the scrub spruces; and we look to the left into Burt's Ravine, which lies between us and a spur of Mount Clay. There is a descent of perhaps 1,000 feet to the floor of this ravine, which was named in 1901 by the county commissioners of Coos County in honor of the late Henry M. Burt, the founder of the newspaper, *Among the Clouds*, printed at the summit.

Now the view unfolded toward the north-west embraces the village of Jefferson, prominent in which are the Waumbek Hotel and its surrounding cottages. Over Jefferson rises the long and conspicuous range comprising Mounts Starr King and Pliny, along whose base a straight highway stretches for several miles, guiding the eye from the Waumbek to the village of Jefferson Highlands, only a few miles from the foot of the Presidential Range. In the broad valley between us and Jefferson glitters Cherry Pond, whose square-cut borders command the notice of every visitor. The valley of Israel's River extends westward to join that of the Connecticut at Lancaster, beyond which we look far into Vermont. Among the nearer mountains in the latter State we note two more sharp peaks of moderate height, but remarkable symmetry, about in line with Cherry Pond,—Mounts Burke and Umpire. Far beyond them is the striking serrated ridge of Jay Peak, near the Canada line. Turning more to the left we see over Mount Dartmouth the massive Cherry Mountain, and many miles beyond, along the horizon, grand old Mount Mansfield, Vermont's highest summit.

But we should leave the distant view and look at our immediate surroundings. The trees have given place to scrub. Now we pass a belt of

dead trees, bleached to the semblance of bones by exposure to unnumbered winters. Rough rocks, overgrown with lichens, cover the larger part of the surface, interspersed with coarse grasses and sedges and alpine flowers.

A sudden angle in the track brings us upon Jacob's Ladder, the longest and highest trestle on the road, about 30 feet high, 300 feet long, and rising with a grade of 13½ inches per yard, equal to 1,980 feet per mile, or 37.41 per cent. No higher grade exists on any cog railway in the world save that up Pilatus.

Just at the foot of the Ladder you note the traces of a path, which has been in view for some minutes at our left, running parallel to the railroad, and which here crosses the track to mount a rocky crag at the right. Opened

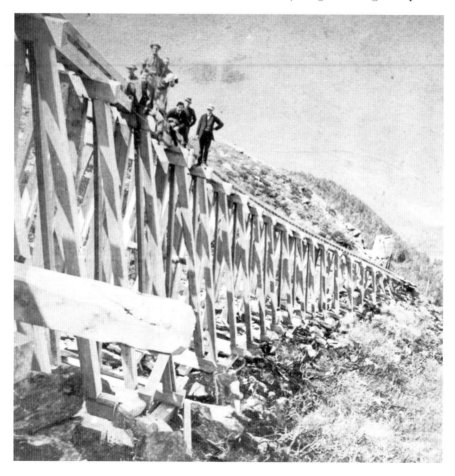

Posing for a photo on Jacob's Ladder, with its 37 percent grade, the steepest on the Cog Railway line. *Author's collection.*

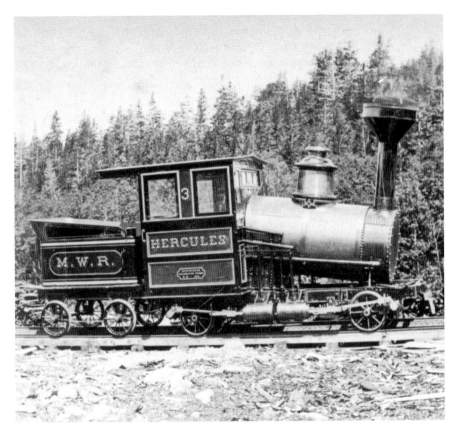

For many years, the engine named Hercules was a mainstay of the Cog rail line. It was built by Manchester Locomotive Works in 1874. *Postcard view, author's collection.*

by Ethan Allen Crawford in 1820 or 1821, this was the second path up the mountain; and the name "Jacob's Ladder" was given to the ascent of the steep crag referred to thirty or forty years before the building of the railway. Made passable for horses by Horace Fabyan soon after 1840, it became known as the Fabyan Bridle Path.

Look quickly to the right as you cross the Ladder, and you see the beginning of the Ammonoosuc as it pours its rapid torrent down from the Lake of the Clouds. Monroe, Franklin, and Pleasant are about on a level with us.

For the next half mile the train toils steadily upward, still skirting the edge of Burt's Ravine, until it draws toward the ridge which joins Mount Washington to Mount Clay. All at once a sharp peak rises above this ridge. It is the apex of Mount Adams, the sharpest summit in this region. A moment later the lesser peak, known as Sam Adams rises at its left;

then, nearer, between Sam Adams and Clay, the symmetrical summit of Jefferson. Now, at the right of Adams, there rises a lower but more graceful mountain, Mount Madison, the fourth in height of the Presidential Range. Clay, Jefferson, Sam Adams, Adams, Madison,—this is the order in which they stand as you go from Washington. Swinging to north and north-east, this magnificent range is easily the grandest feature of the view.

Soon we look into the depths of the Great Gulf, which is hemmed in by the encircling wall of the Presidential Range, and into which we see the rocky precipice of Mount Clay descending nearly 2,000 feet. At the right of Madison flows the Androscoggin through the peaceful Shelburne meadows, while far northward lie the waters of Umbagog and the Rangeley Lakes, watched over by the mountains of Northern Maine.

A second stop for water is made at the Gulf Tank; and the conductor escorts passengers to the edge of the Gulf, giving them their first scramble over the rocks and their first breath of the stimulating mountain wind. Looking down into the depths, they see the tiny Spaulding's Lake, named for John H. Spaulding, an early landlord of the Tip-Top House. In July their eyes are often refreshed with a glimpse of snow banks on the lower slope of Mount Clay, Mansfield, and another on the eastern side of Mount Jefferson. With this suggestion of an Arctic climate they are ready to enjoy the nonsensical nickname of this gorge, which has amused visitors for half a century,—the "Gulf of Mexico."

Growing profusely among the grasses under your feet is the little white blossom of the Greenland sandwort (*Arenaria Graenlandica*), a veritable Arctic flower, of which Dr. Isaac I. Hayes, the explorer, says that it "only disappears in Greenland at latitude 80°," while it is found as far south as the mountains of North Carolina. It is the most abundant of all flowers found on the mountain.

The Summit House is now in sight, and we will be there in eleven minutes. At the left is seen the carriage road from

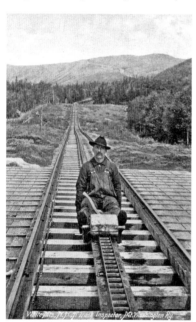

A Cog Railway "track inspector" rests atop a slideboard in this vintage postcard view. This contraption was also known as the "devil's shingle." *Author's collection.*

the Glen House, following the edge of the Gulf. One or two large water tanks are passed, these being reserve supplies to guard against drought, which is sometimes felt in mid-summer, even so near the clouds as on this mountain top.

Rounding the last curve before reaching the top, we see on our right the memorial of a tragedy of nearly half a century ago,—the monument of Lizzie Bourne, who perished from cold and exhaustion while climbing the mountain from the Glen House, September 14, 1855.

We have now turned toward the south-west for the last sharp rise. From the left-hand windows we have a hurried look across a vast sweep of mountain and valley, extending across the State of Maine until the eye falls on the Atlantic Ocean. But there is no more time for an outlook; for in a moment the ascent is finished, and the train stops on the platform in front of the Summit House.

THE LAST CLIMB OF OLD PEPPERSASS

By Winston Pote

From New Hampshire Profiles, August 1960

When it comes to photographing Mount Washington, few who have ever aimed a camera at the mountain can match the work of this well-known professional. Winston Pote's (1899–1989) magnificent pictures, taken at a time when Mount Washington was gaining notoriety for its spring skiing in Tuckerman Ravine and its weather extremes, aptly captured the era between 1925 and 1945. The Massachusetts native, who lived in New Hampshire for the last fifty-two years of his life, produced many stunning aerial shots of the Presidential Range at a time when few such shots were being taken. He was a frequent contributor, both as a writer and photographer, to the popular Granite State publications New Hampshire Troubadour *and* New Hampshire Profiles.

One hundred years ago, when the first climb of Old Peppersass was only an ambitious dream, Sylvester Marsh, a native of Campton, applied to the state of New Hampshire for a charter to build the Mount Washington Cog Railway. He got it in 1858, after much ridicule. One legislator suggested he be given the right to build his railway to the moon if he wanted. The public was equally amused, and no one but Marsh himself took the project seriously.

The rack rail and the cog locomotive were his own inventions, and for the next twelve years he devoted his own capital and a great deal of energy to carry them from patents to actuality. The first mountain-going locomotive was built by Campbell & Whittier of Boston, shipped to Littleton, the nearest rail point, then hauled 25 miles to Mt. Washington piecemeal by ox teams.

When it was assembled, it was quickly nicknamed "Peppersass" for its resemblance to an old-fashioned peppersauce bottle. The "bottle," or boiler, with its flared smokestack, was mounted on trunnions to keep it vertical regardless of grade. The locomotive had no cab and only a single pair of cylinders. A wood-burner, it was designed with the cog-wheel at the front to pull itself up the steep incline.

Finally, in August 1866, a test run over the first quarter mile of track proved entirely successful. Railroad men and the public were equally impressed by Marsh's invention and his enthusiasm. From that point on, work progressed rapidly. A company was organized to build the road, and on August 14, 1868, the track was completed to Jacob's Ladder and the railroad formally opened.

Those early trips with passengers were so popular that the completion of the road was rushed with all possible speed. It was finished on July 3, 1869 when the first passenger rode to the summit on a load of lumber. The beginning of paid passenger service was the next day.

It was a great vindication of "Crazy Marsh" and an equally great accomplishment in terms of back-breaking man-hours. The track climbs an average grade of 25 percent, or over 1100 feet per mile. It is three and a quarter miles long, laid partly over a trestle of varying height. Aside from the timber in the trestle itself, all the material—rails, cars, locomotives—were hauled in from Littleton as Peppersass had been, by oxen and horses.

So, here on Mt. Washington's 6284 feet above sea level was the first mountain-top railroad terminal. Subsequently Marsh's inventions served as the pattern for similar railroads in Switzerland and on Pike's Peak, Colorado. All proved equally safe.

Sixty years later, long after Old Peppersass had become a museum relic, the same old locomotive was returned to Mt. Washington for one last trip over the cog road—with disastrous results. During the descent over the long trestle just above Jacob's Ladder, the cog mechanism snapped, Peppersass careened down over 2000 feet, and jumped the track from a reverse curve. One man was killed, and four others jumped for their lives. The writer was one of those four.

It was a tragic trip—one that never should have been made. Yet strangely enough, this is a story that has never been properly told. July 20, 1929, and the newspaper accounts of the day ran such headlines as "Old Peppersass Explodes!"

This first engine had an active lifetime of only twelve years and was discarded as worn out before 1877. During its early years, when it was

used to push building materials up the completed portion of the track on a flat car, it had no tender. Apparently wood for fuel was picked up along the way.

During its early years of passenger service, Peppersass was accompanied by three other vertical-boiler locomotives of an improved type, with an enclosed cab and a much larger cog wheel working in the rear, which gave more speed. Peppersass would travel only two miles an hour. Then in 1878 the road adopted a fleet of much improved horizontal boiler engines, and the original locomotive was retired.

In 1893 it was exhibited at the Columbian Exposition in Chicago, and for eleven more years it remained in that city in the Field Museum. In 1904 it was displayed in St. Louis and then went on to the Baltimore and Ohio Railroad and was lost in obscurity for 23 years.

It was the late Rev. Guy Roberts of Whitefield—who in 1916 had come to the rescue of the crumbling Old Man of the Mountain at Franconia—who took the initiative in the twenties in finding Old Peppersass and returning her to her rightful home.

Over a period of two years, following 1927, the locomotive was shipped to New Hampshire and put into the Concord, N.H., repair shops of the Boston & Maine Railroad, who owned the Cog Railway at that time. Here she was thoroughly overhauled and redecorated in gay colors, under the eye of E.C. "Jack" Frost, who was to be her engineer on the trip up Mt. Washington.

According to Frost, some trouble was experienced in getting up steam during tests. The water foamed! The repair crew bored a hole in her wrought iron boiler in an attempt to find the cause of this strange phenomenon. They discovered the boiler half filled with nuts and cherry stones, stored there by squirrels, some fifty years before when the locomotive had been on display at Bretton Woods.

The repair crew also found it necessary to weld part of the frame which held the forward wheels and the drive shaft—worthy of note in view of what later happened. It should also be emphasized that the cog wheel of this earliest engine was much smaller than more recent models and could more easily jump the rack rail.

During this period of repair, elaborate plans were made for the return of Old Peppersass after her 36 years of wandering. A temporary grandstand and speakers' platform were constructed at the Base Station. Everything was gay with flags and bunting. The gala day was set for Saturday, July 20, 1929, with 500 guests officially invited, including the governors from six other states. The original intent was to run Peppersass a few hundred yards

up and down the track, but engineer Jack Frost had his heart set on taking her for one last trip to the summit.

The day was perfect—clear, warm, and without wind. Thousands of spectators turned out. Regular trains were cancelled, and six were decorated and waiting to carry the invited guests to the summit, which could be seen clearly above us. The Whitefield band was there, and photographers and correspondents from every important newspaper. At least four newsreel companies had cameramen on hand, so arrangements were made to have them shoot pictures of Peppersass from a flat trailer car in the rear of the last train.

The exercises took place at two o'clock, with Col. Barron of the Crawford House presiding as toastmaster. He had obtained a bottle of water from the Lakes of the Clouds to christen the engine.

At the proper moment Old Peppersass came chugging up the track, blowing her whistle in answer to the cheering thousands. Engineer Jack Frost and fireman William Newsham were dressed in bright red shirts and tall beaver hats.

Governor Charles W. Tobey officially received the locomotive for the state of New Hampshire, and she was christened by President George

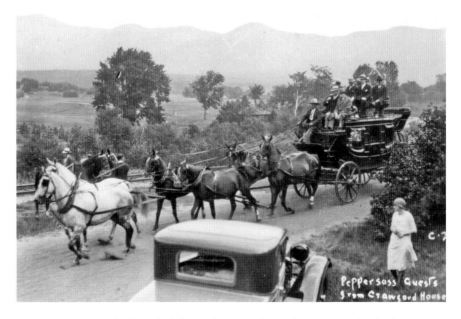

Guests from the nearby Crawford House depart via horse-drawn wagon for the Cog Railway base station to witness what would be the last run of Peppersass. *Courtesy Littleton Area Historical Society.*

Hannauer of the B&M. Soon after, the six cog trains were loaded to capacity with guests and there was a scramble for space on the small trailer car for photographers. I managed to squeeze in behind the newsreel cameras and altogether too many folding camp chairs.

I had arrived on the scene a bit late with a friend and no certain plans for going up the mountain. With me I carried a Graflex camera, a doctor's leather bag full of extra lenses and film, and a Filmo movie camera.

It was not until I found myself on the flatcar that I realized that the lunch was still locked up in the car and that my keys were in my pocket. In my haste to get pictures of the ceremonies I had not taken time to eat, and now there would be no food available for several hours. The fact of my increasing hunger was to be a fateful one in the decisions I made that afternoon.

The cog train we rode climbed as slowly as possible in an effort to keep the slow moving Peppersass within camera range. All of us were trying to get pictures at once, some hopping off and on our train and even hitching rides on the old locomotive for an effective close-up. For it was hard to hold a camera steady, what with the jolting of the cog wheel.

Our train made frequent stops, since no one knew how far Peppersass would attempt to climb. At the first water tank an official appeared to signal for her return, but Frost continued on upward with her to the Halfway House, a small building near the track. There she stopped for more wood, which was quickly loaded onto the queer tender. And again she continued upward instead of starting back down as we half-expected she would. After she had climbed a few feet, we distinctly heard a loud bang.

"That doesn't sound so hot!" said a newsreel camera man. There was no further comment about it, but I was to hear a very similar sound on our descent.

Another quarter of a mile, perhaps, and we crossed Jacob's Ladder with Peppersass following slowly in the distance. Engineer and fireman were busy waving those tall hats and blowing the whistle which made little white puffs in the almost calm air. A perfect day for the festivities!

Above the trestle we stopped again, and Rev. Guy Roberts climbed off accompanied by at least one photographer. I decided to do the same and try for a different picture, but my Graflex had slid under all those chairs and feet, and I couldn't get to it because of the angle of ascent.

Even so, I had half a mind to hop off and recover the camera later, as the train started. But the thought of possible difficulty in boarding a crowded train or walking down on an empty stomach caused me to stay aboard.

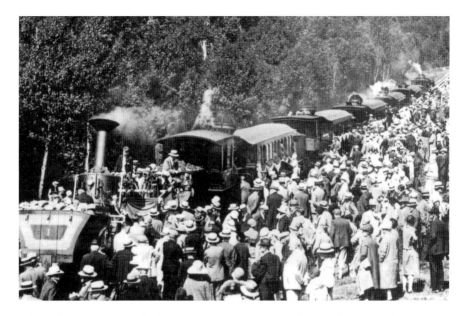

A large throng gathers at the Cog Railway base station to celebrate the return of Peppersass. *Winston Pote photo, author's collection.*

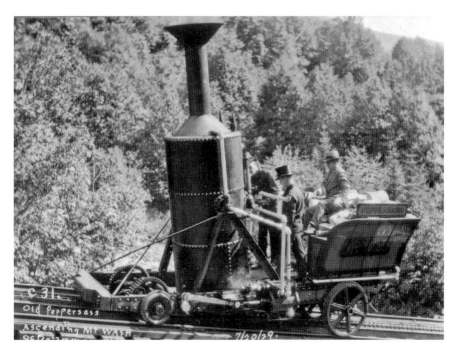

Peppersass embarks on its fateful July 29, 1929 run up the mountain. *Courtesy Littleton Area Historical Society.*

That decision cost me what might have been the most dramatic movie sequence of my career, for shortly after Peppersass flew by this spot completely out of control. It also almost cost me my life. And—ironically—the only thing that went to the bitter end with the old locomotive was my Graflex!

The procession continued upward over "Long Trestle" to the Gulf Tank, where Peppersass stopped to take on water. I remember that they filled it so full it ran over. More pictures were taken of the process, and I climbed out with all my gear. When my train moved off toward the summit, only a short distance, now, I did not rejoin it but stayed watching the old locomotive.

Frost had evidently received orders to take her back down, but still he waited, looking longingly upward as though his goal were fading away.

By now it was five o'clock, and the absence of that lunch was becoming serious. The thought of a hike to the summit with all that gear became less inviting by the moment. If I rode back on Peppersass, I might get a few more interesting shots, and at least there would be lunch in the car. All the movie film had been exposed, but I could re-load on the way down.

As I watched, Peppersass took on two more passengers—the engineer's son Caleb, a boy of sixteen, and Daniel P. Rossiter, who was official photographer for the railroad.

Still I made no move to join them, even as the old engine started steaming slowly down the moderate grade of the area. Then, annoyed at my own indecision, I grabbed up my equipment, and, with both hands filled, tried to run over the rocks—a strange chase after a strange engine.

It was only moving at two miles an hour, so I was sure I could catch up. Yet twice I stopped, as though to give up. It was as though there were some restraining force holding me back. I chalked it up to an empty stomach and ran on, catching it at last. Frost stopped, reached down with a helping hand. Then, with a clank and a roar of steam, we were off down the mountain.

My first need was to load the movie camera. I had done it on a moving dog sled and on a speed boat, but this jolting conveyance was the worse yet. Young Caleb Frost lent a hand, and together we struggled with the camera on the pile of firewood, which was taking up most of the room. We got it finished just as the engine reached the steeper grade.

Watching Peppersass from above, I hadn't realized how noisy and rough she was, once in motion. Conversation was limited to brief shouts. Engineer Frost stood by with a huge oil can and used it when his aim was good. Newsham, the fireman, tossed a chunk of wood into the flaming firebox.

Here were two fine closeup shots, and I shouted into Frost's ear that I would like such pictures if he could stop. It was impossible to hold the camera steady otherwise.

"You can get that at the base"—I could just make out the words. At that point we reached the top of Long Trestle, and I could hear the engineer's words as he yelled to Newsham: "How do you like the looks of that!" I was not alone in feeling apprehensive about this ride.

We passed two climbers who waved....Down we dropped—a different kind of jolt, now....Rossiter sat holding his camera, near the doorway. My equipment was scattered on the woodpile....What a fine, clear day, I thought—and how hungry can you get....

There was a loud sledge hammer crack. We seemed to bounce a bit and lurch to one side. As we picked up speed, there was an ominous grinding sound. Frost grabbed the old hand brake wheel, which spun loosely and seemed to have little effect. I could see his mouth opening, shouting *Jump, Jump!* I'm sure I didn't hear the words, so terrifying was the clatter.

Struggling to the woodpile, I grabbed the bag of film and lens equipment, carefully threw it out the doorway, and watched it roll over on a grassy place. I should have gone with it. Caleb was the only one with presence of mind to jump this soon and got away with only a torn shirt from the bushes that cushioned his fall.

The brake must have been holding partially; we were not going more than fifteen miles an hour—but it was unpleasant. The engine rocked violently, and pieces of flaming wood and embers flew from the firebox. Afterward I found burnt holes in my clothing. Rossiter still sat with his camera.

I lurched back to the woodpile and reached for the Graflex. It was in a far corner, and as I went after it I found myself looking at a breathtaking view of Jacob's Ladder. Still thinking of pictures, I forgot the Graflex and grabbed the Filmo, tightening the wrist strap.

But we were going too fast now. Then something else gave way, and we started to roll freely, a sudden drop, like a high speed elevator. Any braking action was gone.

(I believe an axle had broken at this point, the ends of it dragging on the ties which were splintered for a long distance. Later I saw a trainman with one wheel and part of the axle wrapped in newspaper, showing an old progressive break.)

I was sure the old engine would tip over. And the sensation—an all gone feeling, as trees and rocks whizzed by. Engineer and fireman hung on in the doorways, on opposite sides, looking for a soft spot.

Down we rushed—first a deep hole in the mountain, then rocks all blurred, near the track. As I jumped from the woodpile, I caught one toe on the Peppersass sign. So it was head first, a dive instead of a jump, with no sensation of falling, only of speed.

Sky—rocks—sky—then a huge rock looming up for a landing. I tried to throw my head back to protect my face.

Stars I saw plenty, but I remember better seeing the engine like a comet with a long tail of steam. I seemed to be on my feet, but there was no camera. An eye witness said I immediately jumped up and pulled a handkerchief from my pocket.

I knew I had a broken jaw, because I could hear the bones rattle! I tried to find the camera, but something was wrong with one knee. I was very close to Jacob's Ladder, and some time later remember seeing the engine's smokestack under it. It was here that Rossiter had dropped off, or was thrown, after hanging on the tender with his camera.

He was killed instantly. The engineer and fireman suffered broken bones but recovered, in time. Frost had made a miraculous 30-foot jump on the high ravine side.

Old Peppersass had shot off the track on a reverse curve just below Jacob's Ladder, the wrought iron boiler bouncing over the rocks and into the scrub trees, with only a few dents to show for it. The ash pan remained on the tracks and slid over 900 feet, almost to the Halfway House.

The events that followed are a blur of excitement and confusion. I remember a hiker hurrying down with my black bag…Hunting for my lost movie camera, a painful process. The next day, I found I had a fractured knee cap. The jaw fracture was compound. I walked around holding it together with my hand because it felt heavy. And somehow I hiked far enough up the mountain to get a lengthy ride back down again when the excursion trains descended.

No one on these trains had realized what had happened, of course, until they came to the Peppersass fireman and engineer sitting beside the track. They pulled me up the high step, but I refused to sit inside if they were going on down and stayed on the back platform trying to answer questions for a newspaperman.

Before long they descended to the damaged section of the track where further descent was impossible. So it would be essential to go back up the mountain and down the auto road. But there was no water here and not enough steam for some of the trains. We waited for hours, the area swarming with people, some walking down, many waiting for an eventual return to the summit.

There was a good sunset. A trainman arrived with my movie camera, not badly damaged.

Much later the upper two trains made it back to the summit. The hotel was packed with guests—all staring at me. I was told later that my head had swollen up like a balloon. I couldn't swallow milk. If only I had eaten that lunch!

Newspaper men fought over the use of the telephone, and one of them pulled out the wires. Frantic news—the engine was not to be seen, so it must have exploded!

I continued to hold my jaw together manually until I arrived at a hospital at 1:00 the next morning.

They say the following day the mountain was like an ant hill, with souvenir hunters carrying away anything that was light. Fortunately, most of the engine pieces were heavy. The steam gauge went across the Presidential Range, while the whistle found its way into Pinkham Notch. The only thing that remained on the old engine was my Graflex—and pieces of that eventually turned up at the University of New Hampshire. I never did find the lens.

Before the summer was over, the parts of Old Peppersass were assembled in the Concord repair shops, and eventually it was placed on display at the Base Station, where it may be seen today. It should never have gone up the mountain that day, nor was the trip planned officially. It was a relic of the past, far different from the modern trains with their perfect safety record.

Many photographers went up Mt. Washington July 20, 1929, looking for special pictures. All of us missed the big one. However, I had the fastest ride on the slowest locomotive ever built, and lived to remember the last climb of Old Peppersass.

JANUARY 1933

By Robert S. Monahan

From Mount Washington Reoccupied, 1933

When he first climbed Mount Washington at the age of twelve, Robert "Bob" Monahan (1908–1994) probably wouldn't have guessed that someday not too far in the future, his name would be linked forever to New Hampshire's grandest summit. The 1929 Sumner graduate, who also attended the Yale University School of Forestry, was among the "reoccupants" of Mount Washington during the winter of 1932–33, when weather observers returned to the summit for year-round occupation. The following piece features excerpts from Monahan's daily mountaintop log entries for January 1933. After his stint atop the mountain, Monahan went on to work for the U.S. Forest Service for fifteen years. For several years, he supervised Civilian Conservation Corps (CCC) crews in the White Mountains. Later, he became manager of Dartmouth College–owned timberlands throughout the state and region. He was also a member of the New Hampshire legislature in the late 1950s and early 1960s.

JANUARY 1

I turned out at three this morning to refuel the fires and make sure that the wind had not caused any damage, and especially to ink the barograph pen which was pumping so vigorously in the gusty wind that the ink supply was fast exhausted.

Today was open house on Mount Washington for no less than thirty-nine names were registered in the log, of whom fifteen are remaining

overnight either in Camden or the Observatory. This has been a very busy day welcoming friends, preparing for this evening's illumination, making the usual observations and occasionally enjoying the fine view, especially to the south where Monadnock seemed to rear higher than ever before.

We have had many distinguished guests today including three climbers from Cambridge, Massachusetts, all of whom have acquired enviable mountaineering records: Miss Jessie Whitehead, who returned to Pinkham via Boott Spur; Henry Hall, who made an hour's visit before returning to the Glen House; and Brad Washburn, who is spending the night. Also we are entertaining Al Sise and Josh Crosby, who packed up three ponderous volumes produced by the United States Polar Year Expeditions of fifty years ago to Lady Franklin Bay and Point Barrow. The books were loaned by the Baker Library at Dartmouth upon request written on the summit December 29. Some service!

Fortunately both temperature and wind velocity have moderated considerably today, enabling the holiday visitors to enjoy a regular field day on the heights.

For supper we had the first fresh meat we've enjoyed for some time, also a dessert of vanilla ice cream with chocolate sauce. In the evening we could readily detect the Portland lights and were very much pleased with the fine visibility conditions. At nine p.m. we lit six magnesium flares, which were carried to various high points on the summit, and flashed the 400-watt lamp from the roof. Meanwhile, Brad was recording the holiday display with the standard movie camera which he has loaned us for the winter. While the torches were still glowing we had a phone call from the Mountain View House at Whitefield informing us that the lights were seen from that point and shortly thereafter we received a similar message from South Lunenburg, Vermont.

At ten p.m. we repeated the lamp for five minutes and also lit two more flares. By eleven p.m. the others had turned in but Sise and I used the lamp again and at midnight burned two more flares. An answering light in the direction of Bridgton, Maine, indicated that our flashes had been seen from three states. The wind was blowing hard again at midnight and a flying spark burned the gauntlets Sise was wearing and another spark burned my bare hand slightly.

We enjoyed the novelty of lighting off the fireworks and will wait in suspense for replies from those who may have seen the light. It is unfortunate that the same conditions did not prevail last night as tonight for we suppose many more people were looking in this direction at that time.

JANUARY 2

Only one group climbed the mountain today but it was not until midafternoon that the last (Sise) of our overnight company had left for the lowlands. At eleven a.m. the clouds rolled in again bringing to a close the brief period of clear weather. In the afternoon Mac put in a lengthy sked with Mr. Shaw at Exeter. We were quite surprised that he was able to carry on at all after Sise's alterations to his equipment!

Today we shared a quart of fresh milk, the first such article that has ever graced the dining table of the Observatory. Evaporated milk for cooking and our eighty-five pound drum of parlac for cereals have substituted satisfactorily.

At the 7:15 p.m. sked with Pinkham we were quite surprised to hear Sise's voice at the other end and even more surprised and horrified to learn that an accident had occurred that afternoon in Huntington's Ravine involving Jessie Whitehead and her climbing partner, Walter Sturges. Progress reports were dispatched on frequent schedules to keep us posted on developments until almost three a.m. when Joe and Wen returned from the North Conway Hospital with the news that Jessie was alive, but still delirious and obviously in very serious condition.

JANUARY 4

Today was an historical day for a distinguished company of visitors called on us for two hours in the afternoon: Joe Dodge (his first day on the summit since December 3), Elliot Libby (his first winter climb up the auto road and the first time he has been within his Stage Office during the winter), Wen Lees and Itchy Mills. Landlord Libby presented no rent bill and seemed well pleased with the transformation we have wrought at the summit terminal of the auto road.

The quartet had driven 100 yards beyond Five Mile Turn in the "Hearse," a Pierce Arrow mountain-geared sedan possessing a lengthy and proud record of difficult travel. We had hoped they would remain overnight but they had made plans to return late in the afternoon. Fortunately, both temperature and wind were mild, and the summit cloud cap was thin.

They brought up a batch of mail, including Sal's Massachusetts Income Tax Return blanks. Inasmuch as he has volunteered his services for several months, we suspect the forms will help start the next fire.

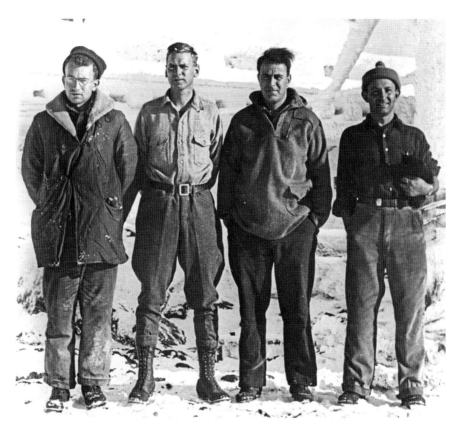

Early pioneers of the Mount Washington Observatory included (*left to right*) Alex McKenzie, Robert Monahan, Joe Dodge and Salvatore Pagliuca. *Courtesy Mount Washington Observatory.*

Confirmation of our lights represented the bulk of the mail. The most distant reply received indicated that the nine p.m. display was seen as far as Boothbay Harbor, Maine, approximately 95 miles airline from Mount Washington. Ralph B. Jenkins of that town reported seeing the light "with the naked eye very clearly." William W. Graves and Marshall H. Metcalf climbed the fire lookout tower on Mount Ararat, near Topsham, Maine, about 80 miles distant, from which they could distinguish the mountain light "without difficulty." The lights were also reported from Lisbon Falls, Maine, and Farmington, N.H., both 64 miles from the mountain. Additional replies were received from many distant points including Lakeport, N.H., Otisfield and Lovell Village, Maine. Probably the most unique setting in which the light appeared was the quiet water of Lake

Winnepesaukee, for Clifton F. Shaw of Concord reported seeing not only the stars but the summit light reflected for a few minutes upon the surface of the water.

JANUARY 5

In clouds all day. However, the telephone conversations between the Base Station and the thrice daily radio phone skeds with Pinkham Notch relieve any monotony that might have developed. At present, we are so busy with our regular observations and calculations that the hours fly by, yet many of our friends below cannot understand what we do to "kill time."

In the afternoon we burned the Christmas tree. It served its purpose nobly but the coal gas in the atmosphere of the room is more telling on the tree than on us. So that much appreciated symbol of the Christmas spirit had to be junked.

Today we heard the sad news that Calvin Coolidge has died. A living ex-president seems about as short-lived as a stretch of clear mountain weather.

At six p.m. we were very much surprised to hear someone open the door. He proved to be the forerunner of a group of four boys and advised us that one of the party was in a bad way, so Sal [Pagliuca] and I picked up the emergency kits and set out down the mountain. However, we met the rest of the party a few hundred feet from the Observatory—a false alarm, for which we are thankful. The youths had no intention of climbing to the summit when they set out but they could not resist the temptation, so, despite their inadequate equipment, they managed to push through to the summit. They knocked in vain on the garage door thinking it the Observatory and next they mistook the snow gage in the center of the parking area for the stove pipe of our snow-blanketed quarters. Our four "stowaways" have been supplied with blankets and food, including some of the several cases of baked beans which Friends Brothers supplied us for just such emergencies.

JANUARY 8

During last night the temperature fell rapidly from 20° at eight p.m. to -14° at eight a.m. this morning, accompanied by a considerable increase in the wind velocity.

During the day we were visited by two groups of three each from Littleton and Whitefield, who climbed via the railroad. At noon the sky was clear for the first time since January 1. The maximum temperature was only 2° but the climbing conditions were ideal and the visibility excellent.

Our period of clear sky was short-lived, for at 6:30 p.m. Cumulus clouds sneaked in from the west and enveloped the summit, thus denying us a moonlight view of the snow covered peaks, and outlook of which we shall never tire.

While waiting for the 7:15 sked which would advise us whether Burho had started up the mountain, we were quite surprised to see him stagger through the threshold and slump into the nearest chair. The round trip, burdened on the upgrade with the 45 pounds of mail and special supplies, had proven almost too much. We have now adopted a standard treatment for such cases of exhaustion and promptly restored Ralph to his usual genial self.

Later in the evening Sal and I brought up his load from the Cow Pasture lower turn, 1¾ miles below the summit, where the pack had been cached. This is the second successive time that our mail has been abandoned in the vicinity of the Cow Pasture. The long pull above the Stone Crusher has proven exceedingly disheartening and now Sal refers to the Cow Pasture as "le pont de l'ane" (the donkey's bridge or the packer's critical point).

JANUARY 10

A terrific wind blew all night and at seven a.m. was sweeping across the summit at a ninety-mile velocity. During the night the pressure dropped rapidly, reaching a record low for the Observatory of 22.881 at four a.m. The snowstorm which raged all yesterday finally let up some time during the night. The gages caught about 5½ inches but the wind and -4° temperature formed a windpacked crust over the peak.

The cat returned this morning triumphant from his conquest of Camden Cottage in which he reduced the summit population by three.

In the afternoon the clouds opened up at 2:45, the temperature increased appreciably and the wind diminished slightly. Sal and I took advantage of these conditions to refuel the gas tank and haul by toboggan several bags of coal from the garage. An attempt was made to photograph a striking scene to the northeast in which the upper edge of the almost full moon was peeking over a formidable lenticular cloud riding quietly over the shadow of Mount Washington.

Snow-covered Mount Monroe rises out of an undercast as photographed by observatory crew members. *Author's collection.*

At eight p.m. Sal and I started the hourly watch of the weather changes for the eleventh and twelfth of this month are International First Order Days when all Polar Year stations are urged to make detailed observations. Sal stood the first watch so I am turning in early.

January 11

Either Sal or I made the rounds of the instruments all night. At 5:30 a.m. the sky suddenly cleared overhead heralding a glorious sunrise thoroughly enjoyed and welcomed by the observer on watch. All night the wind continued very gusty and reached an hourly average velocity of from 55–60 m.p.h. The sky clouded over again at 7:30 a.m. and remained overcast all day with dense haze forming a 360° horizon.

The wind was so gusty that pilot balloon and nephoscopic observations were impracticable but we watched the cloud formations closely until 3:45 p.m. when we went under again. At 5:30 p.m. snow began to fall which, together with the rime already forming, should whiten our summit aspect considerably.

A raging blizzard swept over the mountain all evening. The wind-driven snow reduced visibility to a minimum and added considerable difficulty to the task of making the hourly outside observations.

Between readings I am studying Hobbs' "North Pole of the Winds," an altogether appropriate book to read while we ride out this raging snowstorm.

JANUARY 14

A bank of low clouds which appear to the lowlander as Stratocumulus but which are classified by us as "advection fog" rolled in from the coast all morning. At noon the Sandwich Range went under and soon thereafter Mount Pequawket and Doublehead were enveloped as the mass swept around Moosilauke and invaded the lower summits of the Franconia Range. By one p.m. the dense blanket had concealed the southern half of Pinkham Notch. The very crest of Wildcat and Carter Dome remained clear, for the upper limit of the fog is about 4300 feet. The few peaks over that altitude emerge above the inland sea as so many scattered islands on a vast ocean. Because of the barrier nature of the Presidential Range the cloud bank's advance is halted in our immediate vicinity and the region to the north of us remains clear.

We are enjoying the first calm weather experienced since December 27 and no time was lost in taking advantage of these fine conditions. The Kohler tank was refueled, soft coal and kindling wood hauled by toboggan from the garage and the water supply replenished. Mac was enabled to accomplish some outside soldering for the first time in many weeks. Reports from the lowlands indicate distinctly disagreeable weather but we are basking in continuous sunshine and moonlight.

The wind was from the southeast but gradually veered westward during the late afternoon. The anemograph installed on the railroad platform has been overhauled and we are all set for the next storm.

A party of six Dartmouth students climbed from the Base in the afternoon, remaining overnight in Camden Cottage. It is unfortunate that prospective climbers in the valley do not realize the remarkable conditions prevailing on the upper slopes, for we are sure they would flock to the mountain to share with us the unusual view.

The almost full moon this evening reveals the various currents and eddies of our inland sea. Especially fascinating are the clouds which sweep over

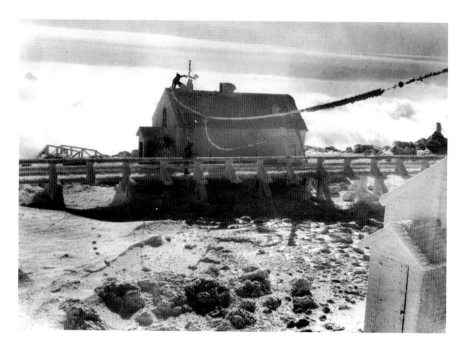

Alex McKenzie works to repair a wind-damaged antenna atop the observatory's summit headquarters. *Winston Pote photo, courtesy Mount Washington Observatory.*

Wildcat and through Carter Notch, for they pour down the north-facing slopes in a great cascade. Snow flurries occurred in the valleys but we have had no precipitation of any kind. The frost is rapidly evaporating under these conditions and I was obliged to turn "road monkey" in order to improve the snow surface on our "skid road" from the garage to the winter quarters.

One of the Dartmouth students tested our telephone hook-up by calling his home in New Jersey. He reported perfect transmission on probably the longest phone call to date.

JANUARY 15

Only a thin layer of Cirrostratus above the eastern horizon obscured the sky. All else is blue. During the night the blanket of fog covering the lowlands broke up to some extent allowing sunshine to filter through at times, but up here we are blessed with constant sunlight. At 11:30 a.m. a few masses of Cumulus floated by causing a decided jump in the pyrheliometer recorder.

The reflected sunlight caused by these clouds increased the millivolts registered by about 50%.

The morning's weather report indicated snow falling in Boston but we are still favored with clear skies. However, the wind is increasing from yesterday's calm, our first quiet weather since December 27, to a velocity averaging forty m.p.h.

In the afternoon Joe and John Eddy in the latter's Ford roadster drove up the unplowed summit road as far as the Halfway House without undue difficulty reaching that point at three p.m. where they were met by Sal and Mac. They were obliged to shovel only twice: at Adams Lookout and just below Jenny Lind Bridge. The fact that a car could be driven halfway up the mountain on this date is concrete evidence of the mild winter thus far in the valleys. But past experience indicates that more wintry conditions may be expected in March and even during April than this month.

The mail was exchanged at the Halfway House and Sal and Mac returned to the summit with a considerable amount of mail, fudge, radio equipment and cold weather clothing. And so our weekly mail service has continued!

A beautiful red moon provided an unusual setting as it rose behind Cirrostratus. We tried to reproduce part of the effect photographically but even our array of filters and special lenses will fall far short in duplicating the scenes as we observe them.

January 18

This morning brought bright sunshine and absolutely clear skies, a very welcome change from yesterday's disagreeable combination of wind-driven snow and fog. The temperature is lower today, ranging from 18° to 1.5° between eight a.m. and eight p.m. Dense Altocumulus clouds were noted in the western valleys moving this way. At sundown the shadow of the mountain was cast upon the haze over the northeast horizon, a common portent of unfavorable weather.

The anemoscope recently installed at the end of the trestle had to be demounted for additional repairs. The canvas cover does not seem to be the best device possible to protect the clockwork and record rolls from the fine snow which is driven into the smallest cracks.

We had hoped to conduct at least one balloon run today but the extreme gustiness of the northwest wind prevented. At seven a.m. the velocity was 78 m.p.h.

JANUARY 19

Inasmuch as every indication of immediate bad weather has been noticed, I left for Pinkham Notch soon after breakfast with an 87-pound load including the sixty-pound pryheliometer recorder which will have to be repaired in the valley. We have been able to make all other instrument repairs on the summit but this requires special attention. At present there is very little loose snow on the road so we are anxious to complete all the back packing necessary while the traveling conditions are still good.

The hygrograph showed an almost vertical rise between seven and eight a.m. accompanying the sudden approach of clouds and snow. The wind slowly veered from SW to W during the day and increased steadily in velocity from 24 m.p.h. at seven a.m. to 85 m.p.h. at eight p.m.

Pushed downhill by the heavy load and the increasing wind, I made good time down the road covering seven miles in exactly two hours to the One Mile, where Joe and Itchy had just hauled the latter's car out of a ditch with the aid of Elliot Libby and his "hearse."

JANUARY 20

The wind velocity let up appreciably early this morning, reaching 44 m.p.h. at four a.m. but it soon increased rapidly and blew at hurricane velocity (No. 12 Beaufort Scale) all day. Outdoor activities were rendered extremely difficult because of the wind gustiness and flying ice. The rapidly forming frost has made it impossible to obtain accurate readings even when the full charge of heat is passed through the present anemometer. We constantly look forward to the day when the new improved anemometer will be in operation and we can hope to obtain a continuous record of the air passage under all conditions.

An attempt was made to use the Tycos portable anemometer but the frost rapidly formed in the air gap making a reading impossible. The velocity must have exceeded 125 m.p.h. and this storm will doubtless go down in history as the most violent in January, 1933.

At 12:30 p.m. the barograph recorded 22.610, which is much lower than the previous existing minimum of 22.961 indicated by the mercurial barometer at 2 p.m., December 31. Today's reading resulted from an instantaneous dip in the ragged curve, for the barograph pumped vigorously all day.

Perhaps it is just as well that we are above tree line, for Mrs. Mary L. Roberts, of Grasmere, N.H., succumbed to a heart attack when today's high wind felled a large maple tree in front of the house where she was staying.

On account of the severe weather I remained in the valley, for we follow a policy of not attempting the ascent unless weather conditions are wholly favorable. It is hard enough to pack up a load when the going is excellent.

When Sergeant O.S.M. Cone was relieved because of sickness 55 years ago today, it is reported that he loaded all his belongings on an improvised sled and started down the track. The crude safety brake failed when about halfway down and the Sergeant with his assistant, Private D.C. Murphy, were thrown from the trestle and Cone's belongings were strewn over the mountainside. Both observers narrowly escaped fatal injuries.

JANUARY 21

At seven a.m. the driving snowstorm which had been raging for almost 48 hours finally stopped leaving an average catch in the six gages of 6.2 inches unmelted and 1.2 inches melted. Today's weather has been much like that of the 18th, a flash in the pan, for the disagreeable weather of the past two days has given way to relatively calm, warm and clear weather. At nine a.m. the sky cleared completely revealing banks of Cumulus moving from the west 1500 meters above sea level. At two p.m. the wind was recording 28 miles, a marked difference from that of the past two days. I returned in the early evening accompanied by John Eddy of the U.S. Forest Service.

JANUARY 23

The snow let up at one p.m. but the fog and frost persisted all day. The wind reached 72 m.p.h. at two p.m., but the temperature remains moderate. The two instrument technicians of the Eppley Laboratory, Newport, R.I., reached Pinkham Notch this morning to repair the Engelhard recorder of the pyrheliometer which they have furnished us. The trouble is caused by a broken suspension spring weighing a fraction of an ounce but to make a satisfactory repair it was necessary to pack the sixty-pound instrument down the mountain.

Rough frost formed early in the day but as the wind shifted more northerly the usual rime took its place. A diffuse aurora was observed from the Base

Station in the evening but the mountain cloud blanket prevented any summit observations by eye, camera or La Cour star box.

This is the 62nd anniversary of one of the most violent storms experienced by the Hitchcock-Huntington Expedition and offers ample proof that mild temperatures in early January are no criterion of continued moderate weather through the month. On January 10, 1871, a temperature of 37° was noted, which is higher than any of our readings since December 1, 1932. But the extreme weather occurring later that month is best described in the Journal of that expedition:

January 22. Having a gale today, and not only a high wind, but a temperature below anything I have ever experienced before, now at nine p.m -34° inside the door. The wind is 80 miles, blowing steadily. At two p.m. wind 72, Professor H. measured the velocity. He had to sit with a line around him, myself at the other end indoors, as an anchor; even then it was almost impossible for him to keep his position. Temperature -31°. I put up a pendulum this morning in our room, it is four feet long, and the rod passes through a sheet of cardboard, on which are marked the points of the compass. The oscillations when the wind blew in gusts were in every direction, changing suddenly, and sometimes had a rotary motion. When the wind was steady the oscillations were northwest and southeast. With two fires the room is cold tonight. Had a long talk with Littleton and Concord, all anxious to know how cold it is here.

January 23. The wind raged all night. The house rocked fearfully, but as we had no fear of a wreck, it did not disturb us much. Sometimes it would seem as if things were going by the board, but an inspection showed everything all right. It is a sublime affair, such a gale—only we do not care to have it repeated too often. Nobody was hurt or scared, though there was not much sleep for our party, with such an uproar of the elements. Evidently the spirits of the mountain are angry at this invasion of their domain. Toward morning the wind ceased, and all day it has been nearly calm. The temperature outside -43°. Professor H. and myself sat up all night to keep fires going. The pendulum gave oscillation of an inch and a half at times during the night. Temperature tonight ten p.m. -40°; a changeable climate this.

January 24

Today the wind blew steadily from the west and northwest at 55–64 m.p.h., discouraging me from returning to the summit. So I improved my time in the lowlands by packing up two loads to the Halfway House, including the original recorder and a spare instrument should the former one give us further trouble.

Rime ice envelops several summit structures in this 1930s postcard image. *Author's collection.*

January 25

Today brought fine weather clear sky, fine visibility, moderate temperature (12° to 16°) and a bracing breeze ranging from 25 to 70 m.p.h. I took immediate advantage of these condition to return via the road, accompanied by Mrs. Dodge and Hi-U, an Alaskan husky–German shepherd.

Mrs. Dodge made a large batch of oatmeal cookies which disappeared like magic, despite the huge quantity baked. We also went through eight pounds of beefsteak in two meals, which Mr. Emerson of the Eppley Lab sent us.

JANUARY 27

Washburn and Hawkins left this morning for the Glen with Observatory mail. We certainly can't complain about our mail service to date. During the night the summit went under and we awoke to find the station engulfed in fog, snow and wind, our usual combination. Judging from the hygrograph record the first clouds struck the summit at one a.m.

The wind has blown steadily all day from the ENE and NE, an unusual quarter. As might be expected with the wind blowing from that direction, the frost deposit is a very heavy accumulation with considerable water content, termed "rough frost." This thick frost, which lacks the delicate structure of the usual rime formed by the west wind, built out at the rate of one inch per hour from noon to ten p.m. on a stick used for measuring snow depth. A plentiful harvest of water is promised when the present storm abates.

We understand that this storm has caused appreciable damage along the New England coast and that violent weather is expected today. The temperature has remained surprisingly constant during the last few days for it has varied little from 15°. The Nantucket Lightship was dragged 30 miles from her permanent position by the high seas and gale, according to reports. Sure hope our anchor chains hold better!

In the early evening the frost accumulation proved too much for the heated anemometer for it rapidly came to a standstill, despite the 600 watts being sent through the heating unit. The apparatus now under construction, we hope, will continue to operate despite such unfavorable conditions as prevail tonight.

JANUARY 29

Today was a real mild Sabbath and judging from lowland reports our weather, though cloudy with light winds, is much more pleasant than the windy raw weather of the valley. We remained in clouds throughout the day. This has certainly been a cloudy month and the last few days are no exception. At four p.m. the snow of the past two days ceased, leaving about six inches in the gages. This snowstorm has been a welcome addition to the scanty snow cover in the lowlands. Now there is a fine foundation for the winter's snow cover which we hope will provide the best of skiing for many weeks to come.

Sal and I went down to the Halfway House in the forenoon to meet Dr. H.C. Willett, acting head of the meteorological department at Massachusetts Institute of Technology, who will be our guest at the Observatory for a few days. A Salem party packed up eight heavy duty insulators and some other gear forwarded from Pinkham. The insulators were sent us by the Corning Glass Works when we made known the severe requirements our antennas must withstand. These are tested for a 4500-pound load and we surely hope they will solve the antenna problem.

A large group of skiers were met at the House including a contingent from Berlin under the guidance of our old friend, Henry Barbin (for whom we have named the drift where we turned back to the summit during the storm of December 12). Skiing was excellent on the lower four miles and above the Halfway House the road was skiable its entire length for about the first time this winter, if one were equipped with "rubber-tipped" skis.

Ray Lavender and Ray Pressey, both of whom had visited the Observatory earlier, accompanied Sal and me on the climb, had a late dinner and returned to the valley in the afternoon with Salem, Mass., as their ultimate destination.

The extensive low-pressure area has remained stationary over Nova Scotia causing heavy snowfall in its rear. The storm of the past three days has left extensive alterations along the coastline and storm damages approaching two million dollars have been estimated. The combination of spring tides and gigantic storm waves appear to have caused great losses along the waterfront.

JANUARY 30

Today is one of those fine invigorating days which we wish were only more common. At seven a.m. the fog became thinner, revealing clear sky with dense Cumulus in the eastern valleys. A two p.m. balloon run indicated prevailing northwest surface as well as upper winds.

I shot 100 feet of 16 mm. film for there is no telling when we shall have bright sun again immediately following a long frost storm. Both near-by and distant views are very striking today and we hope that some of these vistas were recorded photographically. But one must actually be here to appreciate the grandeur of the cloud and frost formations prevailing today.

Several outdoor chores were attended to, such as refueling the Kohler tank and hauling coal from the garage. The skidding surface is the best we

have experienced this year so Sal and I hauled up several loads of hard and soft coal.

On several occasions during the afternoon a double fog bow was observed. This formation showed some color, especially in the primary bow and was caused by refraction and internal reflection of sunlight in the liquid droplets in the air. At sunset the quite common shadow of the mountain was cast on the dense valley clouds to the northeast and on top of this shadow we noticed a corona of striking color.

A trio of M.I.T. students arrived in the afternoon, having waded through the deep snow up the Tuckerman Right Gully with blankets and supplies for several days on the summit.

January 31

A fog bow and solar corona were observed at sunrise. The former is quite common when the cloud cover over the mountain is very thin. The trees are reported heavily frosted down to about 2300 feet on both sides of us. The completely white Franconias and Moosilauke are especially impressive.

In the morning Dr. Willett cleared up several difficulties we have encountered in decoding the Arlington weather dispatch and preparing a synoptic weather map. He also indicated several points that will help in analyzing these charts. Some 200 stations report prevailing eight a.m. and eight p.m. weather conditions, in this way enabling us to learn much about the prevailing general weather conditions and when the more pronounced disturbances may strike us.

This evening we all talked over the 91-mile circuit to Mr. Shaw in Exeter. His voice came through exceptionally fine and he was able to understand perfectly all our comments. It certainly is a great boon to discuss our problems and triumphs with this constant friend and supporter of the expedition. We feel the same thrill as that experienced by the 1870–71 group when they enjoyed thrice weekly telegraphic schedules with their director, Professor Hitchcock in his Hanover office. The telegraph company allowed the observers to use their line directly through to Hanover whenever the company business had been completed, and all the latest news was forwarded to the staff over this hook-up.

This has certainly been a mild month for our mean temperature, calculated according to Weather Bureau practice of averaging the daily maxima and

minima, is only 12.6°, which is a warmer January average than any recorded up here from 1870–1887, except the one year of January, 1880.

Only seven clear days were enjoyed. The lowest temperature was recorded when the thermometer registered -19° January 1 and the second coldest day on January 12–13 with -16°. The only above freezing temperature was registered on the 23rd when 33° was recorded.

The January mean temperature in Boston was 10° above normal with only two days having a mean temperature below normal. The mean temperature in New York was 9.5° above normal. Portland, Oregon, also had cloudy weather this month with 27 cloudy days on 26 of which it snowed or rained!

This month brought deficient snowfall in the East but the opposite condition prevailed in the West where unusually heavy snowfalls have been reported.

The Polar Year observer at Point Barrow must have put in a chilly month, for he reported twenty days with a temperature of -30° or lower; fifteen with temperature -40° or lower; three days with temperature -50° or lower, and one day with temperature -60°!

Fortunately his is not a windy location for the maximum velocity of the month was 17 m.p.h. We shiver when we think of his 34-minute pilot balloon observation with the temperature at -41.

"WE RECORDED THE GREATEST WIND EVER MEASURED ON EARTH"

By Wendell Stephenson, 1979

Though he worked atop the mountain for just a year and a half, Wendell Frank Stephenson (1908–1990) happened to be at the summit in April 1934 when the greatest wind ever measured blew across the mountain. The Aurora, Illinois native and 1930 University of Chicago graduate worked for the newly organized Mount Washington Observatory during a portion of the winter of 1932–33. He was a full-time weather observer the following winter and then went on to work for the Appalachian Mountain Club and eventually become a teacher. Stephenson's wife, Eleanor Ballard Stephenson, met her husband-to-be on top of Mount Washington in the fall of 1933, during a hiking trip to the summit with her dad. The couple were married the following summer, just four months after the record wind.

On April 12, 1934, the greatest wind ever measured on the face of the earth—231 miles per hour—was recorded by three weather observers atop Mt. Washington, New Hampshire. The previous high of 152 mph had been recorded only a year earlier. No wind higher than the 1934 howler has ever been recorded, not even during a hurricane.

Salvatore Pagliuca was the chief observer on the weather team in the hut on the mountain top. Cook, forecaster, and repairman Wendell Stephenson, and radio operator Alex "Mac" McKenzie, were the other team members. Two hikers were windbound with them that day. This is Wendell Stephenson's account of the record-making occasion.

Nothing on the radio or the weather maps on April 11, 1934, gave any clue to the extraordinary events that were about to happen. The temperature

was warm for the mountains—low 20s—and a heavy, almost clear ice rime was rapidly covering everything. When we came back in the house from our routine inspection of gauges and recorders, the melting ice from our storm clothes left puddles everywhere.

Mac and I took a break from normal procedures in the late afternoon. This was tea and doughnut time, as we all were fairly free from duties before supper. Sal commented that if the wind kept increasing, we'd keep a 24-hour watch. He'd take the early shift, Mac would go from 1 to 4 a.m., and I, low man on the pole, would get the shift from 4 to 7 a.m. Well, it kept getting wilder and wilder, with gusts around 100 mph, so the all-night plan, a rather common occurrence in those days, went into action.

We were all young, in good shape, happy with our munificent salary—and why not? The first year it had been $5 a month and now it was $5 a week! We had no trouble sleeping in our unheated bedroom, so Mac had to thump me awake, and in that half-awake state I stood by the stove to dress and tune myself to what was going on outside. I had the tingly feeling that it was blowing about as hard as I'd ever heard it. The house shuddered in a steady

Witnesses to the world record wind of April 12, 1934, were (*left to right*) Sal Pagliuca, Alex McKenize and Wendell Stephenson. *Courtesy Eleanor Stephenson.*

throb. You see, up there the wind blows steadily, not in gusts, so it has a tone for any given velocity. We had learned to guess quite accurately how fast the wind was going by, and I decided to check my guess of more than 100 mph.

Our anemometer sent electric impulses to a recorder in Mac's radio shack. At the passing of a mile of wind, a pen kicked up and made a short, straight line, perpendicular to the line on the clock-driven recording sheet. A fast count of the straight lines over a five-minute span could easily be figured to miles per hour. I counted several blocks but couldn't get much over 90 to 100 mph. I knew that was inaccurate, which meant only one thing—so much ice had built up on the mast carrying the anemometer rotor that it was shielding the rotor from the full force of the wind. This happened whenever rime was forming rapidly, and one of us would go up the ladder to the roof, bash and beat the ice away, and scurry down to take a few fast stopwatch readings and make a note on the chart to explain the sudden increase in velocity.

I could wax dramatic from this distance, but then and there it was my job—so into the storm gear and out the door I went. I began to be suspicious of the situation when I could hardly get the door open against the vacuum of the wind screaming by. I was further convinced when I got knocked down as soon as I stepped out. I had leaned, as usual, into the northwest wind when I stepped out, but the blast was from the southeast and dead against the ladder. It took two tries to get started, with me carrying a club to break the ice and trying to keep my parka from blowing up over my head and arms. I wasn't afraid or apprehensive, just annoyed that I had to go so slow. I hooked a leg around the ladder, hung on madly, and beat away the huge ice shield that had indeed formed. I finally threw the club down, crawled back under the ladder, and ducked around the corner of the house and in the still stubborn door.

Before I even took off the parka, I grabbed the stopwatch and began counting. Once I tried—but couldn't believe the answer. Twice—but it still seemed too fast. Three times—"Ye gods," I whispered, "186 miles an hour!"

And so it was. Had I known, I might never have gone out. But there was more. When Sal and Mac came down, I was almost out of control, and, if anything, the wind was even wilder. We sent the 186 figure on our morning weather report, and did we get reactions! The most important and fortunate break came when Dr. C. Brooks of the Blue Hill Observatory called to check and Mac plugged the anemometer into the radio and let Dr. Brooks time the gusts for a while. Our new high was the famous 231 mph at 1:21 p.m., which Dr. Brooks also timed to lend support to our claim. Sal held the stopwatch as the gust velocity climbed first to 229 and finally to 231.

Wendell Stephenson (on the phone), Alex McKenzie and Sal Pagliuca enjoy a sit-down meal in the summit observatory. *Courtesy Mount Washington Observatory.*

The wind blew ferociously into the afternoon of the 12th, but by the 13th we were back to normal—which for Mt. Washington is about 80 miles an hour. The house hadn't blown over, collapsed, or otherwise suffered, thanks to the 20 or more inches of heavy ice rime.

People are still always asking me if I was frightened up there that day. Well, I was just a young man not too long out of the University of Chicago. McKenzie hadn't been long out of Dartmouth either. We were all in our twenties and full of life. Do you know what we did when that wind hit a record high? We cheered! We were in on a record setter, and we were part of it. We recorded the greatest wind ever measured on earth.

SKIING AND THE MOUNTAIN

By F. Allen Burt

From The Story of Mount Washington, *1960*

Of all places in New England where skiers get together, there is none where snow lingers longer, or where everybody from novice to hardened expert may have more fun and thrills, than in Tuckerman Ravine on the eastern flank of Mount Washington. On a sunny Sunday in spring, when snow still lies deep in the ravine and up the headwall, and when the snow field is colorful with scores of happy, lusty skiers, it is hard to realize that skiing as a sport on Mount Washington dates back only fifty years. This first descent by a skier took place on Thursday, 16 February 1905, when Norman Libby of Bridgton, Maine, made the ascent from the Base Station, accompanied by the winter caretaker of the railroad's property, and slid down the mountain on skis.

Mr. Libby, who was assistant editor of *Among the Clouds* for two summers, was not content with being the first man to "slide down Mount Washington," but returned in February 1907, with a friend, intending to climb to the Halfway House for the ski ride down the carriage road.

But at the Glen House the proprietor promptly offered to secure creepers that would make it possible to reach the summit. So, while waiting for the creepers to be sent from Gorham, the two men made the trip to the Halfway House, wearing skis bound with rope. The road was piled with from three to four feet of snow, and along some parts of it Mr. Libby reported that "the drifts were small mountains." After eating dinner by candlelight in the boarded-up Halfway House, the two men fastened on their skis for the run

of four miles to the Glen House, which they made in a running time of twenty minutes.

Next morning they made Halfway without incident. Just above the house, at Cape Horn, where the road makes a sharp U-turn, Mr. Libby reported the snow as making "an unbroken slope from the top of the spur down hundreds of feet to the threatening gulf below. Not even a twig offered a clutch in event of mishap, and, our creepers not yet put on, it was a thrilling moment as we passed this declivity." On their return, just after they crossed this same spot, a large area of their path slipped from the ice beneath the hard snow and shot into the valley, a thousand or more feet below! Around the Horn they found a deer, frozen and blown dead against the rocks.

Their creepers were moccasins split and laced at the toe, with two ankle straps for adjustment outside overshoes. On the sole and heel were pieces of steel, the edges of which were turned down like a cooky-cutter. These gave security on crusted snow, but were of little help on ice.

From a point four and a half miles up, to the fifth milepost, there is another snow slope that is dreaded by winter climbers. It is like the one at Cape Horn, only more frightful. Here, for nearly a half hour, the two men picked their way, step by step, "daring to look neither to the right nor left, for fear of dizziness."

Between the fifth and sixth mileposts was their longest test of endurance. It was a snow-packed road again, on which the creepers made not the slightest dent. Somehow they made their way across, and from there to the summit the mountain was blown free of snow.

It was even before these ascents—back in the 1890s—that there had appeared at Dartmouth College the first crude homemade skis, awkward contraptions that garnered more laughs than followers. A new era began in 1909–10 when Fred H. Harris of Brattleboro, Vermont, the first Dartmouth man who was a really proficient ski runner and jumper, proposed the formation of an outdoor club. Early in January 1910 the Dartmouth Outing Club (or D.O.C.) was organized, with fifty or sixty members. Fred Harris '11 was its first president. On Saturdays a group of snowshoers, led by a few speedy skiers, would hike out over the snowy fields and hills, their odd clothing and clumsy gait provoking more derision than enthusiasm among the undergraduates. But the seed was sown and sprouted swiftly, and, as one Dartmouth man said, "The college has never fallen so quickly for any other new sport as it did in 1910 for controlled ski running."

As the D.O.C. grew and prospered, the slopes and hills around Hanover became a bit tame. The long finger of Mount Washington was felt, if not

seen, beckoning across the snowy heights, and in March 1913 Fred Harris, Joseph Y. Cheney, and Carl E. Shumway, all members of the Club, were skiing at the very top of New England. That the D.O.C. was the first college club to make that ascent by skis was altogether fitting, for now their alma mater owns that summit.

Early ascents by the Dartmouth Outing Club (prior to winter opening of the Pinkham Notch Camps in 1926–27) were made by snowshoe from the Glen House up the Carriage Road, across on the Raymond Path, and into the floor of Tuckerman Ravine. Then began the laborious job of cutting steps in the hard-packed snow to the rim. If conditions on the cone were good, the hike with crampons above timber line was the easiest part of the trip. One of the dangers pointed out by Robert Scott Monahan, leader of these ascents and later one of the leading spirits in the founding of the Mount Washington Observatory, was the fact that by the time the groups were ready to start down the headwall, the slopes were usually frozen. As Bob Monahan explained: "When the afternoon shadow hits the main wall of the ravine, the snow, if it is at all soft, will 'tighten up' suddenly, and make for tricky descents. One stunt was to 'glissade' down the lower slope, but not always with the same technique used by the alpinists!"

In 1923 Charles A. Proctor, professor of Physics at Dartmouth, widely known as the "Granddaddy of American College Skiing," was the moving spirit in the establishment of the Eastern Intercollegiate Ski Union, formed by Dartmouth, New Hampshire University, and McGill University. From this, and from the famous Dartmouth Winter Carnival, which had its beginning in 1911, sprang the still-growing enthusiasm for this great winter sport at most northern colleges.

Two of the most notable of the Dartmouth skiers to visit Mount Washington were John P. Carleton, who commenced skiing on the mountain in 1916, and Charles N. Proctor, son of the professor. Both held numerous championships, and both had competed in the Olympics. With two such skiers as these making frequent visits to the summit of Washington, it could be only a matter of time before the greatest thrill offered by the rugged old mountain would be attempted—the descent of the Tuckerman headwall, that sheer drop of 1000 feet into the bowl below. Of that event Carleton writes: "So far as I know the rumor is correct that Charles Proctor and I were the first to run the headwall. That was on April 11, 1931."

In the 1924 Olympics, John Carleton, then a Rhodes Scholar at Oxford University, competed as captain of the Oxford-Cambridge Ski Team. Later

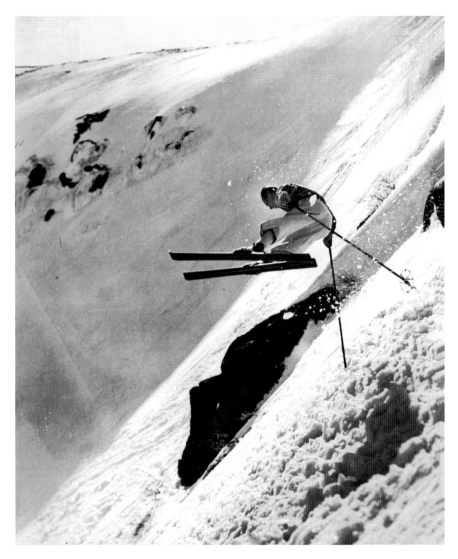

Early ski instructor Sig Buchmayr executes a jump turn on the Tuckerman Ravine headwall in the spring of 1932. *Winston Pote photo, courtesy New England Ski Museum.*

a practicing attorney in Manchester, New Hampshire, Carleton was the first American ski-internationalist.

In 1928, at St. Moritz, Charley Proctor was the only native-born American on the United States Olympic Ski Team. He had already been Intercollegiate Champion in ski jumping and downhill and slalom racing, and in 1927 he had been All-Round Ski Champion of Canada. During the

1930s he became Winter Recreation Director and purchasing agent for all tourist facilities in Yosemite National Park, California.

That was the time when skiing was becoming a full-time winter interest for White Mountain landlords and winter sports fans. As more and more people learned how to ski, and as snow trains commenced drawing thousands of beginners and advanced skiers to winter playgrounds, overnight facilities were strained to the utmost on week ends. But Sunday nights the camps and hotels were deserted.

Although the first descent of Mount Washington by skis took place in 1905, five years before the founding of the Dartmouth Outing Club, and although that club has always been a leader among ski enthusiasts, yet it remained for a little group of Harvard students from Boston to start the first club in America devoted solely to downhill skiing. Robert Livermore, Jr., of Boston and Topsfield, of the United States Olympic Ski Team of 1936, Robert S. Balch of Jamaica Plain, and W. Bradford Trafford of Boston, all members of the Harvard class of 1932, were its originators in 1928–29.

About this time a Swiss watchmaker working at the Waltham Watch factory asked permission to join an outing of the Appalachian Mountain Club. It turned out that Otto Eugen Schniebs was an accomplished skier. The three Harvard boys decided that he was just the man they needed to complete the perfect foursome. And thereupon the Stem-Like-Hell Club was formed.

Bob Livermore and his friends like to recall that they "discovered" Otto Schniebs, who soon quit watchmaking for the more exciting job of coaching Dartmouth skiers. Later he became coach of the St. Lawrence University ski team at Canton, New York.

The Stem-Like-Hell Club members were pioneers in more ways than discovering talent. In February 1930 Bob Livermore became the first Harvard man to enter the Dartmouth Winter Carnival. To the surprise of his Dartmouth hosts he won the slalom race and placed second in the downhill race. In 1931 the club members spent three or four days in the Camden Cottage, and were the first party of skiers to go down from the summit over the headwall of Tuckerman. This was a week after Charley Proctor made his "first" run over the headwall from the lip, with John Carleton following.

It was during that winter of 1931 that Balch, Livermore, and Trafford secured permission to represent Harvard in ski events held under the auspices of the Intercollegiate Winter Sports Union. Although not officially recognized, a ski team was active at Harvard beginning with the winter of

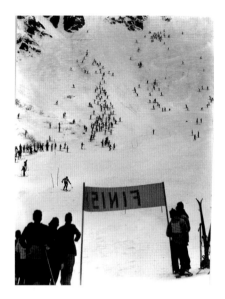

A skier approaches the finish line during the annual Dartmouth-Harvard Slalom Race held April 18, 1937, on the western side of Tuckerman Ravine. *White Mountain National Forest archives.*

1933. Skiing was officially recognized as a minor sport by vote of the Harvard Athletic Association on 5 February 1940.

On 2 January 1932 a heavy snowfall made possible the first thorough testing by skiers of the recently improved Forest Service Trail from Pinkham Notch to Tuckerman Ravine. Its moderate grade and negotiable turns proved its attraction to both expert and novice skiers, and have been of invaluable assistance in getting injured skiers out to Pinkham Notch when emergencies have arisen.

After those exciting days in April 1931, ideas about ski racing in Tuckerman Ravine began to bud in the minds of America's top-ranking skiers. The Nansen Ski Club of Berlin, New Hampshire, the Hochgebirge Ski Club of Boston, and the Deutsche Ski Club of New York, to say nothing of all the college ski clubs and the ski enthusiasts of the Appalachian Mountain Club, turned speculative eyes toward the Tuckerman headwall.

Just under a year later, on Sunday, 20 March 1932, those budding ideas bloomed into the "Mt. Washington Spring Snow Fest," featuring, under the auspices of the Nansen Ski Club, the Glen House, and Joe Dodge, a series of races and jumping events for girls, boys, and senior skiers. The climax of the day's events was the eight-mile race down the Carriage Road, the first ever attempted. Sanctioned by the Eastern Amateur Ski Association, this race attracted Olympic, college, and individual stars from far distances.

In advance publicity describing the race the four miles at the top were spoken of as "the four hardest miles of skiing on the continent. Wind-blown crust, ice, huge drifts as large as ocean waves impede the progress of skiers. The last four miles, from the Halfway House down, are comparatively easy, and afford some of the best skiing in the country. This [lower] four-mile slope is wide and averages a little over a ten percent grade." It had been covered by a member of a Dartmouth ski team in 8 minutes, 16 seconds. Up to that time no one had been known to run from the summit against

time, but it was expected that nearly forty minutes of terrific strain would be necessary for the eight miles.

The Nansen Ski Club, under whose supervision the race was held, was the pioneer ski club of the northeastern United States. The race was promoted by Alf Halversen a coach of the Olympic Ski Team, and a committee headed by Olaf Nelson, president of the club. Assisting the Nansen Club were Joe Dodge and Bob Monahan from the A.M.C. Huts in Pinkham Notch. The Glen House was represented by Elliott C. Libby, the manager, and C.M. (Charlie) Dudley, ski instructor, and former recreational ski instructor at Dartmouth College.

Of course the eight-mile grind from the summit to the Glen was the feature of the meet. But Mount Washington was in no mood to cooperate with flying skiers. Conditions of snow and weather, including a seventy-mile gale, caused officials to give up hope of staging this event. But the five experts who had entered this hazardous race were not to be turned back by a mere hurricane. Facing death at every turn while traveling at blinding speed in the face of the gale, they completed the first race from the summit to the Glen House in a little over twelve minutes.

Over 6000 persons were waiting at the end of the road to cheer the racers as they whizzed like human bullets down the mountainside, ending the race so closely that the winner, Edward J. Blood of the University of New Hampshire, was only twenty-five seconds ahead of the last man to cross the line.

Although they wore special goggles and helmets to protect them from slashing ice particles whipped up by the wind and their own hurtling speed, their noses and mouths were frostbitten, and tiny particles of ice were imbedded in exposed portions of their faces.

Three members of the 1932 United States Olympic Ski Team took top honors in the Carriage Road race, in this order: E.J. Blood, 12 minutes, 20 seconds; Nils Bachstrom, Swedish Ski Club of New York, 12 minutes, 30 seconds; and Bob Reid, Nansen Ski Club, 12 minutes, 35 seconds.

Asked what it was like to rocket down the mountain at a speed sometimes in excess of eighty miles an hour with certain death always jogging his elbow, Ed Blood said:

> *It was like watching a ribbon of white uncoiling beneath me. I could hear a roar in my ear and see a blur of black as I came below the timber line. I could hear a peculiar singing sound as the skis rasped over the snow crystals, and I got the impression of the world flying up to meet me, as if*

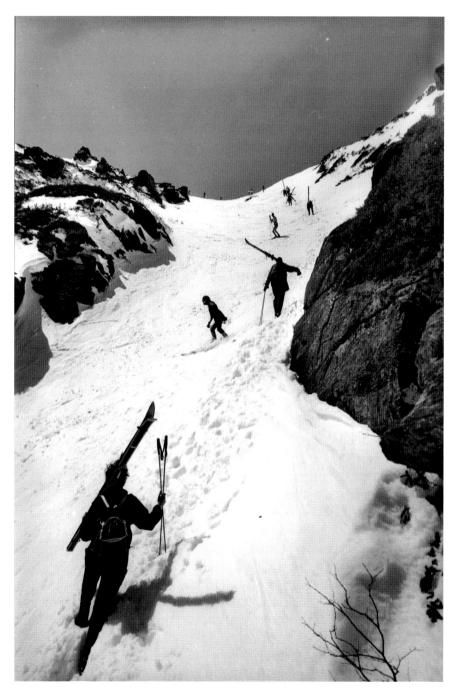

Skiers bound for Hillman's Highway in the spring of 1962 make their way slowly up the steep incline. *White Mountain National Forest archives.*

I was falling from an airplane...but that's about all, except that we had
some mighty close shaves. I never had seen a race so evenly matched. We
swung around the turns just as if we were actuated by a single mind, every
man in his own place, neither gaining or losing a yard.

To apprise the spectators and timers below of the start of the race, a gigantic rocket specially prepared for the occasion was discharged at the summit. The simultaneous start in a ski race is rarely possible in this country, but inasmuch as the first half of the race was above tree line, and the road quite open, the competitors had plenty of room to spread out. Mr. Blood's statement indicated that they early found their respective places in the group and held them to the end.

On Easter Sunday, 16 April 1933, the dream of a ski race from the summit of Mount Washington down over the Tuckerman headwall came to reality in the first "American Inferno." So hazardous was the event considered that it was quickly dubbed a "suicide race."

Sponsored by the Ski Club Hochgebirge, whose motto is "Dash and Abandon," with Joe Dodge as chief official, every precaution was taken against accident. Expected times were three minutes from summit to rim of headwall, where runners were to zigzag almost to a dead stop between slalom flags; one minute down the thousand-foot drop of the headwall; then through the tortuous path past Hermit Lake and down the Forest Service Trail, which had been done in three minutes fifty-five seconds.

Of this first Inferno Race, in which fourteen skiers entered, Winston Pote, color photographer, wrote: "The best time was around 17 minutes, by Hollis Phillips, though that was down the 'right' or north gully. It was in a driving rain and very heavy snow and he was the only skier who came down there on his feet."

Records on Mount Washington depend upon many factors which may never be repeated. While the bowl of Tuckerman usually is 200 feet deep in snow in April, in 1933 there was enough more to form the required angle at the upper rim for an expert skier to make a perfect run of the headwall.

This snow always continues skiable into June. But in 1933 Tuckerman Ravine set up a new record by furnishing skiing on the Fourth of July. Easter week end, however, is likely to be the most popular time of all in Tuckerman. Each year finds a growing host of skiers trekking up the muddy trail from the Pinkham Notch Camp to revel in a sun-blistering paradise of snowy slopes mounting up, up, up, to the pinnacle of all skiers' dreams—the lip of the

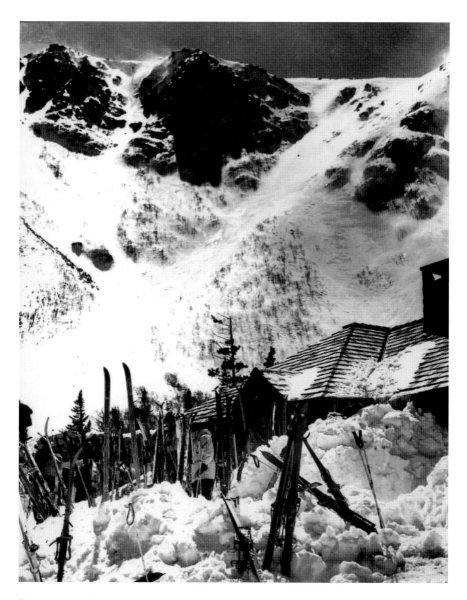

Skis adorn the high snowbank in front of the U.S. Forest Service's former Tuckerman Ravine shelter. *White Mountain National Forest archives.*

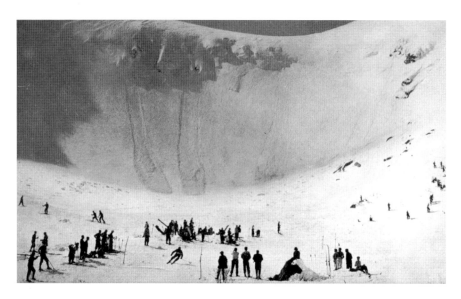

Snow-filled Tuckerman Ravine awaits the first tracks of the day in this postcard view from the 1930s. *Guy Shorey postcard view, author's collection.*

Tuckerman headwall. Gwendoline Keene gave this picture of Easter weekend skiing, "when Tuckerman's bowl is best":

> *Caught between winter's isolation and the summer "goofer" season it is a little world of its own, a pocket warmed by the sun and cooled by the cold that rises from its floor of marble snow, a pendant world where midget skiers come to climb and slide, to climb and slide again, to rest on the warm exposed summits of its few great rocks, to laugh and chatter and hum and hear far-off sounds...*
>
> *That day's big event may be some one running the headwall. Perhaps it's Charley Proctor, and you watch carefully to see the little speck that appears on the rim and is he. The speck starts, swoops, doubles back, swoops again, zigzagging at ever-widening angles until it dashes breathlessly straight down and stops at the bottom in one last side-slip of a Christie.*

But spring in Tuckerman is not all sun-bathing. Sometimes a blinding blizzard will fill the bowl. Snowslides may add to the excitement, and at times people have been carried along, buried waist deep, and may even have to be dug out of the snow.

Illustrating what terrific and swift changes in the weather are to be encountered on Mount Washington: On a beautifully warm and sunny

17 June 1933, at one o'clock in the afternoon, a sudden cold wind blew an immense black cloud over the headwall of Tuckerman. It spread out on the sides of the ravine and shut down like a curtain at the rim of the bowl, leaving the bowl enclosed like a tremendous tent and lighted by a queer twilight. After a few claps of thunder and ten minutes of severe hail, there followed a driving snowstorm which lasted an hour and deposited about an inch and a half of snow in the ravine before clearing again to bright sunshine. Next day young Simon Joseph of Brookline, Massachusetts, perished on the plateau land near the Lakes of the Clouds in a similar storm.

From 1933 to 1939, weather and snow conditions permitting, an Inferno Race was run on skis from the summit of Washington down the cone, over the headwall, and out the Forest Service Trail to Pinkham. In the Inferno of 1934 the Stem-Like-Hell Club again made history. All the contestants went to the summit. During the time they were climbing up there was an avalanche on the face of the headwall, but none of the skiers knew about it. Bob Livermore was one of the first over the lip, going over far to the left of the summer trail, and turning sharply to the right under the overhanging crag. As he did so, he discovered that there had been an avalanche, and realized that he was running directly into the path it had left, which meant disaster. Turning abruptly to the left he attempted to schuss straight for the foot of the headwall. But near the bottom he ran head-on into the debris left by the avalanche. His skis were snagged, and he was thrown into the air with terrific force.

In those days skis were fastened securely with straps. There were no safety bindings to free the feet in case of accident. Where the skis went the skier went also. And in this case Bob went into the air; turned a perfect triple somersault—somebody caught a movie of the dramatic event—and landed with unbroken skis to go on and finish the race, then to find that in his landing he had sprained both ankles!

Perhaps the most remarkable performance of all was the schussing of Tuckerman headwall by Toni Matt, who afterward served as head instructor of the Sun Valley Ski School, and later conducted his own ski school at Whitefish, Montana—one of the most brilliant skiers of all time. Born at St. Anton-am-Arlberg, birthplace of the renowned Hannes Schneider and his famous ski school, Toni strapped on his first barrel staves so early in life that at six he won his first race. At fourteen he was a full-fledged instructor in Schneider's school. For five years he taught as St. Anton, also taking part in most of the big Continental events.

Chosen by Schneider, in 1938, to assist the "Skimeister" in operating his school at North Conway, New Hampshire, and knowing almost no English, Toni Matt began teaching there through the medium of sign language. In the late winter of 1939, while only nineteen, he began to blaze a trail of ski victories that carried him through to practically every major downhill and slalom title in the United States. In the first season of American competition, he won the Eastern Combined at Stowe, Vermont, the Harriman Downhill at Sun Valley, the National Open Downhill at Mount Hood, and the Gibson Trophy at North Conway. This he won five times, retiring one cup and possessing two legs on another. But of all Toni's victories, the most remarkable was the April 1939 Inferno, when along the race course a shout went up that was echoed throughout the entire skiing world: "Toni Matt schussed the headwall!"

Even in a race, the headwall is generally handled in a series of turns. But Toni was not in a conservative mood that spring day, and his line was as straight as a die. "Uncorking one of the greatest schusses in all of skiing history, he took the Headwall in one long dive that left the 4000 spectators literally gasping for breath. Shooting across the outrun at sixty miles an hour, he roared over the Little Headwall and down the Sherburn Trail at full

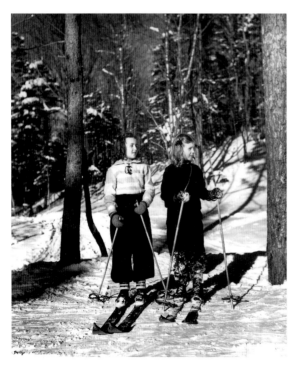

Young skiers frequently used the Pinkham Notch practice slope to hone their skills. Pictured on the left is Ann Dodge, daughter of legendary AMC huts manager Joe Dodge. *White Mountain National Forest archives.*

throttle to record a stunning 6:29.4 mark…a full minute better than that of second place winner Dick Durrance."

Winston Pote adds a word to one of the most spectacular records ever made on Mount Washington: "There is no doubt that Toni Matt made the first real 'Schuss' down the headwall, from practically the top, and I dare say the last! Just like the airplane landings, the elements were kind and snow was favorable. He came over the top very near where I was standing, and made only one turn, some 75 feet below, then straight down! He said afterwards, 'I intended to make two checks, but the snow felt so good I pointed them down!' He had run the cone almost straight, and that was wind-blown. So this unusually deep powder on the headwall must have seemed good."

How swiftly skiers can run into difficulties in Tuckerman Ravine is illustrated by what happened on 19 April 1947, when more than 350 ski racers and spectators were gathered high up in the Ravine for the annual Harvard-Dartmouth slalom race. Suddenly, a ski patrolman, investigating snow conditions above the race course, touched off an avalanche which plunged 450 yards down the steep racing stretch known as "Hillman's Highway" just after the race had started.

Brooks Dodge, son of Joe Dodge and then the seventeen-year-old Eastern Downhill champion, was halfway down the course when the slide started. He immediately let his skis run straight for the bottom, and outran the avalanche.

But avalanches cannot stem the enthusiasm of Mount Washington skiers. The sport is a part of them—is in their very blood—and must be served. So year after year they come back to the rugged old mountain to its most popular ski slope—Tuckerman Ravine.

CRASH OF THE COG RAILWAY

From the Littleton Courier, *September 21, 1967*

First published in 1889, the Littleton (NH) Courier *has been covering news of the western White Mountains and northern New Hampshire for well over a century. Over the years, the weekly newspaper has covered nearly every major event to occur on Mount Washington, including its devastating summit fires, the fatal 1967 Cog Railway accident and numerous search and rescue incidents.*

A tragedy of staggering proportions took place on Mt. Washington late Sunday afternoon when a Cog Railway passenger train left the rails on the next to the last southbound trip of the day and toppled at the Skyline Switch of the scenic mountain ride, about three-quarters of a mile from the summit.

Before night was over it had been learned eight passengers had died and 72 people including members of the train crew were sent to Littleton hospital for treatment of injuries that varied widely in extent of their seriousness. Two more came in for checkups later in the day, and two were sent direct to St. Louis hospital in Berlin.

All of the fatalities occurred at the scene of the crash, with no one succumbing to injuries after they had been rescued.

The unique steam engine and a newer-type **aluminum** and steel passenger car left the Summit about 5 **p.m. Sunday** for the return trip to the Base Station while the last train up for the day was enroute to the top.

The southbound train was moving over a switch to the spur to the main line when the center switch which had been tampered with threw the engine and coach from the center cog, causing the engine to leave the track and crash about six feet to the rocks.

It was reported that the passenger car then picked up speed and travelled an estimated 400 feet before it left the rails, dropping 6–8 feet onto the ground with its human cargo including people who had gone to the top by railroad and hikers who were returning from the mountaintop.

The car landed on its side and was later returned to its wheels by those less seriously injured to permit full rescue operations.

The train crew included Gordon Chase of Lincoln, engineer, Charles Kenison, Jefferson, fireman, Guillean "Rusty" Aertsen, a brakeman who was firing, Nate Carter, South Woodstock, brakeman on the passenger car, and Peter Carter, a brakeman who was riding on the downhill side of the cab during the trip.

As darkness settled in, the plight of the victims became more serious. The railroad management worked heroically to effect the rescues, using equipment including a flat car with emergency supplies for transportation of litter patients, 11 at a time. Dr. Francis Appleton of Gorham directed the handling of the injured at the scene.

All injured people had been removed to ambulances at the Base Station by 9:15 p.m.

The priority was agonizing as rescue workers with flashlights attempted to determine the more seriously hurt in the darkness. While warmer than usual weather conditions prevailed, nevertheless it was cool, adding to the discomfort of many of the victims. Relative calm prevailed, with many acts of mercy.

The site of the crash determined that rescue operations could best be carried out only by the Cog Railway and its Base Station more than 2½ miles below.

The rescue was effected by the upbound train being joined in rescue operations by another train and its crew, and volunteers. The latter crew included Griffin Harris, formerly of Littleton, and his brother, David of Littleton, and another member who had just completed the last trip down for the day. They added a flatcar to the passenger train and worked through the long hours to bring down the injured. "Grif" has been an engineer for 12 years and was doing weekend duty, being a teacher in the Lin-Wood Elementary School in Lincoln. David Harris is employed by New England Power Co. The third member of this crew was Robert Kent of Essex Junction, Vt.

One of the hospital patients, Bertrand Croteau, 31, of Thornton, who was accompanied by his wife, Elmae, 30, his son, Bertrand, Jr., 6, and daughter, Deborah, 11 (the son was also hospitalized) is a teacher of French and social studies at Lin-Wood High school in Lincoln. He was thrown through a window in the crash and was buried under the bodies of other passengers. He told of the nerve-wracking conditions that existed as passengers endeavored to free themselves and to get attention for their injuries.

The bodies of the eight victims were brought to the Pillsbury Funeral Home in Littleton where all-night operations were carried out including identification. When the information had been compiled funeral directors in the home areas of the victims were notified and the fatalities listed as follows: Eric J. Davies, 7, Hampton; Kent Woodward, 8, New London; Monica Gross, 2, Brookline, Mass.; Mary Frank, 38, Warren, Mich.; Shirley Zorzy, 22, Lynn, Mass.; Charles Usher, 54, Dover; Beverly Ann Richmond, 15, Putnam, Ct.; Mrs. Esther Usher, 56, Dover.

The bodies were viewed by Dr. Leandre P. Beaudoin of Berlin, Coos county medical examiner. It was determined that all had died on the mountain.

An estimated 30 ambulances were pressed into emergency service to transport the victims from the Cog Railway to the Littleton hospital. The vehicles came from Littleton (Pillsbury Funeral Home, Ross Funeral Home, and the Fire Department), Bethlehem Fire Department, Lincoln, Whitefield, Lancaster, Groveton, Berlin and North Conway. Each vehicle was capable of carrying two litter patients.

The Littleton hospital was so geared to meeting the emergency under its Disaster Plan that the entire group of victims was brought to this institution. Hospitals at Lancaster and North Conway had been alerted but their services in treating the victims were not immediately required.

Dr. Harry C. McDade, chief of surgeons at Littleton hospital, said the Disaster Plan which had been prepared for any emergency eventuality was put into action about 6:30 p.m. Sunday. The first ambulance delivery was made about 8:15 and the last admittance to the emergency quarters of the hospital was made about 3 a.m. Monday.

The Littleton hospital has a bed capacity of 61 patients and it was fortunate at the time of the tragedy the patient count was at a lower level, about 30.

The entire medical staff, the nursing staff, administration staff personnel headed by Assistant Administrator Robert McLean, and dietary personnel, totaling about 40, were pressed into service and the Disaster Plan was carried out with remarkable efficiency to meet the heavy responsibility placed on the Littleton hospital by one of the worst tragedies in the state's history.

The victims were wheeled into the emergency area or walked in, and dispatched to whatever treatment area was required. Those who were fortunate to require only first aid were released as their conditions permitted, some being sent to private homes for the balance of the night. Three of the victims with serious head wounds were sped to Mary Hitchcock Memorial hospital in Hanover, three sent to Brightlook hospital in St. Johnsbury, Vt., and two to Weeks Memorial hospital in Lancaster for care.

On hand at the hospital as the patients were received for the all-night emergency action were volunteer litter bearers who handled the stretchers with care and dispatch. These stretcher bearers included members of the Littleton Fire Dept., U.S. Forest Service and innumerable volunteers from the Base Station.

The victims of the mountain tragedy were treated for a variety of hurts including head injuries, broken bones and serious lacerations and bruises. There were many particularly pathetic cases such as one mother who consoled her young daughter suffering from facial injuries while aware that a second daughter had been killed in the accident. There were many instances of families endeavoring to be re-united following their harrowing experience. The exclamation, "We're all alive!" was heard more than once during the heart-rending scenes of the nighttime drama.

On hand to render their services wherever possible were the ministers and priests of churches in Littleton, Whitefield, Lisbon and Lincoln. Rev. Raymond Desjardins of Lisbon, Rev. Gerard Supper of Littleton and Rev. Michael Griffin of Whitefield were present at the Base Station during the rescue operations and later came to Littleton hospital.

The victims ranged in age from very young to elderly couples from throughout New England and several other states. One youngster, James B. Dixon of Portland, Me., will long remember his 12th birthday which occurred Sunday.

Of concern to everyone was the inability during the night to identify one child who was among the three dispatched to Hanover hospital for treatment of head injuries. No family member had come forward to assist authorities with the identification.

As the night wore on the well-organized hospital personnel carried out their professional duties with compassion and sympathetic understanding, bearing up under the heavy strain with remarkable stamina.

During the night the hospital was besieged by news media of all kinds for latest information concerning victims, and as the casualty list climbed

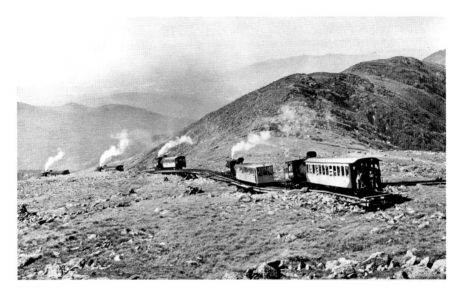

It's a busy day on the Cog Railway as five trains make their way along the three-mile railroad. *Author's collection.*

it became more evident that it was miraculous that more fatalities had not occurred.

As of Monday 11 patients were at the Littleton hospital for continued treatment, the balance of the 72 admittances having been transferred elsewhere or approved for release to pick up the agonizing details of reunion with plans to retrieve their autos at the Base Station and return to their homes.

The major emergency was controlled to provide little or no anxiety for the regular patients at the hospital. Special emergency supplies arranged for under the Disaster Plan were put to immediate use, and anticipated requirements for blood resulted in one shipment of whole blood plasma and blood derivatives being sent from Brightlook hospital and other supplies made available from other sources but not needed.

State Police of Troop F at Twin Mountain under Capt. Kenneth Hayes and Lt. Henry Genest were pressed into full emergency service at the Base Station and at the hospital, controlling traffic situations, compiling accident data and generally expediting the night rescue operation, carried out by personnel of the Cog Railway and others. Nine State Police were at the Base and three at hospitals.

Mrs. John Morgan of Greenfield, sister of Mrs. Arthur S. Teague, president of the Mt. Washington Cog Railway Corp., assisted at the scene

as did Thomas Baker of Littleton, fiance of Miss Margaret Teague; Miss Marjorie Bargar, Cog Railway nurse; Cass White and Paul Philbrook of the Cog Railway staff.

For the most part, regular hospital staff members had little or no sleep before reporting for regular duties Monday morning, and continued follow-up work in the emergency.

The Bethlehem ambulance, en route back to the Base Station for a second group of victims, had motor trouble near the Zealand Campground and had to be abandoned.

A word of appreciation should be given the girls at the Highway Office in Lancaster for their untiring work during the emergency. Mrs. Kathleen Doolan and her assistant went out of their way to help wherever they could.

The N.H. Public Utilities commission this week was continuing its investigation into the crash. It was made clear that the mountain railroad had not been closed down by the PUC and that trains would probably be operated on a limited basis within a few days, probably to the Waumbek station which is about 1/3 of the 3½ mile trip to the summit. The railroad which is probably the best-known mountain railroad in the world normally closes for the year on October 15.

Only two of the five employees of the railroad required continued hospitalization: Gordon Chase of Lincoln, a patient at St. Louis hospital, Berlin, with severe burns and Charles Kenison of Jefferson, Lancaster hospital, with burns. Guillean "Rusty" Aertsen, who had abrasions and contusions and Nate Carter who had shoulder and nose injuries, have been discharged.

Little Monica Gross was the daughter of Prof. and Mrs. Charles Gross of Brookline, Mass. Miss Shirley Zorzy was employed as a secretary at Northeast Airlines at Logan International Airport, Boston.

Funeral services were held yesterday morning in Hampton for Eric Davies, and funeral services for Mr. and Mrs. Charles Usher were held this morning in Dover. In New London yesterday afternoon the funeral service for Kent Woodward was held.

Forest Ranger Richard MacNeil of the Ammonoosuc District office in Littleton was among those on the scene to render any assistance possible. He commented:

"I arrived at the Base Station at 7:30 p.m., contacted the State Police officer in charge and offered the assistance of the Forest Service. Lt. Genest felt that there was enough help on the scene and said he would contact me if we were needed.

"My first thought upon reaching the Base Station was—where did they manage to get so many ambulances?

"I remained at the Base until the first load of injured people came down, then rode the next train up to the scene of the accident.

"At the scene of the wreck I saw Conservation Officers, State Police troopers, AMC personnel, Forest Service personnel and volunteers. All were working together. About 8–10 injured people were still there and we began to load them into litters.

"As we began I saw two things which made a lasting impression on me. The first of these was a young man who had been on the wrecked car, but had been uninjured. He was doing an excellent job of comforting and reassuring the injured people and assisted in loading them into litters. The other thing which impressed me was the sight of three teenage girls. They had gotten off another train to help. They were giving reassurance to a couple who were both severely injured, and were doing a good job in calming them.

"I remained at the scene until the bodies were loaded on a car and then rode down.

"The weather was very cooperative—mild temperature and very little breeze—very strange weather for Mt. Washington.

"The lack of adequate communication from the wreck to the base made the rescue operation somewhat difficult. An efficient two-way radio setup would have helped.

"Naturally the most impressive thing was the tragedy itself. Beyond that was the tremendous spirit of cooperation between many agencies, those already mentioned plus Fire Departments, rescue squads, and just plain people who felt that they could help."

THE UNKNOWN SOLDIER OF MOUNT WASHINGTON

By Peter Crane

From Mount Washington Observatory News Bulletin, 1992

Peter Crane (1954–), curator of the Mount Washington Observatory's Gladys Brooks Memorial Library, has held a variety of positions with the well-known nonprofit. He first hiked in the White Mountains during his high school years and quickly fell in love with the region. He was formerly employed by the Appalachian Mountain Club at a number of backcountry facilities and at Pinkham Notch Camp and spent one year working for the U.S. Forest Service, primarily doing trail maintenance work. Crane received his undergraduate degree from Harvard University and his graduate degree from the University of Pennsylvania. Besides his interest in White Mountain history and lore, Crane is also active as a trail adopter for the White Mountain National Forest, serves on the board of the New Hampshire Outdoor Council and was a longtime member of the all-volunteer Androscoggin Valley Search and Rescue organization.

Readers of the *News Bulletin* are accustomed to our notices of accidents, particularly fatal accidents, that occur on Mount Washington. The purpose of these articles is not a morbid fascination with these tragic incidents, but rather to help make people more aware of the potential dangers which are associated with the mountain, and especially with skiing, hiking, and climbing here. Most of the news which we present with regard to such occurrences is recent, but occasionally we are presented with some new information on older events which we feel should be brought to our readers' attention, especially when it has to do with "one of our own."

A reading of William Putnam's recent volume, *The Worst Weather on Earth,* gave us a shock. On page 74 we found the following passage:

> *...Private William Seely...was a 29 year old farmer from Seneca Falls, New York, who had been signed up for less than a year and barely arrived at Station 46 (the Mount Washington summit station) when his slide-board got away from him on a trestle and he received fatal injuries...*

A quick review of the Mount Washington "fatality list" (with variant versions maintained by the Observatory, A.M.C., the U.S. Forest Service, and Mount Washington State Park) indicated that Private Seely's untimely death had gone unnoted! While the only other Mount Washington weather observer to die in the line of duty—Private William Stevens who died of "paralysis of the left side" on the summit on February 26, 1872—had been given the simple honor of recognition, Seely had disappeared from the active historical record.

While the Signal Service log in the Boston Public Library deals mostly with meteorological matters and does not mention the incident that led to Seely's death, information on the hapless man and his passing is available from United States Army records in the National Archives and from contemporary news accounts. We felt the compulsion to consult these sources, having unduly neglected the memory of our forebear for so long.

According to Seely's enlistment papers, he joined the Army in Saint Louis, Missouri, on August 16, 1872, at the age of 29. The papers indicate that he was "born in Seneca Falls, New York, and (was) by occupation a farmer," (unfortunately, the early records of Seneca Falls were destroyed in a fire in 1881). He was single and had no children. He enlisted for the standard term of five years. The recruiting officer certified that Seely had "brown eyes, brown hair, fair complexion, is 5 feet and 5¾ inches high." The officer also endorsed that standard statement that the recruit "was entirely sober when enlisted"—sufficient evidence to suggest that, in that day and age, they had a goodly number of potential recruits that were not sober at the time. Added to Seely's enlistment papers were the remarks "Residence when enlisted Saint Louis, Mo." and "Enlisted in the General Service for assignment to the Signal Service U.S. Army."

At this point we do not know what brought Seely from Seneca Falls to Saint Louis; nor do we know what path he took from the Gateway City to Mount Washington. Sadly, we do know which route he was taking down

the summit on Saturday, June 28, 1873, as an account in Littleton's *White Mountain Republic* for Thursday, July 3, gives us the following information:

> *On Saturday last, as Wm. Seeley* [sic], *employed in the Signal Service on Mt. Washington, was sliding down the railroad track on one of the apparatus used for that purpose,* [he] *was run into by a comrade, whose sled became unmanageable, and was seriously injured. He was brought to this village by Mr. E. Cox of the Marshfield House, and taken to Jennison's Hotel, where he lies in critical condition.*

Editions of *The New Hampshire Register and Farmer's Almanac* for the era note a Union House operated by a William Jenerson (*sic*); Eastman's *The White Mountain Guide Book* for 1873 refers to a boarding house of William Jennison, which had room for 20 people at 7 to 14 dollars per week. Apparently only primitive medical care was available in Littleton at that time; though there were four physicians and one homeopathic practitioner listed in the *Register*, the Littleton Hospital was not dedicated until 1907. We can only speculate, but perhaps Seely was attended by Dr. Frank Tifft Moffett, M.D. According to Dr. Charles M. Tuttle, writing on "The Profession of Medicine" in *Exercises at the Centennial Celebration of the Incorporation of the Town of Littleton, July 4th, 1884*, Moffett "will be long remembered by the members of the signal service as the physician who ascended Mt. Washington in mid-winter, 1872, and took charge of the remains of the first member of the corps who died at the summit station" (page 165).

The next issue of the *White Mountain Republic*, that of Thursday, July 10, 1873, completed Seely's sad tale:

> *William Seeley* [sic], *who was injured in the descent of Mount Washington, as announced last week, died on Wednesday, the 2d, at Jennison's Hotel. He remained unconscious from the time of the accident till his death.*

The "Final Statement" of the Army for Seely asserted that at the time of his death, the soldier was 30 years old and died "by reason of wounds received from falling through the trestle work of the Railroad on Mt. Washington, New Hampshire, in the line of his duty." Seely's remains were buried at Littleton's White Mountain Cemetery, the name of which was changed to the Glenwood Cemetery in 1877. According to James R. Jackson's *History of Littleton New Hampshire*, "The northeast corner (of Glenwood Cemetery) is set apart for the burial of persons without family or strangers in the

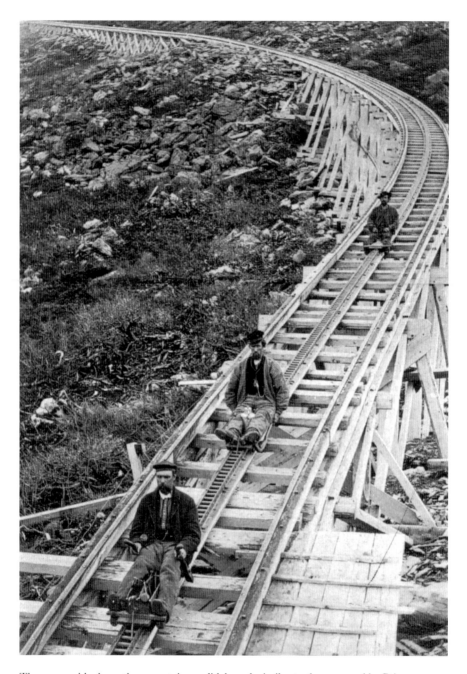

Three men ride down the mountain on slideboards similar to the one used by Private William Seely in 1873. *Courtesy Littleton Area Historical Society.*

town," and there were laid to rest both Seely and his predecessor Stevens (Volume III, page 511). Two simple headstones mark these soldiers' graves. While both observers died as privates, the headstones refer to each of them as sergeants—evidently an error, but we won't begrudge the men their posthumous promotions.

Seely's tragic rendezvous with the devil's shingle underscores the hazards associated with that form of transportation on Mount Washington. Putnam (pages 70–71) relates another serious, but not fatal accident which befell Sergeant O.S.M. Cone as he attempted to slide down the railway tracks on January 27, 1878. The same author (pages 73–74) also notes that about ten years after Seely's death another observer, Private P.J. Cahill, came to grief between Long Trestle and Jacob's Ladder. On October 27, 1883, the soldier broke his leg in two places and received severe scalp wounds, such that he had to spend two months off the mountain recovering. A colleague attributed the injuries to "too much slideboard."

F. Allen Burt, in *The Story of Mount Washington*, noted that slideboards were used for "early-morning delivery of special editions of *Among the Clouds*," (page 115) but it does not appear that the devices were regularly used by the paperboys. We know they were used, at their peril, by weather observers, but it seems they were most frequently utilized by railway workers. Burt, who considers them "the most picturesque, and hazardous, method of transportation on Mount Washington" (page 100) claims that "no one but workmen were ever permitted to use them, as it required both experience and strength to manage a slideboard safely." While he acknowledges that two accounts exist of women traveling on the devices, there is no evidence that a woman ever rode a slideboard alone. He also notes that the three-mile trip was customarily achieved in ten minutes, with the record an astonishing two and three-quarters minutes (pages 100–101).

We do not know exactly when the slideboard was invented. We can only assume that it wasn't very long after work began on the railroad in 1866; we know that they were used by members of the Huntington-Hitchcock expeditions in the fall of 1870. It is not clear when use of the devices ended. Frederick Kilbourne, in *Chronicles of the White Mountains*, published in 1916, claims that a fatal accident by an employee using a slideboard "cost the Railway Company several thousand dollars in damages and made evident the liability to mishaps of this kind," and thus caused the discontinuance of the use of the slideboard (page 245). This would date the end of slideboard use in 1916 at the very latest, but Burt states that "about 1930,

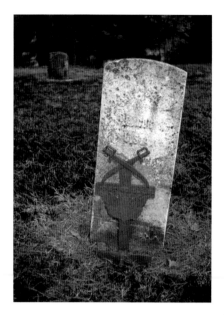

Following his death, Private William Seely was buried in Littleton's Glenwood Cemetery, where this simple gravestone marks his final resting place. *Photo by author.*

because of several deaths over the years, slideboards were permanently banned" (page 110). Donald Bray, in *They Said It Couldn't Be Done*, would seem to side with Kilbourne in suggesting that the banning may have occurred shortly after the August 23, 1906 death of Alexander Cusick, evidently the employee to whom Kilbourne refers (page 70). Cusick, of Websterville, Vermont, had nearly 30 years of experience working for the Railway, but evidently lost control of his slideboard below the base of Coldspring Hill, near the foot of the mountain; another railway worker who was descending ahead of Cusick barely escaped being hit by him. Offering evidence against a 1906 ban of the devices is the article "Kindellan v. Mt. Washington Railway," by Guy Gosselin (*MWONB*, Vol. 17, No. 2, June 1976) which refers to a non-fatal slideboard accident which occurred to a Cog Railway worker on July 17, 1908. Testimony offered in 1910 stated that "during a period of 20 years or more, three or four accidents had occurred through slideboards in collision, and for a time their use was forbidden," which indicates that their use was not forbidden in 1908, and suggests that their use was still authorized in 1910. (One of the accidents, a September 28, 1900 crash of two railroad workers which resulted in serious injuries to one, is noted in an article by Douglas Philbrook, *MWONB*, Vol. 29, No. 1, 1988, page 10.)

Two additional fatalities can be blamed on ill-thought-out attempts to slide down the Cog Railway tracks. On August 5, 1919, Harry Clauson, 19, of South Boston, Massachusetts, and his companion Jack Lonigan, 20, of Boston, tried to travel down the Railway on "an improvised sliding board made of two planks." They quickly lost any semblance of control and plunged to their deaths "about 100 yards above the half-way station." A companion, John Jansky, 18, "fell off the board right at the start and thereby saved his life, getting out of the affair with only a scraped knee," according to the *Littleton Courier*, of August 7, 1919.

There have been occasional reports of bold (or perhaps fool hardy) adventurers trying out home-made slideboards on the cog railway tracks in the 1940s and 1950s, but such reports are difficult to confirm. Changes in the design of the center cog rail have eliminated the slide flanges against which early slideboard brakes once acted, making this dangerous and sometimes deadly activity even more hazardous than when Seely and Cusick took their last, lethal rides.

We hope that this long overdue notice will correct the record with regard to our fellow observer Seely's death by giving the soldier the dubious distinction of a place on Mount Washington's list of tragic victims. He has been the "unknown soldier" of Mount Washington; let him be unknown no longer. In chronological order, he would be considered the sixth person to perish on or as a result of activities on the mountain, following his colleague Private Stevens, William Seely, *"Ave atque Vale.*

SELECTED BIBLIOGRAPHY

Among the Clouds. Mount Washington, NH.

Appalachia. Journal of the Appalachian Mountain Club, Boston.

Belknap, Jeremy. *The History of New Hampshire*. Vol. III. Boston, 1792.

Bliss, L.C. *Alpine Zone of the Presidential Range*. Edmonton, CA, 1963.

Burt, F. Allen. *The Story of Mount Washington*. Hanover, NH: Dartmouth Publications, 1960.

Burt, Frank H. *Mount Washington: A Handbook for Travellers*. Boston, 1904.

Crawford, Lucy. *The History of the White Mountains, from the First Settlement of Upper Coos and Pequaket*. Portland, ME: B. Thurston & Company, 1886.

Cross, George N. *Dolly Copp and the Pioneers of the Glen*. N.p., 1927.

Daniell, Eugene S., III, ed. *AMC White Mountain Guide*. 26th ed. Boston: Appalachian Mountain Club, 1998.

Drake, Samuel A. *The Heart of the White Mountains: Their Legend and Scenery*. New York: Harper and Brothers, 1881.

Eastman, Samuel C. *The White Mountain Guidebook*. 7th ed. Boston: Lee and Shepard, 1867.

Goldthwait, Richard P. *Geology of the Presidential Range*. N.p.: New Hampshire Academy of Science, 1940.

Gosselin, Guy A., and Susan B. Hawkins. *Among the White Hills: The Life and Times of Guy L. Shorey*. Portsmouth, NH: Peter E. Randall Publisher, 1998.

Hitchcock, C.H., et al. *Mount Washington in Winter or The Experiences of a Scientific Expedition Upon the Highest Mountain in New England: 1870–1871*. Boston: Chick and Andrews, 1871.

Kidder, Glenn M. *Railway to the Moon*. Littleton, NH, 1969.

Kilbourne, Frederick W. *Chronicles of the White Mountains*. Boston: Houghton Mifflin Company, 1916.

King, Thomas Starr. *The White Hills: Their Legends, Landscape and Poetry*. Boston: Crosby and Ainsworth, 1859.

Littleton (NH) Courier.

McAvoy, George E. *And Then There Was One*. Littleton, NH: Crawford Press, 1988.

McKenzie, Alexander A., II. *The Way It Was: Mount Washington Observatory, 1934–1935*. N.p., 1994.

Monahan, Robert S. *Mount Washington Reoccupied*. Brattleboro, VT: Steven Daye Press, 1933.

Mount Washington Observatory News Bulletin. North Conway, NH.

New Hampshire Profiles. Portsmouth, NH.

Pote, Winston. *Mount Washington in Winter: Photographs and Recollections, 1923–1940*. Camden, ME: Down East Books, 1985.

Putnam, William Lowell. *Joe Dodge: One New Hampshire Institution*. Canaan, NH: Phoenix Publishing, 1986.

———. *The Worst Weather on Earth*. Gorham, NH: Mount Washington Observatory, 1991.

Ramsey, Floyd W. *Shrouded Memories: True Stories from the White Mountains of New Hampshire*. Littleton, NH, 1994.

Randall, Peter E. *Mount Washington: A Guide and Short History*. 3rd ed. Woodstock, VT: Countryman Press, 1992.

Spaulding, John H. *Historical Relics of the White Mountains, Also a Concise White Mountain Guide*. Boston, 1855.

Sweetser, Moses F. *Chisholm's White Mountain Guide*. Portland, ME: Chisholm Brothers, 1902.

———. *The White Mountains: A Handbook for Travellers*. 4th ed. Boston: James R. Osgood and Company, 1881.

Teague, Ellen Crawford. *I Conquered My Mountain*. Canaan, NH: Phoenix Publishing, 1982.

Torrey, Bradford. *Nature's Invitation: Notes of a Bird-Gazer, North and South*. Boston: Houghton, Mifflin and Company, 1904.

Ward, Julius H. *The White Mountains: A Guide to Their Interpretation*. New York: D. Appleton and Co., 1890.

Washburn, Bradford. *Bradford on Mount Washington*. New York: G.P. Putnam's Sons, 1928.

Waterman, Laura, and Guy Waterman. *Forest and Crag: A History of Hiking, Trail Blazing and Adventure in the Northeast Mountains*. Boston: Appalachian Mountain Club, 1989.

White Mountain Echo and Tourists' Register. Bethlehem, NH.

INDEX

L

M

ABOUT THE AUTHOR

M ike Dickerman is a longtime northern New Hampshire resident who was lured to the White Mountains region by its many foot trails and magnificent summits and lush valleys. After more than a decade of reporting on area events for the *Littleton Courier* newspaper, he started his own publishing company (Bondcliff Books) in 1996 and regularly writes, publishes and distributes books related to New Hampshire's North Country and White Mountains. For more than twenty-five years, his popular hiking column, "The Beaten Path," also appeared regularly in newspapers across the Granite State. He has authored or edited numerous books, including *White Mountains Hiking History: Trailblazers of the Granite, Stories from the White Mountains, The 4000-Footers of the White Mountains* and *The Life of James Everell Henry.* He was also co-editor of the award-winning anthology *Beyond the Notches: Stories of Place in New Hampshire's North Country* and served as co-editor of the twenty-ninth edition of the *AMC White Mountain Guide.* He lives in Littleton, New Hampshire, with his wife, Jeanne.

Visit us at
www.historypress.net
..
This title is also available as an e-book